Time-Life Books Inc.
is a wholly owned subsidiary of
TIME INCORPORATED

FOUNDER: Henry R. Luce 1898-1967

Editor-in-Chief: Henry Anatole Grunwald
President: J. Richard Munro
Chairman of the Board: Ralph P. Davidson
Executive Vice President: Clifford J. Grum
Editorial Director: Ralph Graves
Group Vice President, Books: Joan D. Manley
Vice Chairman: Arthur Temple

TIME-LIFE BOOKS INC.
EDITOR: George Constable
Executive Editor: George Daniels
Director of Design: Louis Klein
Board of Editors: Dale M. Brown, Thomas A. Lewis,
Martin Mann, Robert G. Mason, John Paul Porter,
Gerry Schremp, Gerald Simons,
Rosalind Stubenberg, Kit van Tulleken
Director of Administration: David L. Harrison
Director of Research: Carolyn L. Sackett
Director of Photography: John Conrad Weiser

President: Reginald K. Brack Jr.
Executive Vice Presidents: John Steven Maxwell,
David J. Walsh
Vice Presidents: George Artandi, Stephen L. Bair,
Peter G. Barnes, Nicholas Benton, John L. Canova,
Beatrice T. Dobie, James L. Mercer, Paul R. Stewart

LIFE LIBRARY OF PHOTOGRAPHY
EDITORIAL STAFF FOR THE
ORIGINAL EDITION OF
DOCUMENTARY PHOTOGRAPHY:
SERIES EDITOR: Richard L. Williams
Picture Editor: Carole Kismaric
Text Editor: Anne Horan
Designers: Herbert H. Quarmby, Angela Sussman
Staff Writers: Sam Halper, Suzanne Seixas,
John von Hartz, Johanna Zacharias
Chief Researcher: Nancy Shuker
Researchers: Sondra Albert, Elizabeth Dagenhardt,
Angela Dews, Rhea Finkelstein, Lee Hassig,
Kathryn Ritchell, Carolyn Stallworth, Jane Sugden
Art Assistant: Patricia Byrne

EDITORIAL STAFF FOR
THE REVISED EDITION OF
DOCUMENTARY PHOTOGRAPHY:
SENIOR EDITOR: Robert G. Mason
Designer: Sally Collins
Chief Researcher: Patti H. Cass
Associate Editor: Donald Davison Cantlay (text)
Researchers: Janet Doughty, Reiko Uyeshima
Assistant Designer: Kenneth E. Hancock
Copy Coordinator: Anne T. Connell
Picture Coordinator: Eric Godwin
Editorial Assistant: Carolyn Halbach

Special Contributors:
Don Earnest, Gene Thornton

EDITORIAL OPERATIONS
Design: Arnold C. Holeywell (assistant director);
Anne B. Landry (art coordinator); James J. Cox
(quality control)
Research: Jane Edwin (assistant director),
Louise D. Forstall
Copy Room: Susan Galloway Goldberg (director),
Celia Beattie
Production: Feliciano Madrid (director),
Gordon E. Buck, Peter Inchauteguiz

CORRESPONDENTS
Elisabeth Kraemer (Bonn); Margot Hapgood, Dorothy
Bacon (London); Miriam Hsia, Lucy T. Voulgaris (New
York); Maria Vincenza Aloisi, Josephine du Brusle
(Paris); Ann Natanson (Rome). Valuable assistance
was also provided by: Mimi Murphy, Ann Wise
(Rome).

*The editors are indebted to the following individuals
of Time Inc.: Herbert Orth, Chief, Time-Life Photo
Lab, New York City; Peter Christopoulos, Deputy
Chief, Time-Life Photo Lab, New York City; Photo
Equipment Supervisor, Albert Schneider; Photo
Equipment Technician, Mike Miller; Color Lab
Supervisor, Ron Trimarchi.*

Introduction

The term documentary photography came into use during the Depression years, when telling pictures of poverty-stricken farmers awakened Americans to the need for social reform. And in many minds this field of photography still suggests pictures of the Dust Bowl, of rural hardship and urban slums.

Yet as this book shows, there is, and always has been, far more to documentary photography than the recording of the world's ills. For there is much more to document than suffering and poverty: faraway places and exotic peoples, quirks of nature and of society, the whole gamut of emotions and relationships. The subject matter is, indeed, almost unlimited.

Then is every photograph a documentary? Not really, for it must convey a message that sets it apart from a landscape, a portrait, a street scene. It may record an event, but the event must have some general significance, more than the specific significance of a news photo. It may record character or emotion—but again, of some general social significance; it is more than personally revelatory, as a portrait is.

Yet whether it shows us family life in Paris or in Maine, the central square of Peking or a stretch of U.S. Route 66, a dive in New York's slums or a village café in Hungary, a sharecropper's cabin or a suburban living room, the documentary photograph tells us something important about our world—and, in the best examples, makes us think about the world in a new way.

The Editors

To See, to Record—and to Comment 12

BUSY: *Priestess of the Cult of the Three Worlds* (celestial, terrestrial, aquatic), Tonkin, 1916

To See, to Record—and to Comment

Documentary photography: a depiction of the real world by a photographer whose intent is to communicate something of importance—to make a comment—that will be understood by the viewer.

That is the definition on which this book is based. It is arbitrary by necessity, since there is no universally accepted definition that suits all aspects of this important and intriguing category. A documentary photograph may be as public as a picture in a mass-circulation magazine, or as private as an intimate view of a loved one. On cursory inspection a good documentary photograph may seem little more than a snapshot. But under more careful scrutiny it generally reveals itself to be a visual representation of a deeply felt moment, as rich in psychological and emotional meaning as a personal experience vividly recalled.

That the attributes of a documentary photograph seem contradictory may be the result of the newness of the term. It was not even coined until the 1930s and then it was linked in the public mind with documentary films—movies that, without fictionalized plot, usually examined the lives of little-known people in remote places. These films, unlike the routine travelogue, were a visual commentary on the world. The same kind of communication had long been provided by still photographs, but until that point they had never been dignified by categorization as something special.

The photographs made by the pioneers of documentary photography look quite different from those being created by many of its modern practitioners. Yet they are fundamentally the same—all comment on reality—and the apparent differences developed logically as the form progressed from the simple to the complex. Documentary photography evolved in several stages, each of which has its own characteristics. The first stage was broad-based and was directly related to the invention of photography itself. With the introduction of the daguerreotype in 1839 came the first relatively simple and inexpensive way to perpetuate images, to fulfill the common desire for a permanent record of the appearance of family, friends and familiar scenes. Record-making became still easier in 1888, when George Eastman brought out his roll-film Kodak: What had been comparatively simple now became so routine that anyone could—and almost everyone did—take personal pictures; the album pasted full of snapshots became a source of family unity and pride. In the broadest sense, the record pictures were documentary photographs: They were scenes from the real world of a subject important to the photographer. And if the photographer was a prodigy like Lartigue, who made photographs of his family, friends and relations before World War I *(pages 26-31),* the results were lighthearted, sophisticated art.

If the familiar made a cherished photographic record, so did the unfamil-

iar. The early photographers rushed off to capture views of distant, exotic places that could be visited only by the well-to-do and adventurous. Pictures of such romantic sites as Niagara Falls, the Egyptian pyramids and the Alps were purchased to frame and hang on parlor walls; no late-19th Century home was complete without a scene from a faraway place on display. In the 1850s the popularity of the stereoscope, a device in which pictures could be seen in three dimensions, expanded the already booming market for pictures of scenic places. But even without an optical gimmick like the stereoscope, photographs brought the world into the home.

These scenic views won such wide popularity partly because they emphasized a quality, essential to the documentary photograph, that is a basic characteristic of the camera-made image: It provides a clear representation of what the retina of the human eye sees but does not always notice. In the beginning this quality alone seemed miraculous, and the camera was used mainly as a copier of nature. The results were regarded as evidence—as documents—of nature as it exists. Faith in the camera as a literal recorder gave rise to a belief that persists to this day—that the camera does not lie. This trust of the camera provides documentary photography with its greatest psychological strength and its strongest selling point—it tells the truth.

As the camera gained acceptance as a reliable visual reporter, its potential became apparent to photographers who had something more to say than could be communicated by a mere snapshot. A picture of the Alps, if made with sensitivity and skill, could be more than a literal record of a majestic scene. The photograph conveyed ideas beyond the two-dimensional, black-and-gray image of shadows and light. The scene before the lens was reality, but the photographer could make his camera's rendering of the scene generate another reality, deeper and perhaps more important—he could introduce comment. If the first attribute of the documentary photograph was its ability to convey the truth about the real world, its second was its ability to communicate the photographer's comment on that truth.

The first master of this technique was Eugène Atget. He referred to himself simply as a maker of documents—clear, uncluttered views of his beloved turn-of-the-century Paris—which he sold occasionally as reference material for artists and architects. Yet he was a genius at understanding the uses of the camera, particularly its ability to convey his own view. Shots of empty parks *(pages 36-42),* when made by Atget, blended the reality of the scene with its deeper meaning as a part of a city, and with his own feeling for the city. The results are masterworks of documentary photography.

The realization that the camera could communicate truth while commenting upon it led to the second stage in the expanding history of documentary photography: the discovery of the camera's power to hold up a mirror to so-

ciety, to let the world see its reflection. Jacob Riis, a Danish-born newspaper reporter of the late 19th Century, was one of the first to show how photographs could become social documents. Riis picked up his camera in desperation. He wanted Americans to see for themselves what he had been writing about— the grinding brutality of life in New York City's slums. His pictures were as trenchant as his reporting, exposing to the world the gray, lined face of American poverty. Following soon after Riis came one of the best social documentarians in the history of photography, Lewis W. Hine. Hine was a trained sociologist and schoolteacher whose passionate social awareness took him into factories and down into mines in order to photograph the inhuman conditions imposed on working-class children and immigrant laborers. His pictures were down-to-earth indictments of early-20th Century American industrial practices, but his talent and compassion made his work do more than arouse indignation; it made the viewer embrace the subjects as fellow human beings and share their hardships. Together, Riis and Hine turned documentary photography to a study of the human condition. This visual comment on the joys and pains of society has to a great extent occupied practitioners in this field ever since.

Through the Depression of the 1930s, the war years of the 1940s and into the postwar recovery period, documentary photographers roamed the world— and examined their own neighborhoods— to capture the special feel of time and place created by each society at a given moment in history. Although these photographers, who included such giants as W. Eugene Smith, André Kertész, Dorothea Lange and Walker Evans, viewed human suffering and despair everywhere they wandered, they also captured the inner strength, dignity and transcendent hope of their subjects. They believed that man was redeemable. Perhaps more important, they felt man was worthy of redemption. Like the Romantic novelists of the 19th Century, these documentary photographers thought that by showing man his follies, they would lead him to correct them. The brooding genius Smith was convinced that once his pictures laid bare the futility, savagery and brute stupidity of war, mankind would be horrified into abolishing warfare for all time.

By the 1950s, however, it was clear that the documentary photographers had achieved no more in reforming society than had the Romantic novelists. Some consciences had been stirred, some laws had even been enacted— Hine's photographs led to the passage of labor legislation that rescued children from servitude in factories. But mankind had not been elevated to a state of greater purity through photographs, and many disillusioned documentarians turned to another approach.

The development of a new concept of documentary photography was signaled by a single event, the publication in 1958 of Robert Frank's book, *The*

Americans. A collection of photographs that Frank made during a tour of the United States, it presented views of the country by an outsider — Frank was born and raised in Switzerland. In his pictures, he saw the patch in the fabric of the American flag *(page 162).* He set down the tedium of daily life, the polluting residue of industrial society, the frustrations of those Americans caught between the promise of the national rhetoric and its everyday reality. Frank's view was hard-nosed, direct and very personal.

After *The Americans,* documentary photography entered the contemporary phase of its evolution. Many photographers turned inward as they withdrew from the rough-and-tumble of public life and actions. Their concern became the recognition — and the problems — of the inner man. But this introspection proved as hard to maintain as the harsh and often cynical criticism of society that preceded it. The best of recent documentarians have sought a middle path, walking out into the world — or a carefully chosen part of it — to record a strong personal view or to document an intensely personal experience.

In this new form, documentary photography is, oddly, returning to its beginnings for much of its subject matter. These modern photographs, like daguerreotypes of old, frequently show families, friends and homes — though not necessarily the photographers' own families or native homes. The new documentarians would certainly claim their subjects as friends: For whether documenting the lives of cowboys in the American West or of Maasai herdsmen in East Africa, these photographers carry sympathy along as a piece of equipment every bit as essential as film or lenses. They tend to concentrate on well-defined topics: one country, one profession, even one person. They take the time to know their subjects thoroughly before picking up their cameras. For them, documentary photography is a hybrid of all it has been — the family album, the factual record, the social message and the celebration of man.

John Thomson: Guide to Far-off Places

In the mid-19th Century, England enjoyed a heady new craze—travel and exploration. The Orient and Africa were opened at last to the Western world, and the public devoured the descriptions each traveler felt compelled to write. The flood of books could not satisfy the general curiosity. It took photographs to make the unbelievable real.

Among the first of the photographer-explorers was a practical Scotsman, John Thomson. In 1862 he took his cameras to the Far East, and there for about 10 years, five of them in China, snapped cities and landscapes. Thomson's purpose was clearly documentary; the photograph, he wrote in his introduction to *Illustrations of China and Its People,* "affords the nearest approach that can be made toward placing the reader actually before the scene which is represented."

The book, published in four volumes between 1873 and 1874, was illustrated with 200 of his photographs. In them the enthusiastic public now saw just what Thomson saw: every building stone, every human posture, every detail of clothing. They were so brimming with information that the viewer felt transported to China. Thomson made the photograph serve as the viewer's vicarious experience.

Didactic Victorians took these photographs very seriously—and no one thought of them as "art," least of all Thomson himself. His purpose was simply to instruct. But in documenting the previously undocumented, Thomson did produce a body of work with, to quote Beaumont Newhall, "that sense of the immediacy and authenticity of documentation, which a photograph can impart so forcibly."

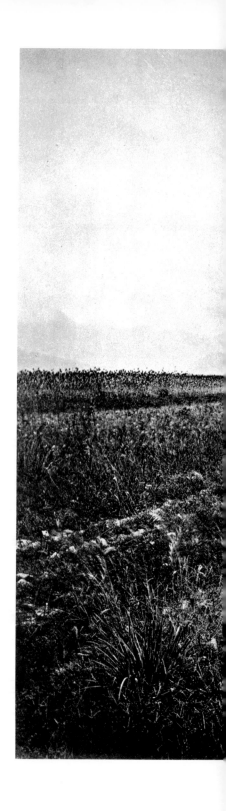

Camels sculptured from white limestone flank the Way of the Spirit leading to the tombs of the Ming Dynasty emperors 30 miles north of Peking. Two elephants can be seen in the distance. The greater-than-life-sized statues, thought to be guarantors of good fortune, date from the 15th Century. The receding statuary emphasizes the vastness of the sacred valley, and the standing man, dwarfed by the statue, seems no more alive than the animals in this forbidding necropolis.

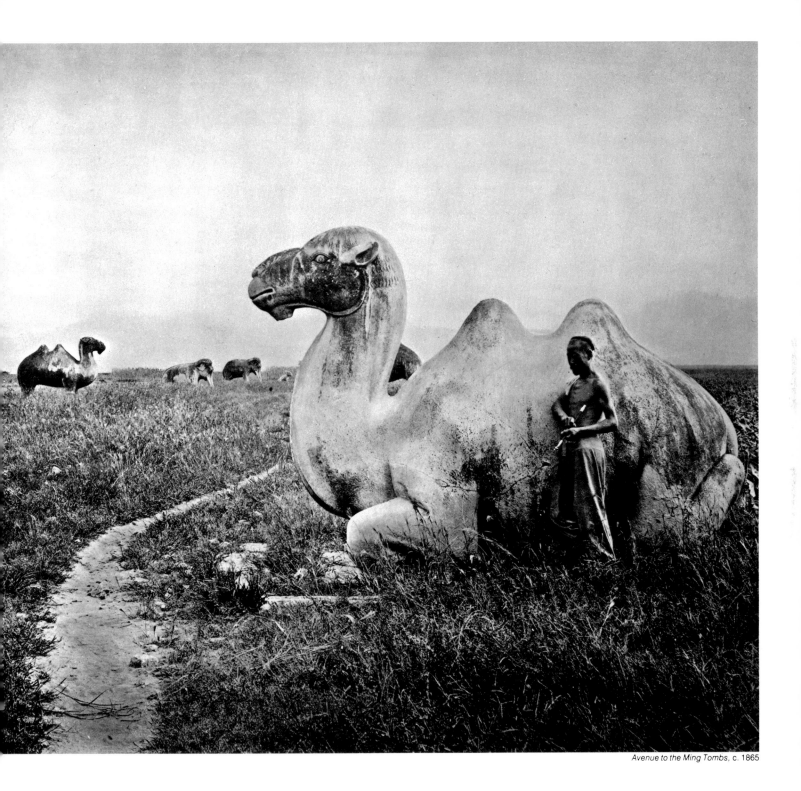

Avenue to the Ming Tombs, c. 1865

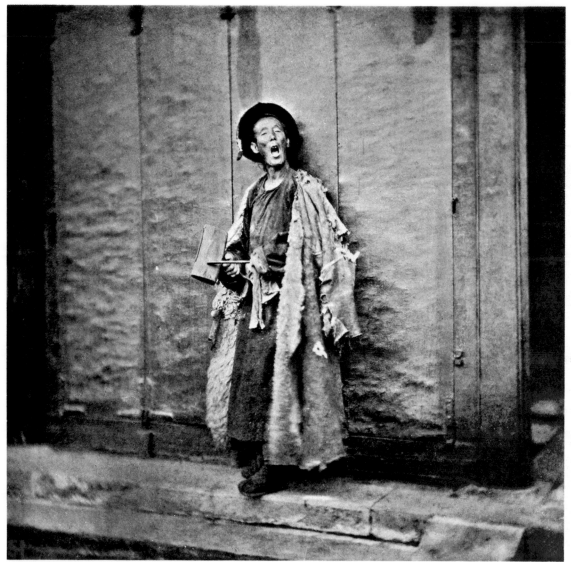

Night Watchman, Peking, c. 1865

Old Wang, a Manchu fire guard, beats his wooden
clapper to warn of the dangers of fire. The
government allotted him the sheepskin coat for
protection on winter nights. Ragged and hollow-
cheeked, this functionary provided a shocking
glimpse of a China long hidden from Western eyes.

Thomson climbed to the top of the city wall for
this panorama of the central roadway of old
Peking. His picture is so clear, and so crammed
with information, that the eye can travel endlessly
through this strange and wonderful toy town, and
at every viewing discover a new detail. In the right
rear, beyond the wide, low bridge, tiny makeshift
shops cluster beneath the giant memorial arch; in the
foreground, a laborer with buckets suspended
from a yoke joins a crew repairing the cobbled road;
and far off on the horizon the three rising tiers of
the Temple of Heaven are just barely visible.

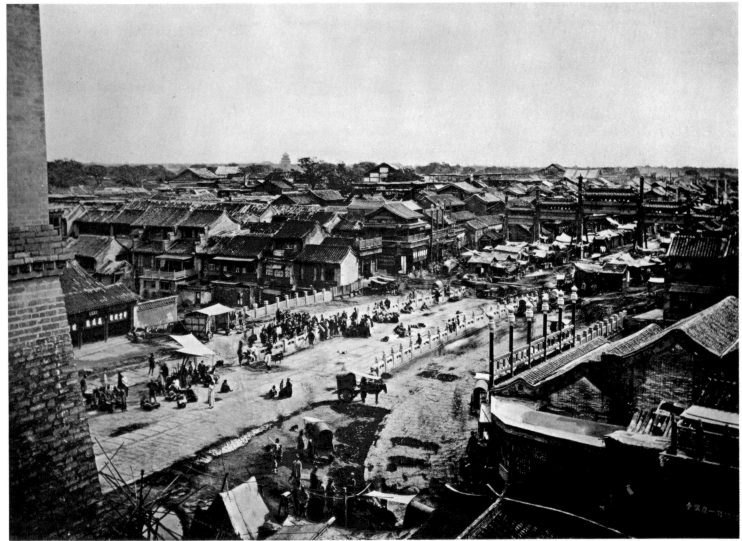

View of the Central Street, Chinese Quarter, c. 1865

Benjamin Stone: Chronicler of a Fading Era

Sir Benjamin Stone's passion for the photographic record was at least equal to that of his fellows, but he found the close-at-hand world of Victorian and Edwardian England more intriguing than the faraway places that fascinated such predecessors as John Thomson.

Stone was greatly interested in the survival into his day of ancient customs and ceremonies, and he began taking pictures simply because he could not buy the sort he wanted.

"Photographs are the most reliable, the most correct recording means, and therefore they become the most important aid in educating and obtaining instruction," he wrote. And for some 40 years, applying the enormous single-mindedness and the energy that were so eminently Victorian, he catalogued British life, as a contemporary wrote, "to portray for the benefit of future generations the manners and customs, the festivals and pageants, the historic buildings and places of our time."

His dedication to this goal was astonishing. How many photographs he took no one now knows, but more than 25,000 prints survive, all in near-perfect condition. This great body of work was produced in his spare time—Sir Benjamin was also a successful glass manufacturer, a tireless civic leader and a Member of Parliament. Happily, he was wealthy; the £30,000 he spent on photography would be equivalent today to about $1,270,000.

Famous as a photographer in his own day, Stone has been almost forgotten in ours. Nevertheless the intense honesty of his work, as well as its immense value as the chronicle of an age, earns him an important niche in the history of documentary photography.

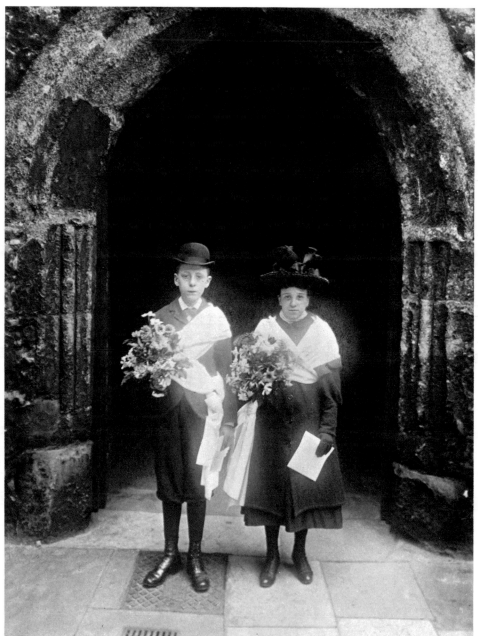

Maundy Thursday Ceremony, 1898

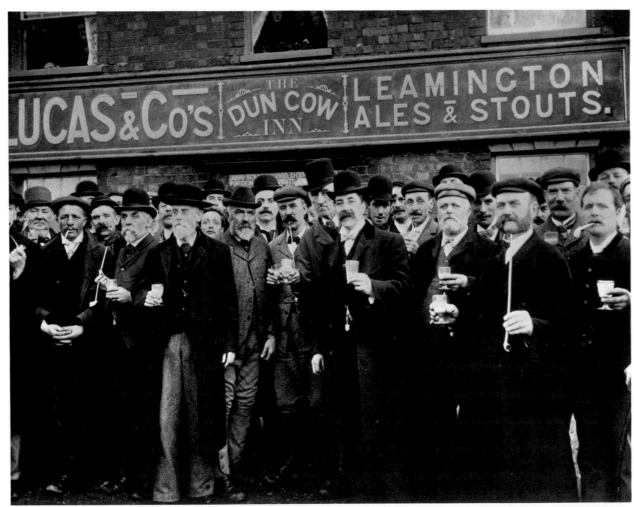

To the Duke's Health, 1899

◄ *Two solemn young people stand framed by a portal of Westminster Abbey after taking part in the Holy Thursday ceremony at which alms are given to the poor. The observance commemorates the day when Christ washed the feet of His disciples; the white scarves represent the towel He used to dry them. The glow radiating from the scarves may have resulted from halation, the reflection and scattering of light from the back of the glass plate; but the photographer clearly valued its air of supernatural significance.*

Dressed in their Sunday best, neighbors of the Duke of Buccleuch drink his health in rum and milk. By centuries-old custom they paid him a small annual road toll called Wroth Silver, and he provided them a lavish breakfast at the Dun Cow. The arrangement was agreeable to everybody.

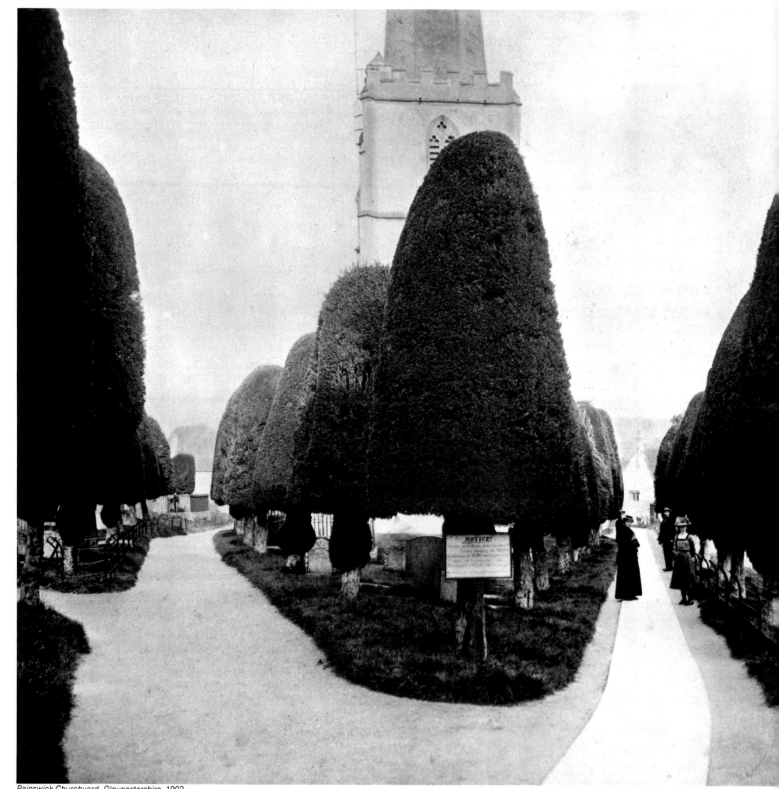

Painswick Churchyard, Gloucestershire, 1902

22

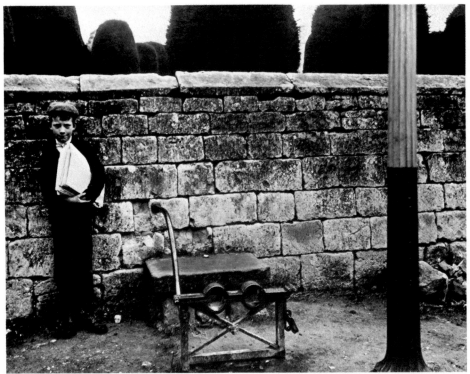

Stocks at Painswick, 1902

◄ Painswick churchyard is a burial ground, yet in this picture it looks anything but morbid. In the rows of plump, meticulously clipped yew trees —symbols of immortality—and in the tidy pathways, so obviously meant for casual strolling, the photographer found an orderly scene to document, yet one full of airiness and grace.

Outside the same churchyard a young news vendor stands warily beside a set of leg stocks. Confinement to the stocks, once a common form of humiliating punishment for minor offenses, was not imposed after the 1860s, but this set remained as a local relic—perhaps as a warning to the overly high-spirited. And the cautionary effect is heightened by the composition of the picture, its severe horizontal and vertical lines softened only by the billowing tops of the yews.

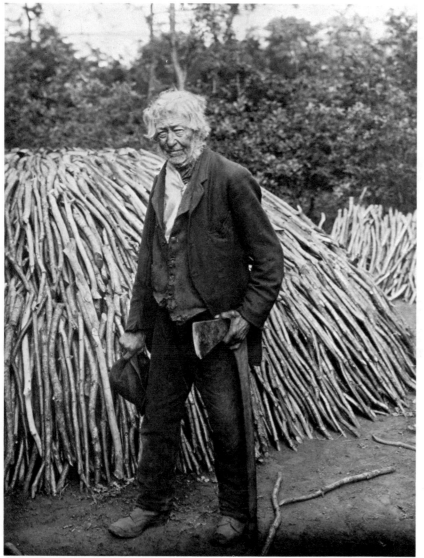

Charcoal Burner of Worcestershire, 1896

Self-conscious, and perhaps a bit suspicious of Sir Benjamin's motive in photographing a humble workman, a charcoal burner poses with his ax and hand-hewn pyre. To proper Victorians, though, the hearty old man might have illustrated the maxim, "the laborer is worthy of his hire."

One moment of an outing down a Cornish lane ▶ will exist as long as this photograph survives. The enormous amount of information in the picture —from the carriage and its occupants, dwarfed by the trees, to the wealth of detail in the branches and leaves —adds up to a re-creation of reality.

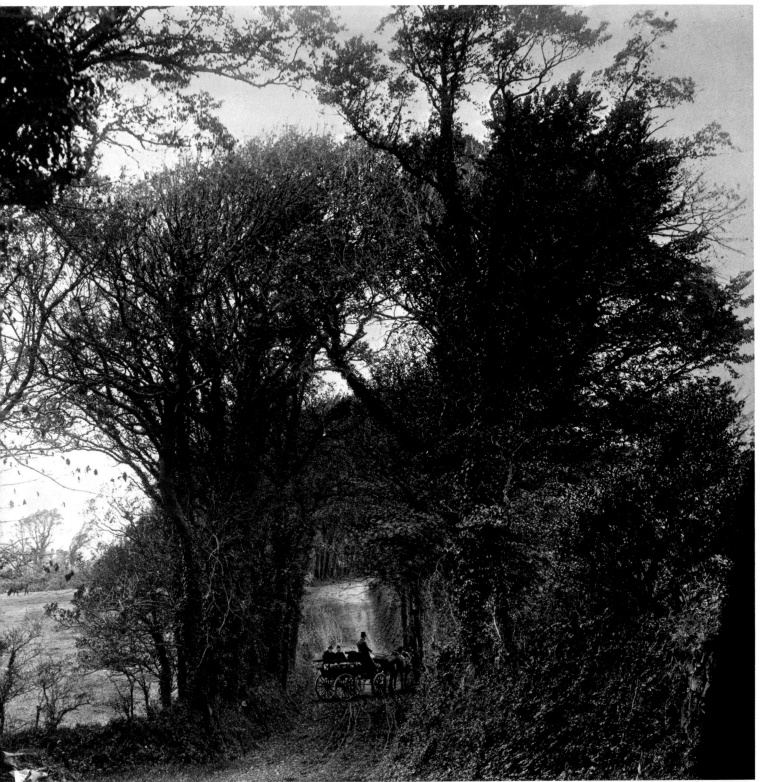

Lane near Penzance, Cornwall, 1893

25

Jacques-Henri Lartigue: One Boy's Family

By the beginning of the 20th Century, photography had become everyman's toy. The rich and the poor, the esthetically gifted and the insensitive duffers, all used the camera to create visual records of their family histories. But it remained for a seven-year-old boy in France, Jacques-Henri Lartigue, to make the family photo album a work of documentary art.

"My motivation regarding photography is still today, seventy years later, the same: a deep love for a certain period of my life and a desire to freeze its beautiful moments," Lartigue declared when he was nearly 80. "Photography to me is catching a moment which is passing, and which is true."

Before the young photographer ever owned a camera, he had tried to "be" one himself: By blinking rapidly three times he thought he could fix a scene firmly in his mind. When he found that the pictures were never there when he wanted them, the little boy became so depressed that his parents had to call a doctor. No remedy was found. Then Papa Lartigue, by a stroke of brilliant intuition, bought the boy a camera. A rapid cure was followed by fierce photographic mania.

That Lartigue's life thereafter, as a child and young man, was a turn-of-the-century idyll, untroubled either emotionally or economically, is our luck as well as his. For his pictures of his family and the greater world around him have such spontaneity, such humorous unposed freshness, such generosity of spirit, that we enjoy sharing his private moments. It is his genius that the record of the zany, sports-crazed Lartigue family becomes the family album everyone might long for.

A sumptuously befurred promeneuse, preceded by her brace of fox terriers, sharply eyes the young photographer snapping her from a park bench. Although he clearly admires the elegant lady, his mischievous boy's vision captures something about her that is —just faintly—comic.

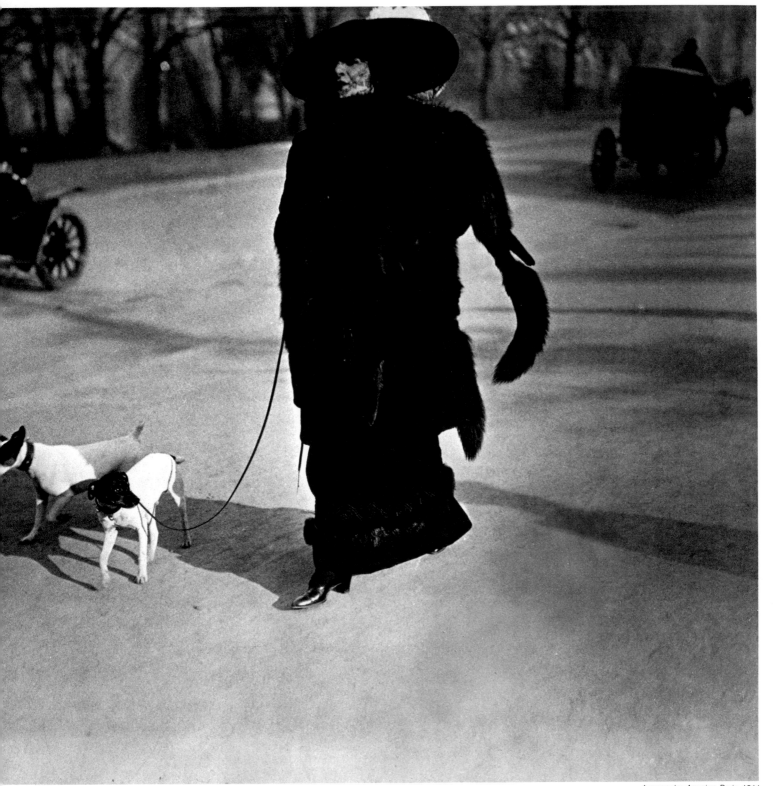

Avenue des Acacias, Paris, 1911

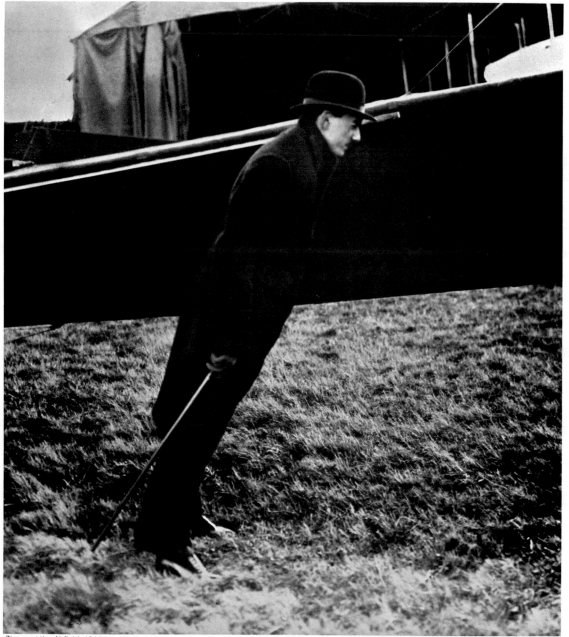

Zissou at the Airfield, 1911

Older brother Maurice, known as Zissou, seems to defy gravity; actually, he is leaning into the wash of air created by a whirling propeller at Buc airfield. "In order to resist the wind of the propeller he had to bend forward," says Lartigue. Zissou's stolid look, dandified outfit and cane accentuate the picture's Chaplinesque air.

Seventeen-year-old cousin Simone, abandoning dignity, rehearses in the park at St.-Cloud for a starring role as acrobat in a circus movie. The film was never made, but the still indicates it would have been lively. Simone was a close friend of Jacques's from childhood and, like all his madcap family, thoroughly used to his camera.

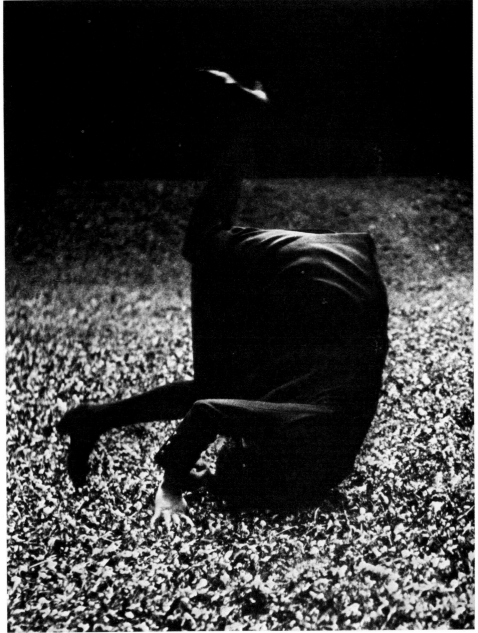

Simone in the Park, 1913

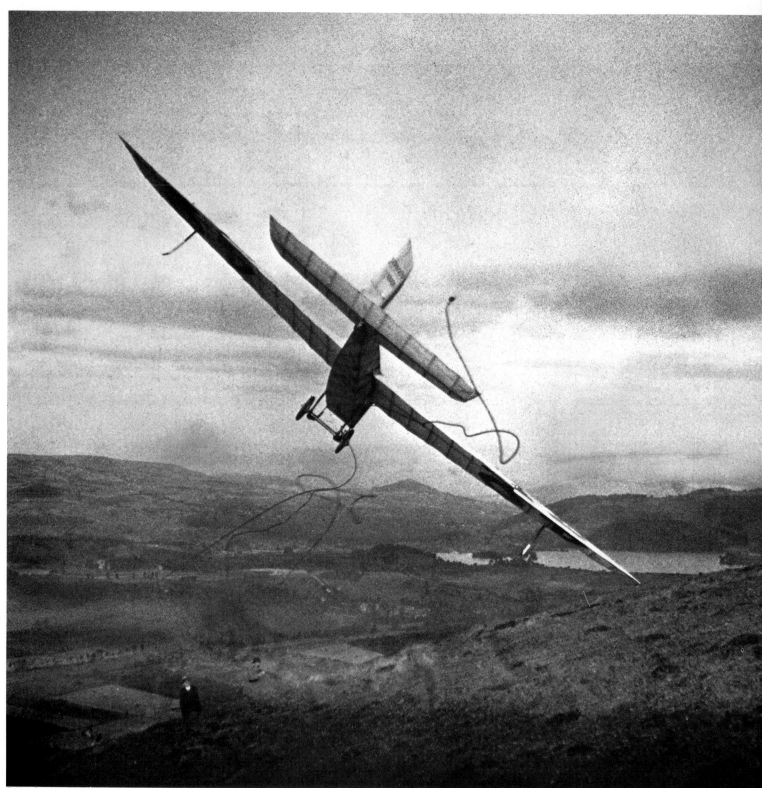

Falling Glider at Combegrasse, Auvergne, 1922

Lartigue and his brother Zissou were passionate about airplanes; from early boyhood they cut classes to hang around airfields and they experimented with homemade gliders themselves. In 1922 they journeyed to Auvergne to see the tests of a new glider. Alas, the craft failed to gain altitude and fell almost at once, its launching cables still flapping. Lartigue snapped just as the wing dipped; failure was so rapid the onlookers are just beginning to react to the accident.

The Kahn Collection: A World Record in Color

About the time Lartigue started chronicling his own happy family, French banker Albert Kahn decided to commission a kind of family album for all of humanity. Kahn was not a photographer, but he was rich—and troubled by the pace at which the world was changing. So, in 1910, he began to send photographers around the globe to record those "modes of human activity whose disappearance is now merely a question of time."

Kahn's photographers recorded their premodern subjects by a then very modern means: color-producing plates called autochromes, which had now made color photography as portable as black-and-white. The exposed plates were grainy; but their color—derived from dyed bits of potato starch—was natural and soft, enhancing the beauty, the vividness and thus the authenticity of the images.

Kahn eventually commissioned expeditions to 38 countries, including Morocco, Outer Mongolia, Serbia and Canada. His documentarians shot their subjects as they found them, whether an itinerant tinker in Paris or a female opium smoker in Hanoi. "Life, life," Kahn told them repeatedly. "That's all that counts."

By 1930, when the project ended, they had filled Kahn's "Archives of the Planet" in suburban Paris with some 72,000 autochromes and 500,000 feet of documentary film. About a third of the plates were never developed: Kahn was so anxious to capture the world that he often left no time for such work between expeditions.

The reclusive Kahn never traveled with his photographers, and he allowed himself to be photographed just once—for his passport. But the project he conceived and funded left a priceless record of how the world once looked, and the lives its inhabitants once lived.

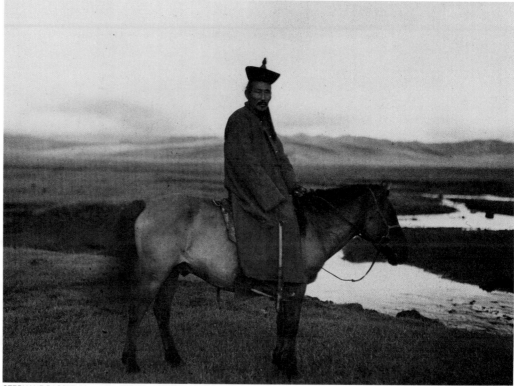

STEPHANE PASSET: *Mongolian Official on the Road to Urga,* Mongolia, 1913

On the high plains of Outer Mongolia, a government official breaks his journey toward Urga, the capital city now called Ulan Bator, to pose for one of Albert Kahn's itinerant photographers. A riding crop hangs from his seemingly handless sleeve. The official was evidently a good horseman: Only the horse's blurred tail hints at the long exposure required by the autochrome process.

One arm up, the other down, a Roman Catholic from the city of Sarajevo in present-day Yugoslavia displays her traditional blue tattoos. Less than two years after this picture was taken in 1912, Serbian nationalists in Sarajevo assassinated the Austrian Archduke Ferdinand, precipitating World War I.

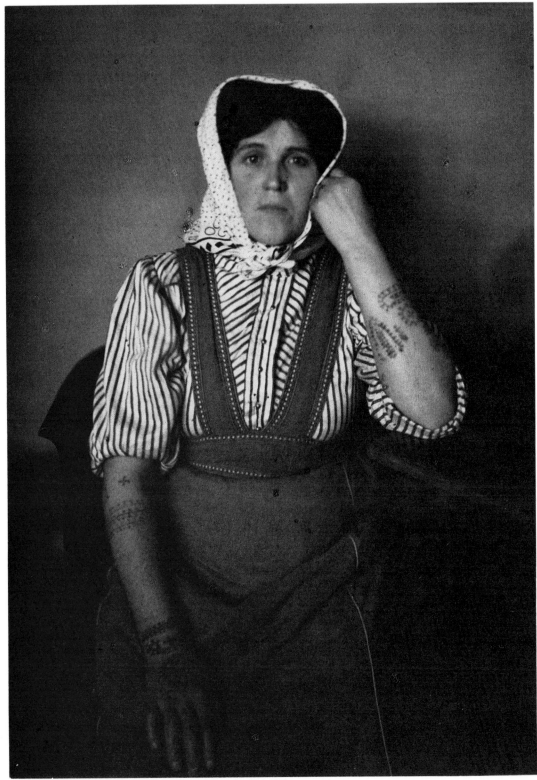

AUGUSTE LEON: A Catholic Woman with Traditional Tattoos, Sarajevo, 1912

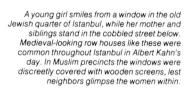

A young girl smiles from a window in the old Jewish quarter of Istanbul, while her mother and siblings stand in the cobbled street below. Medieval-looking row houses like these were common throughout Istanbul in Albert Kahn's day. In Muslim precincts the windows were discreetly covered with wooden screens, lest neighbors glimpse the women within.

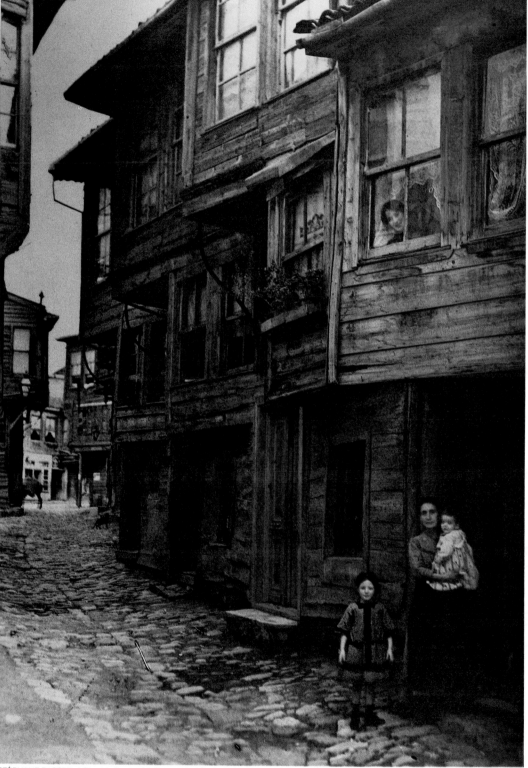

STÉPHANE PASSET: *A Street in the Jewish Quarter*, Istanbul, 1912

Garbed in the robes and scarf of a Buddhist novice, an Indo-Chinese girl pores over a sutra, or religious text, in the courtyard of the Pagoda of the Two Sisters in Hanoi. Though young, the novice could have been at her studies for years, since Buddhists entered nunneries at ages as tender as six.

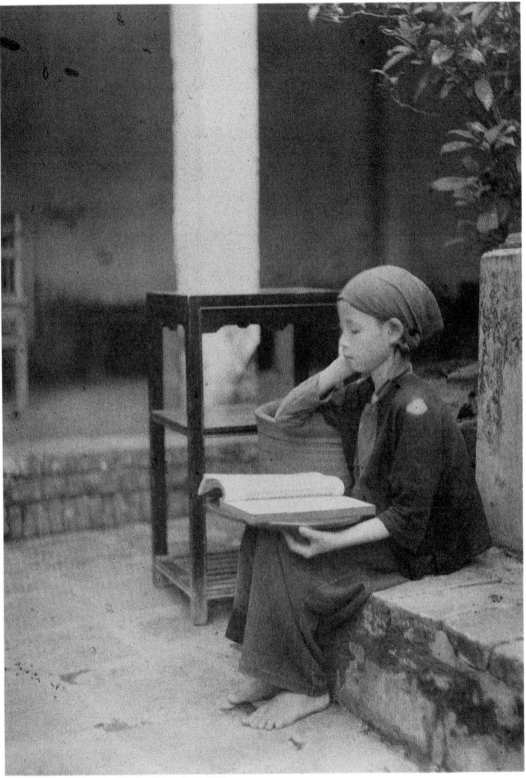

BUSY: *Novice of the Pagoda of the Two Sisters, Hanoi, 1916*

Eugène Atget: A Romance with Paris

While Kahn's photographers tramped the earth, fixing the world on glass plates, Eugène Atget quietly garnered a treasure in the city he and Kahn shared. His aim, a friend later explained, was "to create a collection of all that which both in Paris and its surroundings was artistic and picturesque." He began the task in 1898 and kept at it the rest of his life, for 29 years lugging his old-fashioned, heavy view camera all over the city. He documented historic buildings, all-but-hidden architectural details, glimpses of side alleys and ordinary street life—bits and fragments that would fit into the great mosaic he planned as a monumental record of the Paris he knew and loved.

A former sailor and small-time actor, Atget was 41 when he began his new career. His pictures won him no fame in his own lonely lifetime. But his photographs of the lovely parks that surround and embellish Paris are a special part of the work that has become famous since he died. Almost all of them were taken by dawn's early light, when no one else was around. They are documents, clear and uncontrived, of the city's quiet side. That they are also works of art is a tribute to a photographic vision that transcended strict record making, to preserve forever the spirit of a city as well as its appearance.

Like a giant bishop's crook, a lampless light standard rises gracefully from an ironwork gate, one of many such dividers, beautiful as well as utilitarian, that demonstrate the concern for the esthetic that endeared Paris to Atget.

Iron Gate and Lamppost at St.-Cloud, date unknown

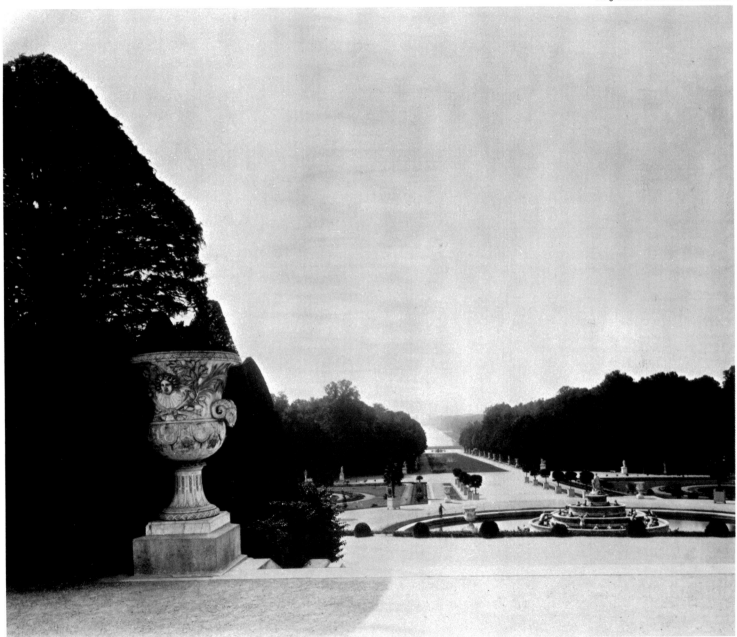

Tapis Vert from the Parterre d'Eau at Versailles, 1901

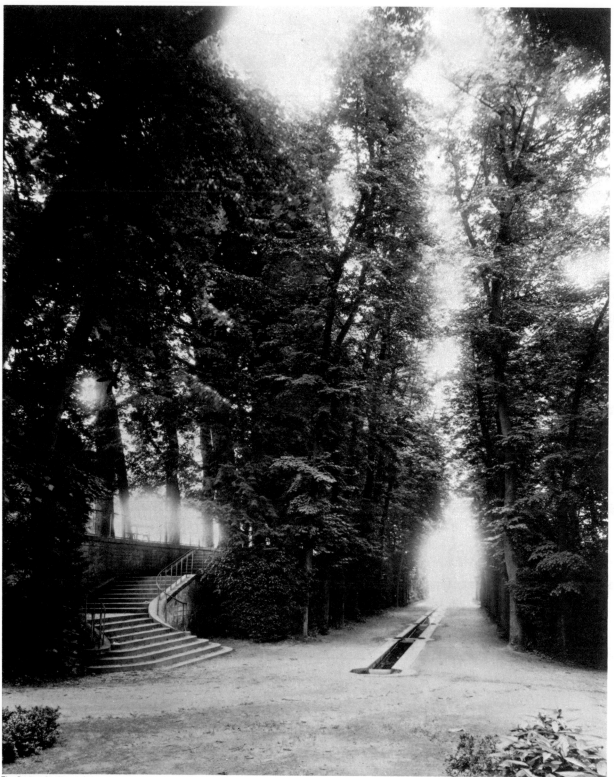

The Park at St.-Cloud, date unknown

The Park at Sceaux, c. 1900

◀ Just across the Seine from Paris' busiest gate lies the 970-acre park of St.-Cloud (left). Its manicured trees and precisely laid-out walks and fountains, contrasting with the rambling vegetation of Sceaux (above), were more typical of a city where human artistry could be seen on every hand.

The carefully cared-for estate of Sceaux, confiscated from the Duke of Penthièvre during the French Revolution, had reverted almost to woodland at the time Atget photographed it. The place was soon to be restored as a public garden, and before it disappeared forever, the photographer captured a small bit of the wilderness that lent a piquant touch to the sophisticated Paris he loved.

The Hundred Steps at Versailles, date unknown

40

The Hundred Steps at Versailles rise to a walk offering a vista of the palace gardens. They became a setting for the enjoyment of Louis XIV and his court; the picture shows the scene from the vantage point of a dwarfed and dazzled subject.

Ornamental Urn at Versailles, date unknown

Curving lilies and a leaf emerge from a stone urn on one Versailles path in this record of the masterly design and craftsmanship of the Sun King's palace. And the picture, by focusing so sharply on a detail, provides one small clue to why Paris became the center of the elegant world.

Soft morning light bathes a corner of the coin du parc, where marble statues stand like silent sentinels before receding columns of plane trees. The angle of view on the trees—which were planted at regular intervals in a gentle arc—shows how at Versailles even nature was made to serve the kingly design.

Coin du parc at Versailles, date unknown

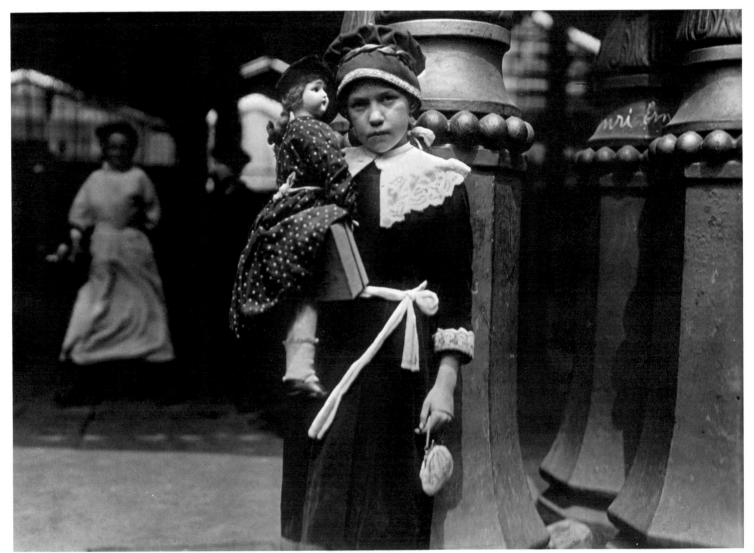

LEWIS HINE: *Child with Doll*, Paris, 1918

Rallying the Conscience of Society

Once the camera had proved itself a device for showing things as they were, it was inevitably thought of as a tool for changing things to the way they ought to be. Among the first to sense the persuasive power of photography was John Thomson, who turned his camera from exotic China *(pages 16-19)* to the equally exotic — at least to his genteel readers — slums of London *(right)*. Thomson's photographs of lower-class life were sympathetic but, like his Chinese pictures, mainly educational in purpose; they acquainted the public with evils of the slums without urging specific remedial action. It remained for an American to show how the documentary photograph could become an effective weapon in a campaign for reform. He was Jacob Riis, a young Danish-born reporter for the New York *Tribune* and later for the *Evening Sun.* And the target, again, was city slums.

In the late 1880s, New York's immigrant-jammed slums, which were Riis's beat, included the most densely crowded urban areas in the world. More than a million people lived in their tenements, and one ward on the Lower East Side had a population density of 334,000 persons per square mile. The death rate was high: Nearly 25,000 tenement dwellers died in a single year, and 80,000 were said to be sick at any given moment. The crime rate was equally shocking: In one tenement 102 of the 478 tenants were arrested in a single four-year period.

As a crusading reporter Riis wrote exposé articles in his paper and complained personally to city health officials — with scant results. But he was as resourceful as he was committed, and he no sooner learned that newly invented flashlight powder permitted photographs indoors than he took a camera inside overcrowded flats and filthy cafés.

The pictures that Riis made *(pages 49-55)* resulted in an article in *Scribner's Magazine* and a year later (1890) in a historic book, *How the Other Half Lives.* They had a shocking effect that is hard to imagine today, when pictures are all around; at that time photographs in print were new. Theodore Roosevelt, then a rising young politician, promptly called on Riis and left him a note saying, "I have read your book and I have come to help." When Roosevelt became New York Police Commissioner he did, cracking down on some of the worst abuses. Others joined in an effective reform movement that changed the face of a part of New York and cleaned up many slums. But the indirect results were equally important, for Riis had proved what crusading documentary photography could do.

Two decades later another cause gripped Americans, this time the issue of child labor. Almost two million youngsters between the ages of 10 and 15 were working for a living, and a reform-minded organization called the National Child Labor Committee engaged Lewis Hine, a photographer who had already made a name for himself with poignant photographs of immigrants

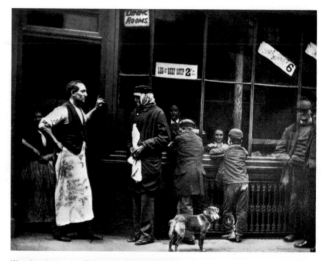

Wearing the apron of his trade, the keeper of a London hostel in Drury Lane, where ex-convicts just released from prison could get lodgings or a ha'penny pudding on credit, talks to a customer. The photograph, taken by John Thomson about 1877, appeared in the book titled Street Life in London, a landmark in pictorial persuasion.

arriving at Ellis Island, to do for child labor what Riis had done for the slums. Hine did: By World War I, when he enlisted his camera in the aid of war relief, the tide running against child labor was irreversible.

But it was not until the '30s that the camera became so deeply involved in reform that any documentary photograph was likely to be a picture with a social purpose. Photography's commitment to reform was a product of the times. And hard times they were in the United States, with as many as 15 million unemployed, numbers of them homeless and hungry. For the first time a national administration took on broad-scale responsibility for Americans' food and shelter — a step that was unpopular with many citizens, who held to traditional ideas of private incentive and, where necessary, local help for the needy. To win support for the unprecedented federal relief programs, the documentary camera went to Washington.

The United States employed photography in a number of federal agencies, but the one that outperformed them all was a small bureau of a section of the Department of Agriculture charged with dealing with the plight of the farmers, the Farm Security Administration *(pages 66-80)*. Throughout its existence the FSA had hardly more than a dozen photographers all told, and never more than six at a time; yet that small band left a monumental collection of 270,000 photographs documenting the state of the nation at a crucial moment in its history.

The collection stands today in the Library of Congress as one of the finest pictorial records of American life extant, for the photographic bureau of the FSA went far beyond the objective for which it was conceived. The eloquent photographs did a far-reaching job of persuasion in their time; they hung on the walls of galleries, where they revealed to city people the problems their rural countrymen faced, and at county fairs, where they informed farmers about existing federal programs and showed how to qualify for aid. They illustrated dozens of books — including publications of a new kind in which text was incidental and the photographs stood on their own, aided only by slender captions. And in one two-year period pictures distributed on behalf of the FSA appeared in an estimated 175 magazines and newspapers having a total readership of many millions.

So commonplace had the documentary photograph become by then that it was a part of the public's everyday reading matter. The innovation that Riis had introduced was now established tradition, and in the years that followed, the photograph became an instrument of persuasion for every purpose — from winning presidential elections to fighting air pollution, from promoting integration to ending wars. Today such photographs are so familiar their special character may escape notice, yet they never lose their power to convince or to stimulate action.

Jacob Riis: Fighting the Slums

On Lincoln's Birthday in 1888, the New York *Sun* carried a chatty item that portended some serious news. "With their way illuminated by spasmodic flashes," the paper reported, "a mysterious party has been startling the town o'nights." The mysterious party consisted of Jacob Riis, two photographers and a health board official. The flashes came from ignited magnesium powder, which had just been found to give off sufficient light for taking photographs in dark places. And the dark places into which this was leading the little group were the slums of New York City.

New York's slums were among the worst in the world. Three quarters of the city's population lived in tenements: those in the Lower East Side's infamous 10th Ward—many of them recent immigrants—were packed together, 522 to the acre. The health board called it the typhus ward; the bureau of vital statistics called it the suicide ward. While the city had not actually given up on it, Riis felt the officials were doing little about it. He believed that the filth and overcrowding of the slums were the causes of their crime and disease, and that the afflictions could be cured only by eliminating the causes.

"The wish kept cropping up in me that there were some way of putting before the people what I saw there," he said. "I wrote, but it seemed to make no impression." He greeted the news of photography by flashpowder "with an outcry that startled my wife, sitting opposite. There it was, the thing I had been looking for all these years."

He lost no time in hiring photographers to assist him. But the late hours soon palled on the first two aides, and a third photographer proved unreliable. "There was at last but one way out of it, namely, for me to get a camera myself," Riis concluded. "So I became a photographer, after a fashion."

Photography was neither a pastime nor an art with Riis: "I had a use for it," he said, "and beyond that I never went." That was far enough. His writing, backed up with photographs, exerted an influence on the nation that is still being felt. New York's dreadful police lodging houses—where a "spot" could be had free, but whose filth and overcrowding were as awful as in the five-cent commercial flophouses *(right)* —were abolished. Lights were installed in hallways of tenements. One block, known as The Bend, was torn down and turned into a public park. Playgrounds were built for the schools, classrooms were opened after hours for children's club meetings, and clean water was supplied to the city. Riis helped accomplish all this by means of seven books, plus newspaper stories, magazine articles and lectures. In time he was called Emancipator of the Slums. But photographers remember him as the man who demonstrated the camera's power as a weapon for social reform and gave documentary photography a theme that has preoccupied it to this day.

KENYON COX: *Drawing after "Five Cents a Spot." 1889*

When Jacob Riis shot the flophouse at right, the reproduction of photographs by photoengraving was in its infancy. To illustrate his article How the Other Half Lives, Scribner's Magazine, *in 1889, had Riis's photographs transcribed into drawings that could be reproduced from wood blocks (above). But some of the reality of the squalor was lost. When Riis submitted his account of slum overcrowding to the city health board, he found that his arguments "did not make much of an impression"—until "my negatives, still dripping from the darkroom came to reenforce them. From them there was no appeal." Thanks to his photographic persuasion, a park replaced the block on which this flophouse stood.*

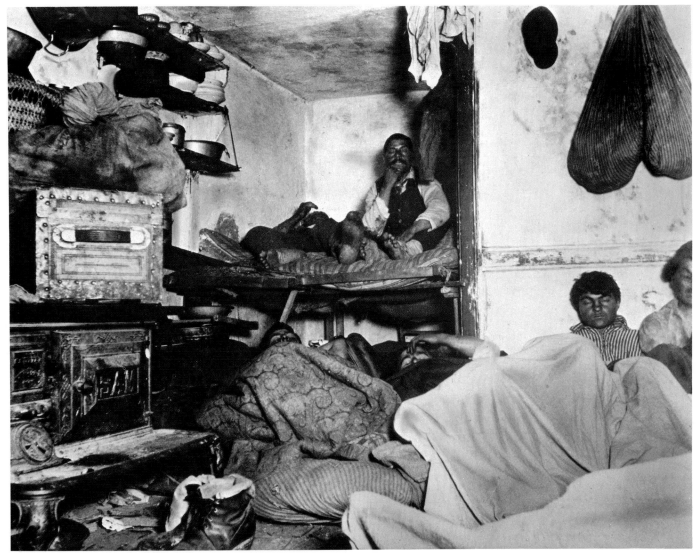

JACOB RIIS: *Five Cents a Spot*. New York. c. 1889

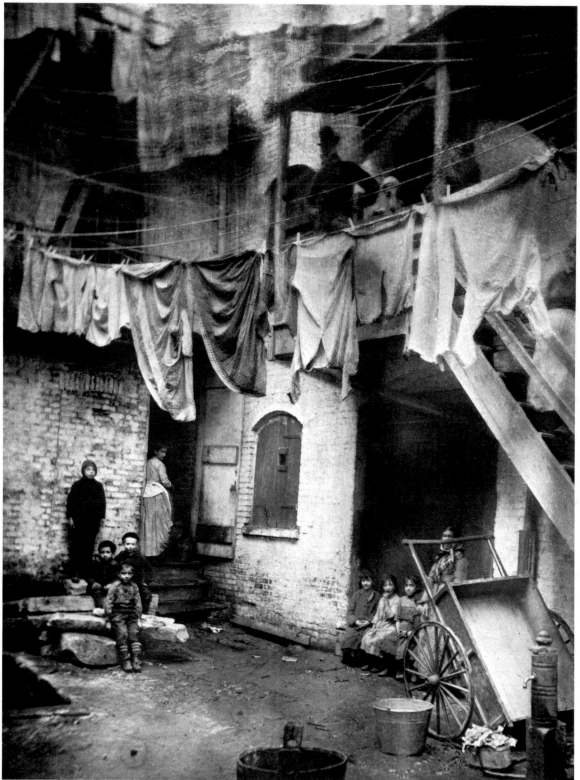

Baxter Street Court, New York, 1888

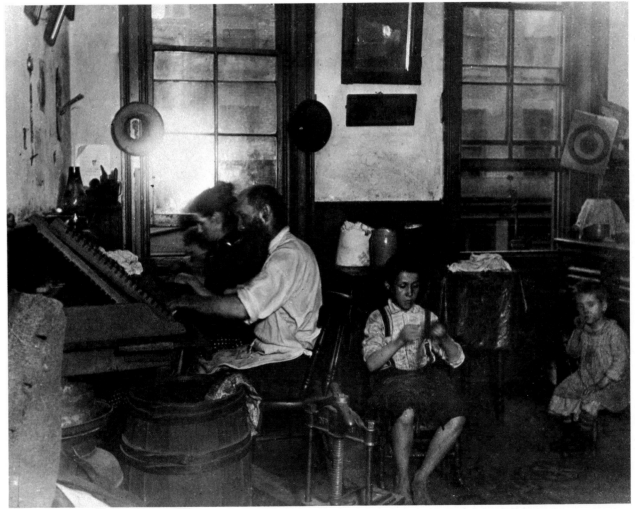

Bohemian Cigarmakers Working at Home, c. 1890

◄ *Photographs such as the one at left, showing children loitering in a slum courtyard that is littered with trash, helped to bring about truancy laws to keep the young in school, and to provide playgrounds for them to use when school was not in session. "Honest play is interdicted in the streets," Riis wrote. "The policeman arrests the ball-tossers, and there is no room in the backyard."*

A great deal of manufacturing — including the family cigarmaking shown above — was carried on at home in the 1890s, enabling employers to evade laws regulating labor conditions. Only when photographs like this were widely published did Americans realize the extent of home labor, and the degree to which it kept youngsters from studying and mothers from caring for children.

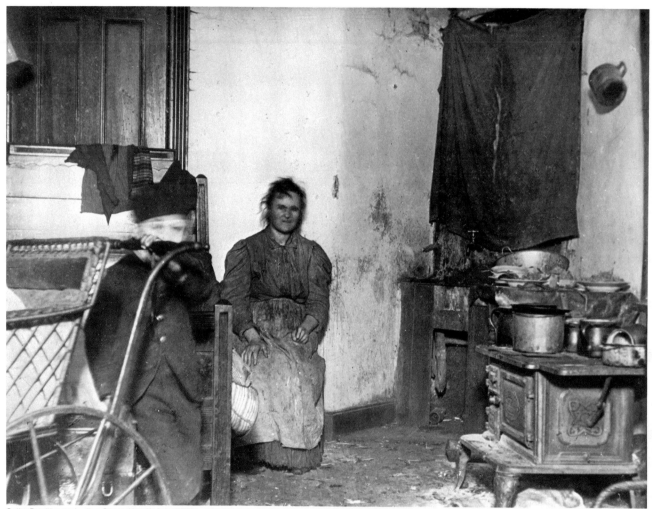

Cellar Dwelling on Ludlow Street, New York, c. 1890

Indoors the reeking tenements had peeling walls, canted floors and little ventilation. The woman living in the cramped cellar dwelling shown above has at last surrendered to the pervasive filth: Her dishes, her floor, even her clothes have clearly gone long unwashed. "From these tenements," the outraged photographer wrote, comes "the vexed question 'Is life worth living?'"

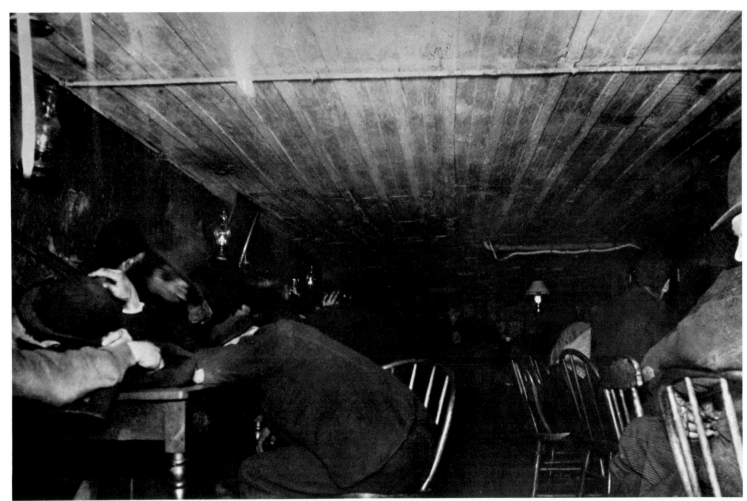

Stale Beer Dive on Mulberry Bend, New York, c. 1890

The infamous Bend—which Riis located "where
Mulberry Street crooks like an elbow"—had a
shockingly high crime rate, some of it emanating
from all-night restaurants like this one, where the
homeless could nap over stale beer, and where
the owner was usually beholden to a political
boss. Of all the changes his pictures effected, Riis
was perhaps proudest of reforming the Bend.

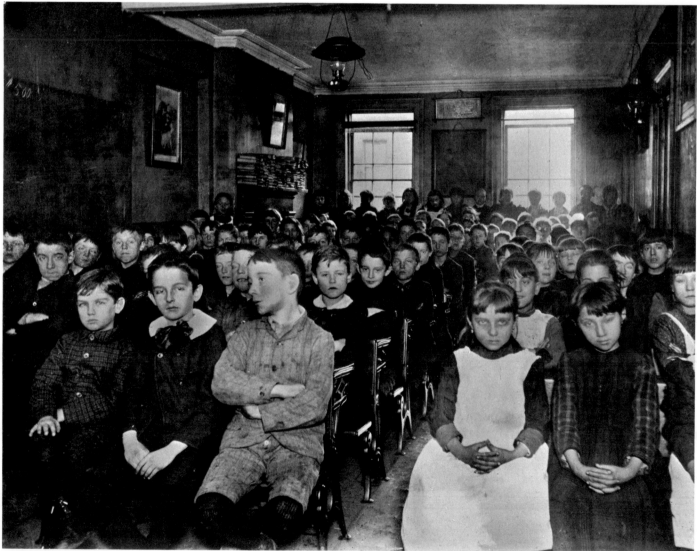

Vocational School on West 52nd Street, New York, c. 1894

*A simple photograph of children jammed in a
classroom obviously meant for half their number
becomes a plea for better schools. Then as now, a
chance for a decent education, even a measure
of vocational training, seemed the best hope for
the younger generation to escape the slums.*

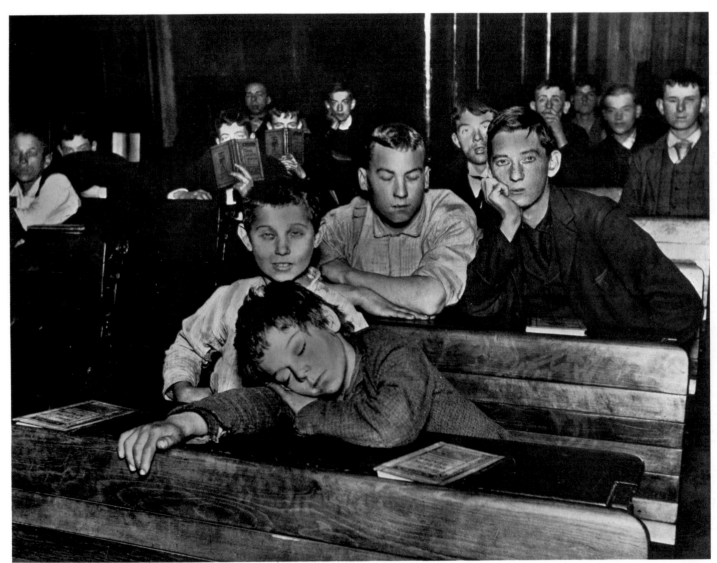

Night School in Seventh Avenue Lodging House, date unknown

Night-school students, at a class after working
all day, often found it difficult to pay attention.
Though such situations were hardly ideal,
the reformer-photographer agreed that night
schools, such as those provided by the Children's
Aid Society, were better than no schooling at all.

Lewis Hine: Abolishing Child Labor

With Lewis Hine, documentary photography moved out of the slums of New York and across the country—wherever contemporary reform movements led the way. One of Hine's major preoccupations was the abuses of child labor, and he documented this widespread evil to provide photographic evidence for the reformers to circulate and to take into the lobbies of state legislatures. To do so he left a position as a science teacher in a New York private school. He still regarded himself as a teacher—and thought of the magazine-reading public as his class.

Unlike Jacob Riis, who considered himself primarily a reporter and who used his pictures solely to supplement his written reportage, Hine relied chiefly on the camera to communicate his message and wrote very little once he had left the classroom. "If I could tell the story in words," he said, "I wouldn't have to lug a camera."

When the National Child Labor Committee enlisted Hine in its crusade in 1908, there was some legislation to protect children from exploitation, but the laws were few, weak and not vigorously enforced. Children worked in coal mines *(opposite);* in West Virginia, for example, they toiled from 7 a.m. to 5:30 p.m., breathing noxious coal gas and in constant danger from rolling rail cars. In the Southern cotton mills they worked even longer, from 6 a.m. until 6 p.m., and were sometimes mutilated by dangerous machinery (whose placards of safety cautions they usually could not read). It was not that all child labor

resulted from insufficient legislation or lack of law enforcement. Sometimes a foreman was inclined to wink at the law because the child's parents—often impoverished immigrants—could not survive unless every member of the family was at work earning at least a few pennies a day.

The job Hine assigned himself was formidable. He often had to overcome the hostility of owners, foremen and guards in factories. Sometimes he got by the gates only by posing as an insurance salesman or a fire inspector. Once inside, he had to make friends with the children to get them to talk while he surreptitiously took notes (he used the buttons on his vest to estimate the child's height). One of his biggest problems was to keep the children at ease even when startled by a burst of magnesium flashlight powder. Somehow, between 1908 and 1921, Hine made 5,000 pictures for the National Child Labor Committee; and the pathetic little drudges he portrayed in factories and mines, mills and tenements, bowling alleys and city streets, persuaded the voting public and legislators of the urgent need for reform.

Not all of Hine's purpose was exposé. During World War I the Red Cross hired him to document its efforts to help war victims—and hence persuade the public of the need for support. The Red Cross later gave him a similar assignment at home. In the performance of that task *(pages 62-63)* Hine turned documentary photography from muckraking to a new and positive role.

Breaker boys—who separated by hand the useless slate from a mine's yield of coal—gather for Hine's camera before the entrance to a Pennsylvania coal shaft. By the time this picture was taken, many states had laws prohibiting mine operators from hiring boys under 14, but some foremen took them as young as six. At whatever age, the children worked adult hours. Pictures such as this helped point to the evils of child labor, prompting enforcement of laws already on the books and enactment of better ones.

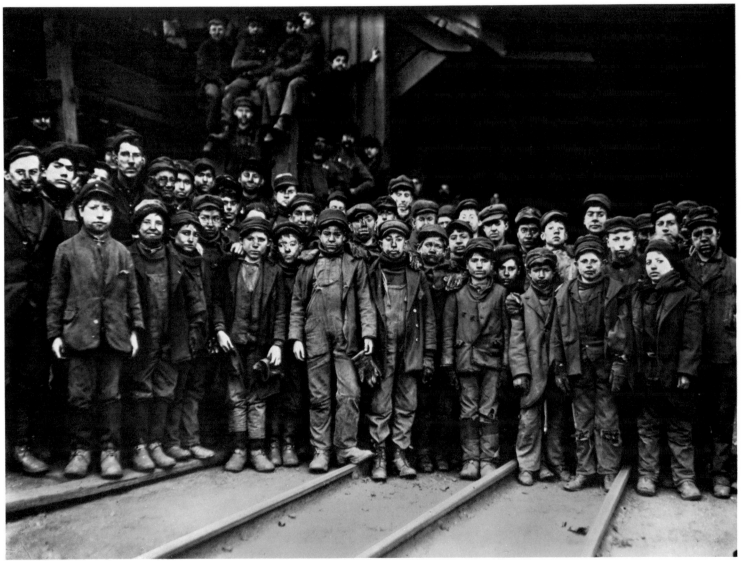

Breaker Boys, Pennsylvania, c. 1910

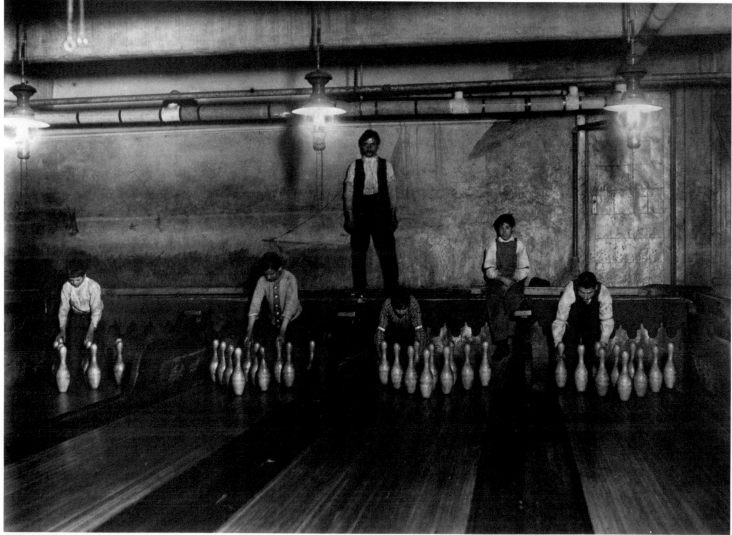

Pin Boys in a Bowling Alley, 1910

*The hour was 3 a.m. when these boys were
photographed at work in a bowling alley. Three
pin boys were kept out of the picture by the boss,
presumably because they were even younger.*

A casualty of a mill accident, this one-armed boy gamely posed for Hine in about 1910. "We don't have many accidents," one foreman said at the time. "Once in a while a finger is mashed or a foot, but it doesn't amount to anything."

Victim of a Mill Accident, c. 1910

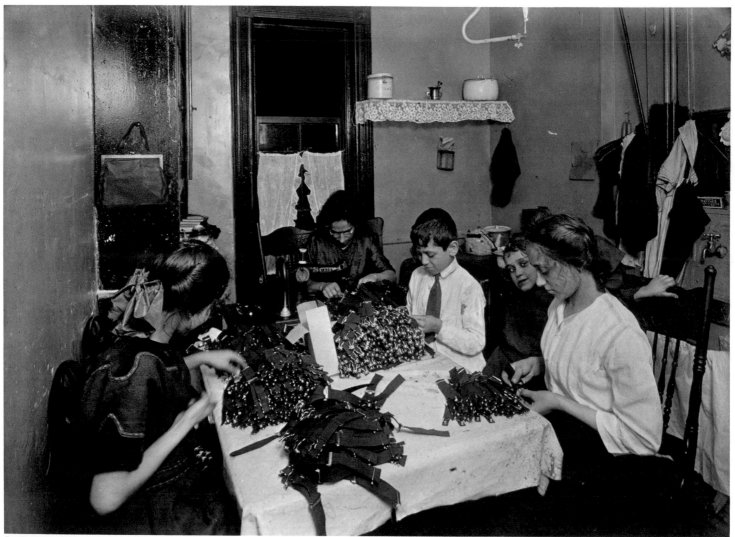

Family Making Garters at Home, c. 1910

◄ Some 13,000 tenement houses in New York City were licensed by the state as places where families could manufacture small articles on a piecework basis. But there were also many unlicensed premises, such as the one at left, where young and old labored day and night to earn less than 10 cents an hour making such things as the sock garters this family is producing. A New York State survey in 1912 found that 25 per cent of those working at home were under 10 years old; 45 per cent of them were under 14.

This youngster in soiled work apron and bare feet, leaning on a thread-spinning frame in a North Carolina cotton mill, was one of approximately 40,000 children under the age of 16 employed in the cotton mills. Despite photographs like this, efforts to legislate reform met resistance. One state officer explained: "The cotton mill people are the poorest paid workers in the country. They have to put their children in the mills."

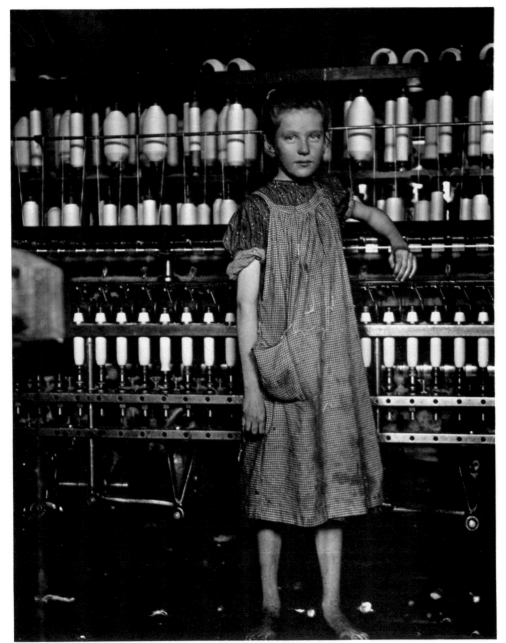

Spinner at Frame, North Carolina, 1908

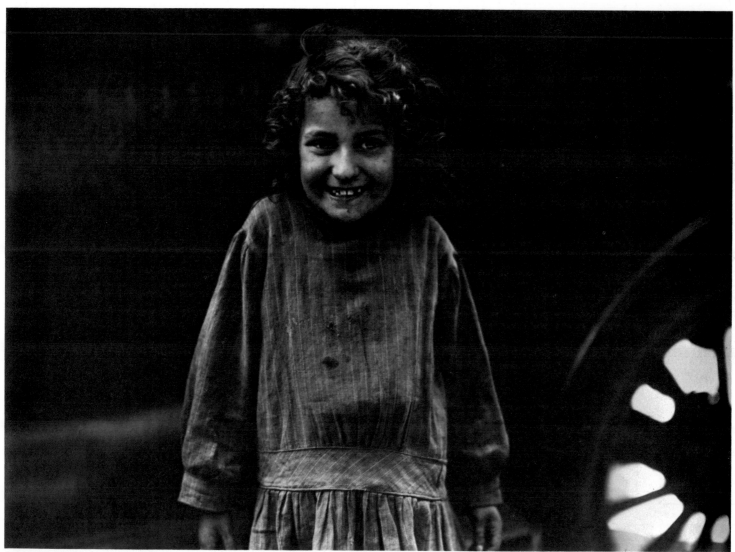

Parisian Child, 1918

Childish cheer in the midst of disaster — a grinning girl among World War I refugees in Paris — made a touching portrait. Pictures like this were used by the Red Cross to encourage donations.

Documenting the work of the Red Cross closer ▶ to home, Hine photographed victims of a drought in Kentucky during the 1930s. He found this young man perched on a school bench, holding a milk bottle given him by the Red Cross.

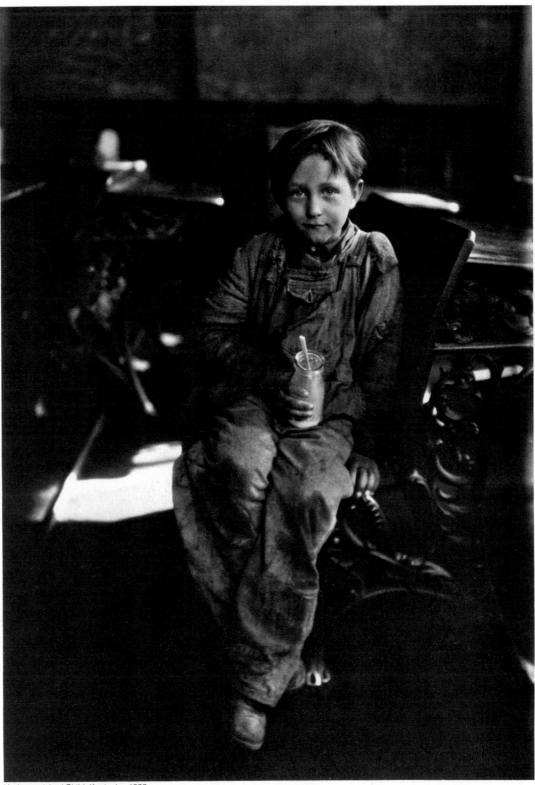

Undernourished Child, Kentucky, 1933

The FSA: Crisis on the Farm

By the 1930s the camera had proved itself a valuable weapon in the reformers' battles against the evils of city slums and child labor. Now came the greatest challenge of all: the Depression. This time, with the nation's entire economic structure in deep trouble, the impetus for reform came from the government itself.

The economic blight of the Depression struck rural America with extra force because it was intensified by a devastating natural blight: Drought and dust storms followed the collapse in the market for agricultural products. To help meet the crisis on the farms—on which 33 million Americans, a quarter of the population, lived in 1935—President Franklin D. Roosevelt appointed Rexford Guy Tugwell, a Columbia University economics professor, Assistant Secretary of Agriculture. Tugwell's aid to the farmers included low-interest loans and outright subsidies. The subsidy program was expensive and controversial, and Tugwell realized that photographs could help prove both the extent of the problem and the effectiveness of the cure. To direct the procurement of the pictures he recruited a former protegé named Roy Stryker.

Tugwell's choice was a stroke of genius. As a young economics instructor at Columbia, Stryker had enlivened his classes with photographs, using them to make urban students see the reality behind facts and figures on crops and acreage. In Washington he applied a similar technique. Although his job was only to record the activities of a single branch of the Department of Agriculture, the Resettlement Administration (later the Farm Security Administration), he left behind a collection of pictures that has become a classic archive of documentary photography.

No photographer himself, Stryker recruited a remarkable band of young talents, only a few of whom can be represented in the gallery following. And he exercised his considerable gift for teaching, instructing and cajoling to transform them into anthropologists, economists and historians, as well as reporters and commentators. Carl Mydans, one of that now-famous group, recalls his discussion with Stryker before his first assignment, a trip into the Deep South. Stryker asked casually, "What do you know about cotton?" Mydans replied that he did not know much. "And we sat down and we talked almost all day about cotton," Mydans remembers. "We went to lunch and we went to dinner, and we talked well into the night. We talked about cotton as an agricultural product, the history of cotton in the South, what cotton did to the history of the U.S.A. and how it affected areas outside the U.S.A. By the end of that evening, I was ready to go off and photograph cotton."

Although Stryker and his photographers were accused of boondoggling, the pictures fulfilled the government's initial aims, by documenting both the need for the farm relief programs and their ultimate success. For photography the pictures did far more. They were not only eloquent records but such compelling works of art that they drew public attention to a form of photography that had been taken for granted. They were the first documentary photographs to be known as such; thus the FSA men and women who made them were the first people ever called documentary photographers.

The unrelenting realism that became a hallmark of FSA photographs is plain in every detail of this fact-crammed picture of an Alabama sharecropper's family: shoeless feet; tattered, dirty clothing; a peeling bedstead supporting a rumpled bed; a bare and cracked floor. Touches of sad beauty, such as the eyes of the young girl, gave such scenes the power to shock America with the plight of "one third of a nation." But they also offered desperately needed reassurance. For in the midst of misery this photograph finds strength: eager-faced boy, steely-eyed grandmother, even grim-faced father and mother proclaiming an unconquerable will to survive.

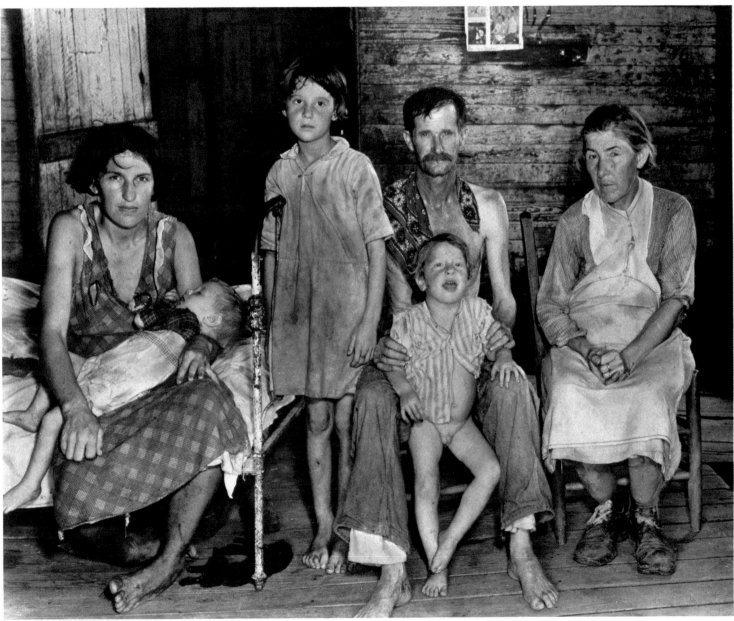

WALKER EVANS: *Alabama*, 1936

Walker Evans

The least sentimental and in terms of the art of photography the most influential of all the FSA photographers was Walker Evans. Among other things, Evans helped set the FSA style of documentary simplicity and directness. One of his favorite subjects was architecture; but whether the subject was a peeling billboard, a cabin wall *(opposite)* or a family group *(page 65),* his photographs resemble still lifes.

Evans is a symbolist: He makes the temporal seem eternal and the specific seem general. In his days with the FSA team he achieved his effects—strikingly spare and stunningly textured—by shooting head on, rarely from an angle, and by using an 8 x 10 view camera set at a small aperture, which gave his pictures amazingly fine detail and crisp focus that conveyed coldly sharp realism. Evans was the only FSA photographer who regularly used such a large negative size, and although others emulated his style, none quite duplicated the effect. Even after the passage of a generation has obscured the wounds of the Depression, Walker Evans' pictures of the most wretched subject matter still have a starkly evocative beauty.

A cotton farmer's wife stands before her tenant cabin like a specimen pinned to a wooden wall, her bleak and immobile stare fixed on the photographer's camera—as though her miseries had rendered her incapable of expression.

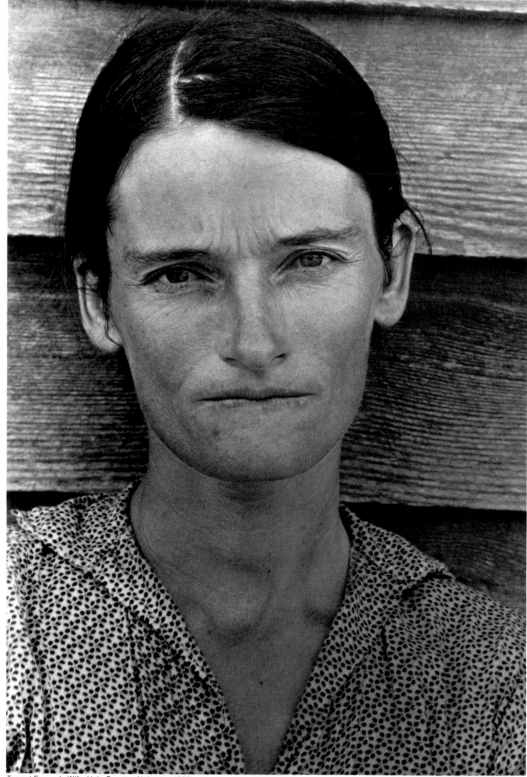

Tenant Farmer's Wife, Hale County, Alabama, 1936

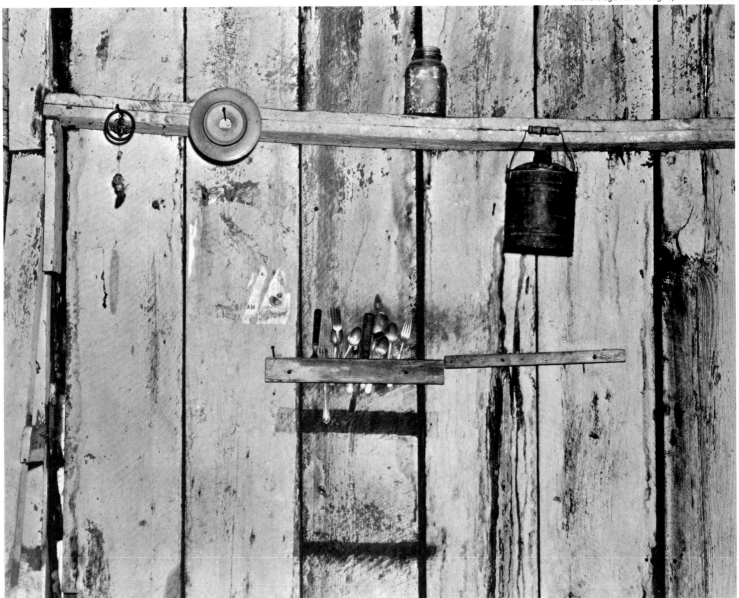

Kitchen Wall, Hale County, Alabama, 1936

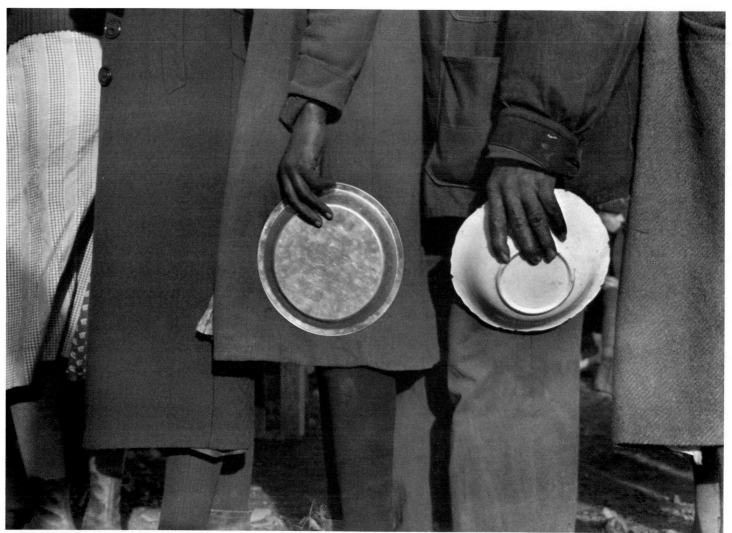

Mealtime, Forrest City, Arkansas, 1937

*Empty plates clasped by anonymous hands in a
jammed queue speak tersely of hunger in a time
of disaster. The figures, waiting for food at a camp
for flood refugees, are reminders of the persistent
paradox of scarcity in the land of plenty.*

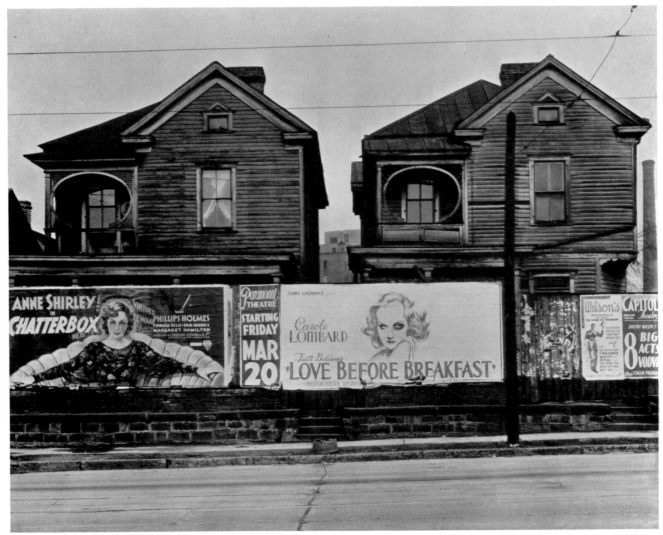

Street Scene, Atlanta, Georgia, 1936

In an acid comment by Evans on the gap between
reality and the American dream, two bleakly
similar houses on a dreary Atlanta street form a
backdrop for billboard promises of celluloid
romance. The irony is heightened by one billboard
showing a current movie star, Carole Lombard,
with the blackened eye her role called for.

Ben Shahn

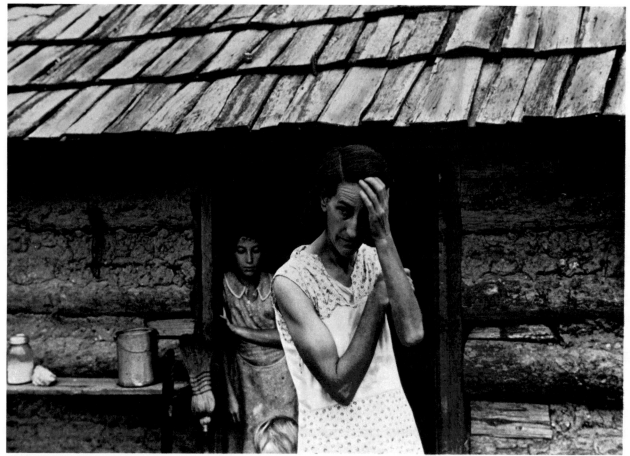

FSA Rehabilitation Clients, Boone County, Arkansas, 1935

Ben Shahn came to the FSA through a side door. A renowned painter, he was contributing paintings and posters to the FSA, and was lured into Roy Stryker's orbit partly because he had once shared a studio with Walker Evans and partly because he had found the camera useful as an instant sketch pad.

For the FSA, Shahn took a three-month excursion through the South and Southwest and returned so excited by photography that he thought of making it his life's work. He did not, but after he returned to painting, he acknowledged that his FSA experience with the camera influenced his later art. His photography also made a great contribution to the FSA, for his painter's conception made many of his photographs persuasive works of art.

Framed by the spare lines of the cabin that seem to indicate the limits of their life, an Arkansas farm woman and her daughter seem to be stopped in motion, yet with nowhere to go.

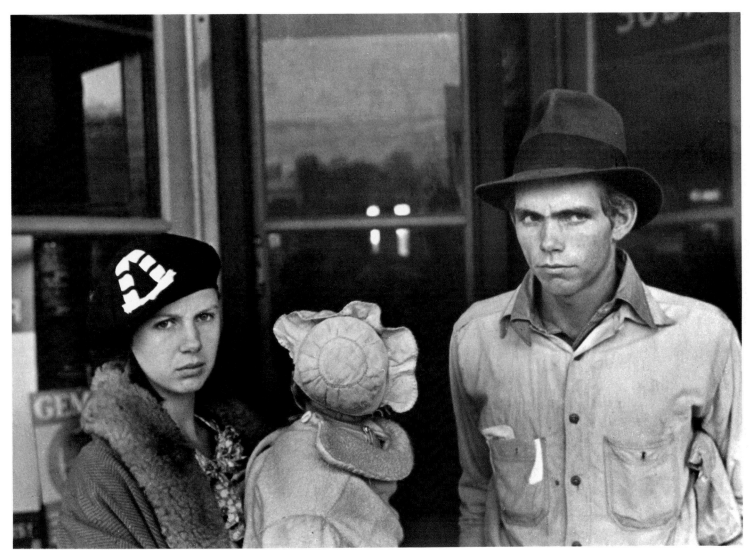

Man, Woman and Child, Smithland, Kentucky, 1935

In another example of life suddenly frozen into immobility, the artist-photographer caught this couple and child as they passed in front of a soda fountain. The family is arrested in one of those moments of uneasiness so characteristic of the depressed times when even the Sunday best that should bespeak confidence and tranquillity could not mask fear of the future.

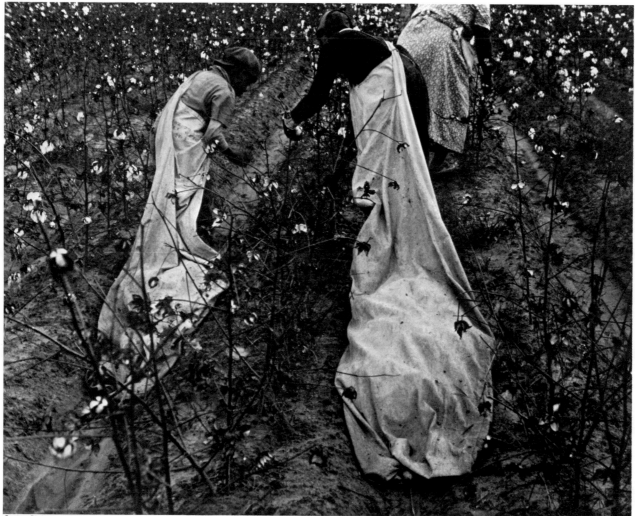

Cotton Pickers at Work, Pulaski County, Arkansas, 1935

*The artist's eye spotted these sacks as they trailed
like regal trains behind the cotton pickers,
who, painfully stooped, trudged up and down along
the rows to gather the harvest for wages
that sometimes were as low as 45 cents a day.*

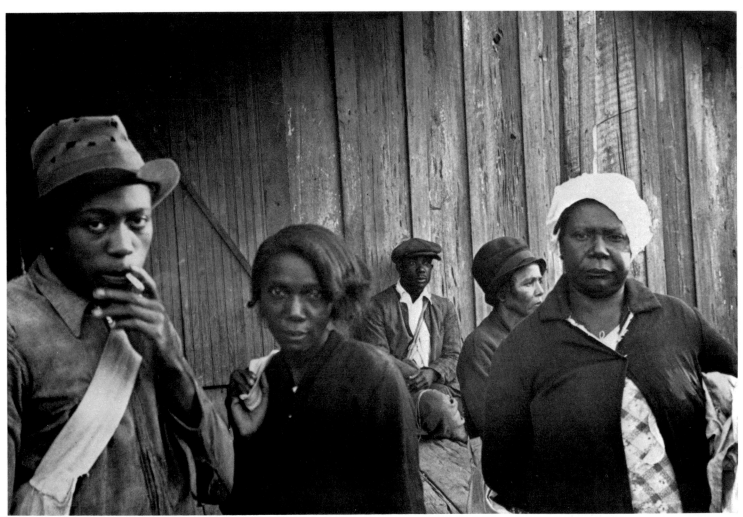

Cotton Pickers, Pulaski County, Arkansas, 1935

Warily confronting the camera, cotton pickers are photographed against the rough backdrop of a wooden shed. Shahn used to meet the workers at 5:30 in the morning, photograph them during their long working day, and then drive them to the company store where, he recalled, they would buy soft drinks and "drink up in one sweep one quarter of their earnings."

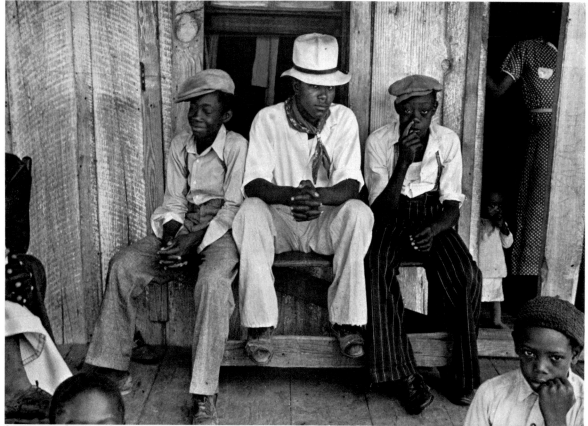

Sharecropper's Children on Sunday, Little Rock, Arkansas, 1935

Sunday clothes sharpen the message of poverty conveyed by the rough boards of the cabin and the worn, crude bench. Yet there is art as well as social significance in Shahn's picture. The range of facial expressions and bodily contours is united by the classical triangular composition in which the family have arranged themselves.

A woman and a girl waiting in line for relief ▶ payments outside an office in Urbana, Ohio, look in different directions, pointing up a series of opposites: age and youth, contemplation and observation. Yet they are drawn together in their common engagement, waiting for the relief money that will keep them alive through jobless times.

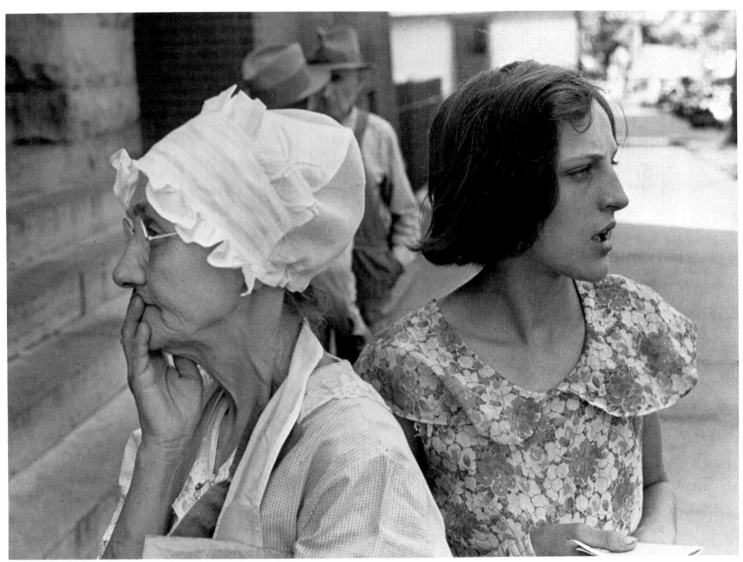

On Relief, Urbana, Ohio, 1938

Russell Lee

To the technical skill, artistry and compassion that had enriched the FSA pictures, Russell Lee added another value. He recognized the need for communication between groups of Americans separated by social class and geography, and he possessed the depth of human understanding to make photographs that filled that need. "America was very provincial in those days," he said. "City people didn't know about people living in the country; rural people didn't know about the city. One of our jobs was to acquaint city dwellers with the rural way of life."

To that task Lee brought a journalist's eye for the significant and a tongue for friendly persuasion. When a woman in the Midwest resisted his efforts to photograph her, he told her reassuringly: "Lady, you're having a hard time, and a lot of people don't think you're having such a hard time. We want to show them that you're a human being, a nice human being, but you're having troubles." Lee got not only the pictures he set out after, but others of several of her friends—and invitations to share their meager meals. Such understanding enabled Lee to get some of the most revealing and poignant studies of rural America made in the '30s.

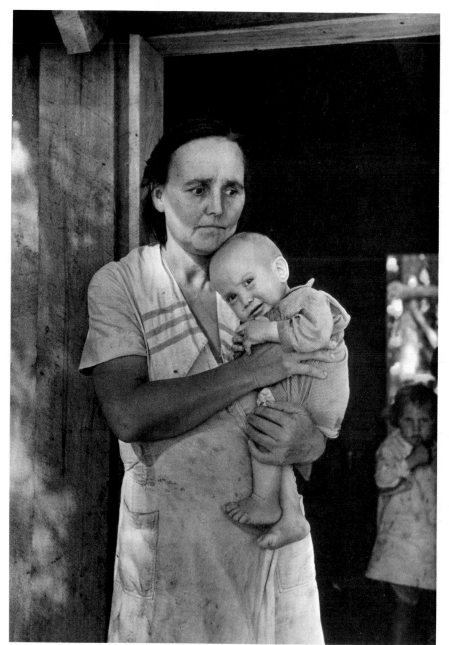

A stolid farm mother permits a glimpse into a bitter life as she stands in her cabin doorway, holding her crying infant while an older child looks on from the emptiness of their poor home.

Sharecropper's Wife and Children, Missouri, 1938

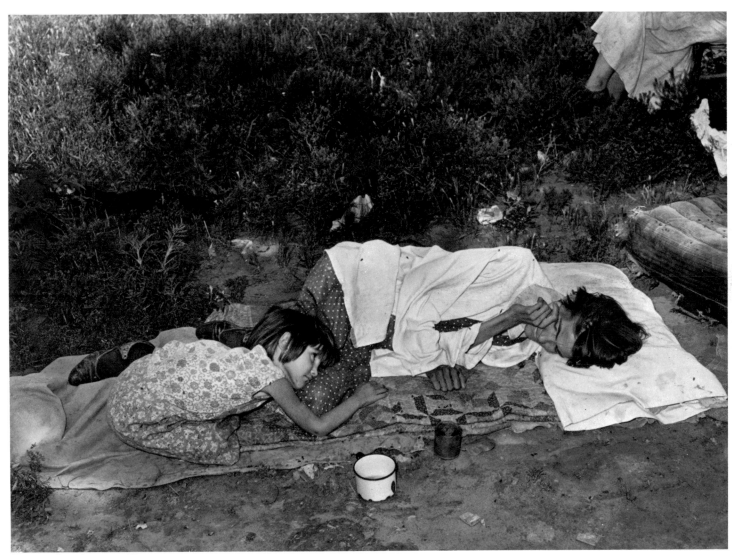

Mother and Child, Oklahoma, 1939

A small girl watches with tender concern as her sick mother, a farm laborer, lies down to rest on a stony patch of ground. The poignant scene gains much of its realism and immediacy from the harsh lighting, deliberately created with a flash bulb.

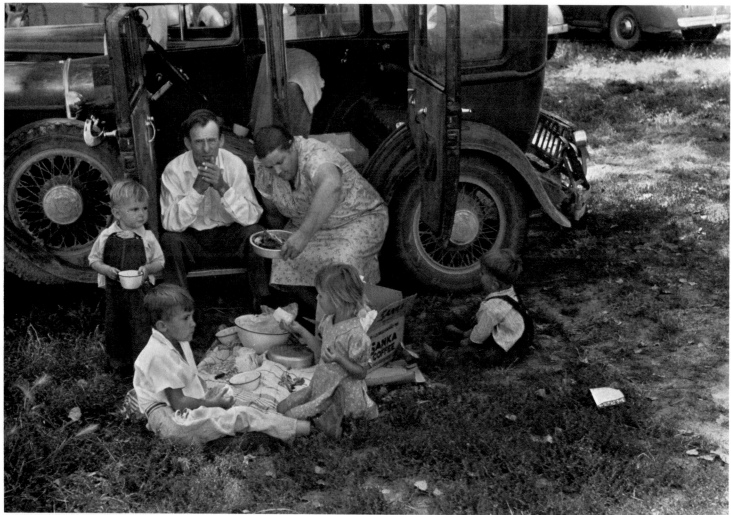

Fourth of July Picnic, Vale, Oregon, 1941

*Lee found this family celebrating America's
birthday with a quiet but crowded outing in a park.
Here, cut off from other celebrants by parked
cars, the mother serves up a homemade picnic
to her brood while the father smokes in silence.*

The Photo League **3**

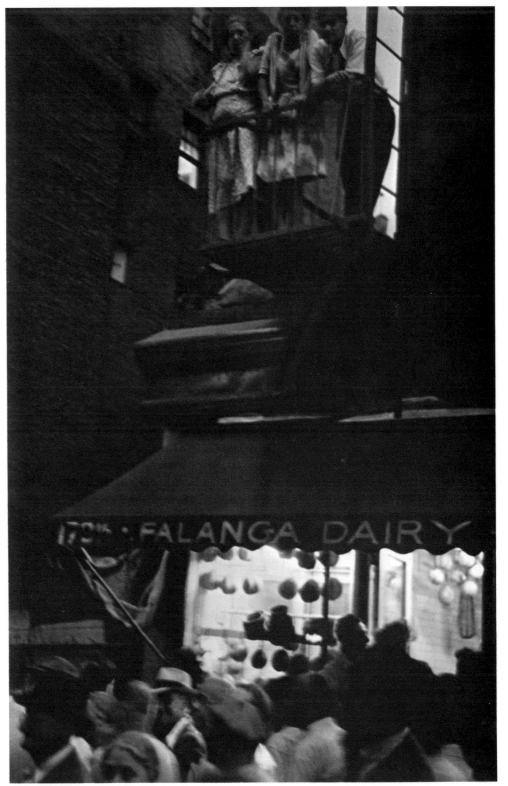

SID GROSSMAN: *San Gennaro Festival*. 1949

"A True Image of the World"

In 1928, the year before the stock market crashed and the Great Depression began to spread over the country, a group of New York City motion-picture and still photographers formed an organization called the Film and Photo League. Their major aim was to record events of social significance that were frequently not reported in the commercial press: street demonstrations against unemployment and for home relief and, since much of their work was commissioned by unions, labor strife— strikes, picket lines, clashes between police and pickets. In 1936 the motion-picture men broke away from the group, some going on to produce documentary films, others continuing to make newsreels. The rest renamed themselves the Photo League and based their documentary work on a broadly conceived credo. It read in part:

"Photography has tremendous social value. Upon the photographer rests the responsibility and duty of recording a true image of the world as it is today. . . . The Photo League [works] in keeping with the traditions set by Stieglitz, Strand, Abbott and Weston. Photography has long suffered . . . from the stultifying influence of the pictorialists. . . . The Photo League's task is to put the camera back in the hands of honest photographers, who will use it to photograph America."

Though hampered by a lack of money (some League members were still in school, others held low-paying clerical jobs, a few eked out a living photographing for merchandise catalogues), they scraped together the rent for a loft, which they remodeled to serve as exhibition room, lecture hall, classroom and darkroom all in one. They approached such big-name photographers as Paul Strand, Berenice Abbott and Margaret Bourke-White to form a board of advisers. Their spirit was infectious, and the big names consented. Encouraged, the young people began persuading other members of the photographic elite— Roy Stryker, Edward Weston, Robert Capa, Dorothea Lange— to speak at the League and to allow their work to be exhibited there. Soon they began issuing a monthly mimeographed bulletin, "Photo Notes," devoted to documentary photography. It contained original articles, reviews of current shows and reprints of essays on the subject, as well as news of League events. Distributed free to galleries, museums and photographers, "Photo Notes" had wide influence and drew more members into the League, where for no charge they could hear and interview such professionals as Henri Cartier-Bresson, Ansel Adams or Lewis Hine. After Hine died in 1940, most of his work was given to the League.

A major part of the League was its school, where students were taught the history, techniques and esthetics of photography. Just as membership dues were kept low (seven dollars a year), the school's tuition was about $30 for a 12-session semester, and no one was turned away for lack of funds. Probably the school's most important course was a workshop on documentary pho-

tography taught by the late Sid Grossman *(pages 86-87),* a gifted if controversial instructor. Former League members describe him as "brilliant," "a man you either loved or hated," "authoritarian and demanding but at the same time a sentimentalist," "rough on everybody but underneath gentle." His analyses of students' work could be abrasive, and some students weathered only one class; but a survivor expresses the graduates' general opinion: "Grossman excited you about photography; he was a great teacher."

The workshop developed group projects that sent students out to photograph the neighborhoods of Manhattan, for, as a publicity pamphlet put it, "the streets of New York . . . are the League's most important studios." Many of the students were born and bred in the city, many knew the tenement areas firsthand, and they brought the insider's sensitivity to bear on their work. From these projects came the Photo League Documents: series of pictures that interpreted photographically the people of certain areas—Pitt Street, Chelsea, Park Avenue, Harlem—and their way of life.

During World War II, though most of its members were in the armed forces overseas, the League produced documentary photographs for the Red Cross and servicemen's organizations. By 1947 the organization could boast that more than 1,500 photographers had been trained in its school and darkrooms. Money was always in short supply; but at the end of that year, after strenuous fund-raising, the group had substantially more than 100 members and was preparing to move to larger quarters in the basement of a hotel in Greenwich Village.

Then an event occurred that stunned its membership: In December the Photo League appeared on a list, issued by Attorney General Tom Clark, of organizations the Department of Justice had found to be subversive. The League was shocked; it categorically denied the charge of disloyalty, describing itself as "a photographic and not a political organization." Membership took a sudden leap, as photographers from as far away as California rallied to the League's support; and for a time things went well. But in May 1949, a former member, testifying at a trial of Communist leaders, implied that the League was a Communist-front organization. The League challenged anyone to "present an iota of evidence to prove our activities as subversive," and reiterated its stand that it was a purely photographic group. By this time, however, political tensions brought about by the Cold War had increased, and some League members, facing serious professional ostracism, felt compelled to resign. Young people, more affluent than the League generation had been and with a variety of photographic schools to choose from, did not replace the members who left. By 1951 the Photo League had ceased to exist. The essay that follows presents the work of some of its members, with their comments about the League and the influential documentary photography it produced.

Sol Libsohn

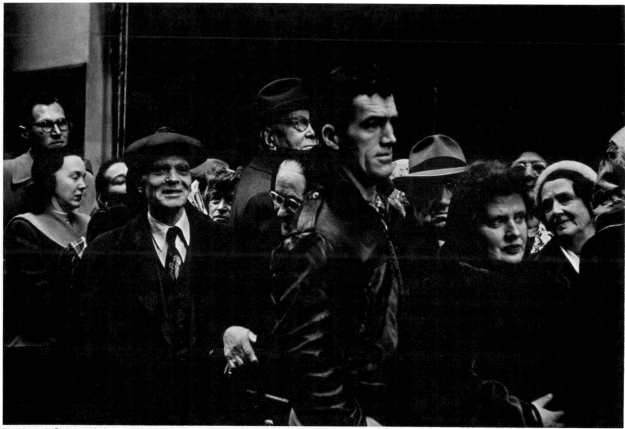

Washington's Birthday, 1940

"These pictures," explains Sol Libsohn, a leader in the Photo League from its early days, "combine two ideas we had—one, that by its nature the camera actually sees more sharply than the eye, and that this quality of the medium should not be discarded lightly as we believed the pictorialists had done. And secondly, that unless you feel an involvement with people, with the human condition, you should not photograph them at all. I took the one above at a holiday sale at a large department store in Manhattan. They were selling radios for a penny, things like that. I was struck by the visual juxtaposition of these people, strangers, closed in against each other for warmth against the chill February air. They were there for bargains, but what fascinated me was an instinct I had that they really seemed to need something completely different, something spiritual, even if they didn't know it.

"The picture on the right was taken on the Lower East Side. I had a deep interest in the ordinary people who lived there then, and when I saw that group I was overcome by another feeling I often have: that streets are like stage settings, and sometimes you can catch people on those stages in very penetrating tableaux."

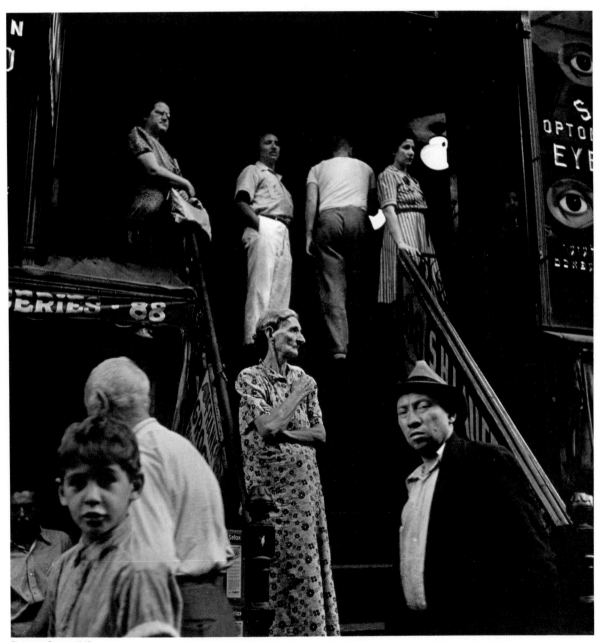

Rivington Street, 1945

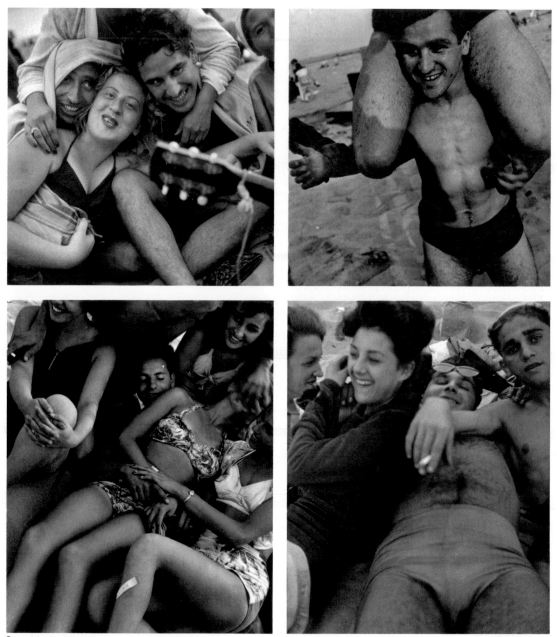

Coney Island, 1947-1948

Sid Grossman was 21 years old, fresh out of City College of New York and working as a pick-and-shovel man on a Works Progress Administration street-repair crew in 1936, when he joined and helped reorganize the Photo League. He later became the director of the Photo League School, whose aim he said was "to help the student to develop a personal approach to photography . . . to make his individual interpretations of his immediate world."

Grossman applied this aim in his own photographs of such familiar subjects as the Coney Island bathers shown on these pages. His style, recalls a former League member, "was really revolutionary at the time. Sid was one of the first photographers to chop off pieces of bodies—heads and arms and legs.

He would practically get on top of the subject, moving up to what seemed like only a few inches away. It was as if he couldn't get close enough to what he was trying to say." In the shot at lower left, opposite, he seems to have joined the tangle of merrymakers, to have gotten so intimate that he is one of them and they are no longer aware of his camera.

Grossman, who died in 1955, once said, "The function of the photographer is to help people understand the world about them." He would ask his students if they ever took pictures just for themselves. He would answer for them: "No, you don't," and add that he did not himself, "though I have boxes of pictures that nobody wants to buy. . . . I know the time will come that they will be usable and I will have won."

Jerome Liebling

''I was about 22, a World War II vet studying photography on the GI Bill at Brooklyn College in 1947 when my teacher, Walter Rosenblum, suggested I join the Photo League,'' Jerome Liebling recalls. ''Since I was a city boy I liked the League idea of going into the streets to photograph New York.

"I took the picture at right with a 2 1/4 x 2 1/4 Super Ikonta B, a camera with a convenient eye-level rangefinder viewer, when I revisited my old East Side neighborhood. It was changing and becoming an artists'-colony extension of Greenwich Village, but I managed to find this view of the traditional tenement architecture and the woman in the classical tenement-dweller's pose — leaning out of the window to get some air and to watch the life going on in the street.

"In 1949 I was in Paul Strand's class at the Photo League, where we documented the area near Knickerbocker Village, a Manhattan housing project that had been built in 1934 on the site of a notorious slum. By the time we photographed it 15 years later, new decay was evident. By shooting this youngster *(opposite)* without much environmental detail, I wanted to invite the viewer's sympathetic interest in him, from his curious gaze to his gracefully crossed hands to the poverty betrayed by his cheaply made, broken shoes.''

East Side Windows, 1948

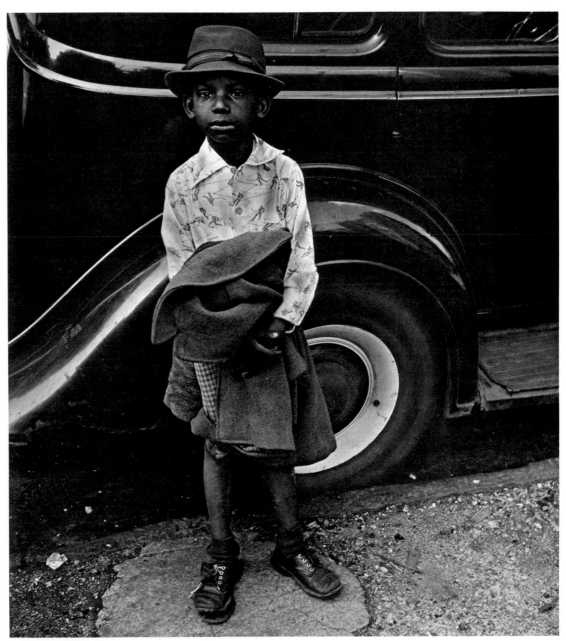

Knickerbocker Village, 1949

Jack Manning

"The Photo League was a few blocks from the high school I went to in 1937, so I used to visit their exhibits," says Jack Manning, now a photographer for *The New York Times*. "I had a Rollei and I had begun to teach myself photography. One day I showed Aaron Siskind some of my pictures, and he invited me to join the League's Harlem Document group *(pages 92, 100),* which he headed. You had to know your craft for that project because you went out and worked on your own. I was with the project for two years and I liked it so well that in my spare time I still shoot the same kind of documentaries—I've done them on the slums of Puerto Rico, on the Puerto Ricans in New York City and on the people of Spain.

"The picture at right was part of a series I took of 20 kids at a settlement house in Harlem who were forming a band. The one opposite was taken on an Easter Sunday—I approached the young lady and told her about the Document project and then asked her if I could take her picture, and she was very willing to pose for me.

"I learned from the League that a documentary photographer has to be technically good enough so that he can concentrate on content, in order to make honest statements with his camera that will serve to help people. The critics disparaged us by calling us the Ashcan School of Photography—but I liked the title, and was happy to be identified as an Ashcan photographer."

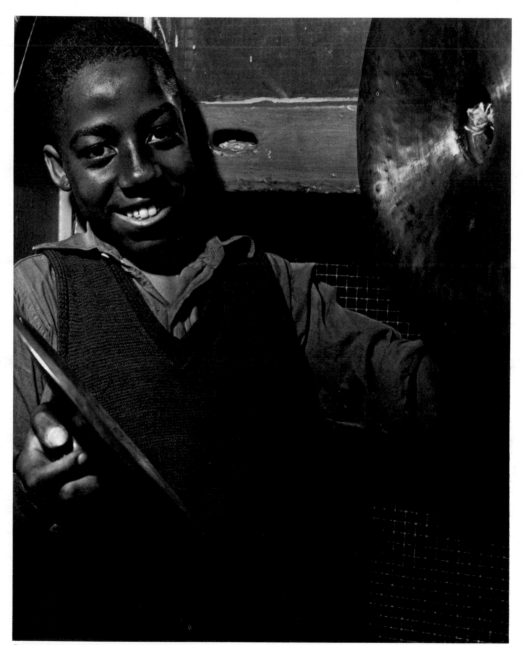

Boy with Cymbals, 1938

90

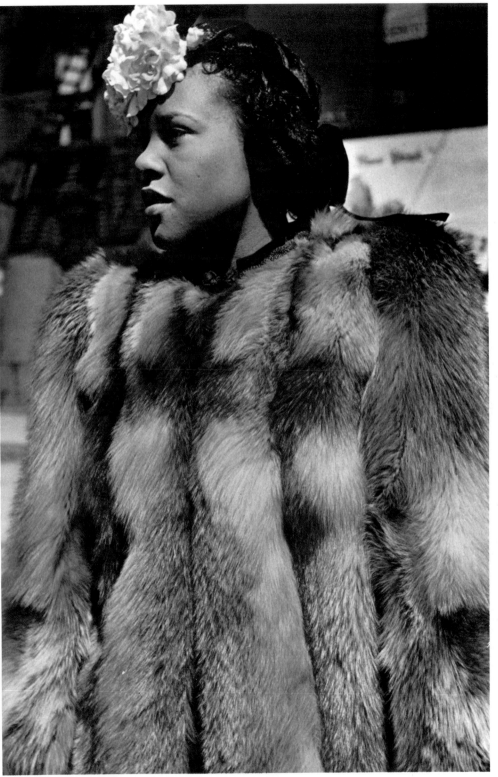

Easter Sunday in Harlem, 1938

Aaron Siskind

"I was a schoolteacher who used to take pictures as a hobby with a little 12-dollar camera in 1932 when I went to an exhibit at the old Film and Photo League, and the pictures of men made homeless by the Depression stirred me," Aaron Siskind remembers. "So I joined and some years later organized the Feature Group, where rank beginners went out to document city areas. A black journalist suggested we do a study of Harlem, and that's how the Harlem Document came about.

"I went out just as the others did, even though I was directing the project. These pictures were taken with a 40-dollar Voigtlander-Avis camera and two lights set on stands. The shot on the right was made at a little nightclub—in those hard times there were very few customers and those few were white. The picture opposite was at the Savoy Ballroom, where every night for 50 cents people could shag and stomp to two dance bands. I set up my gear on the edge of the floor and then I induced this couple to dance into the area.

"To me documentary photography means making a picture so that the viewer doesn't think about the man who made the picture. At its esthetic core is a very old tradition in art: naturalism. And its purpose is to document all facets of social relationships."

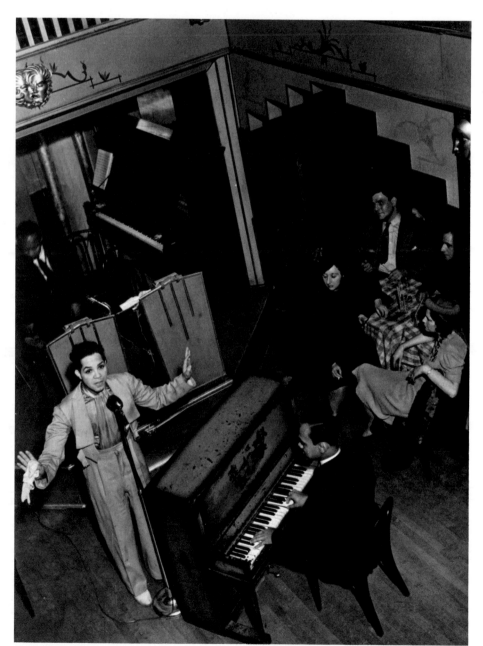

Harlem Cabaret, 1938

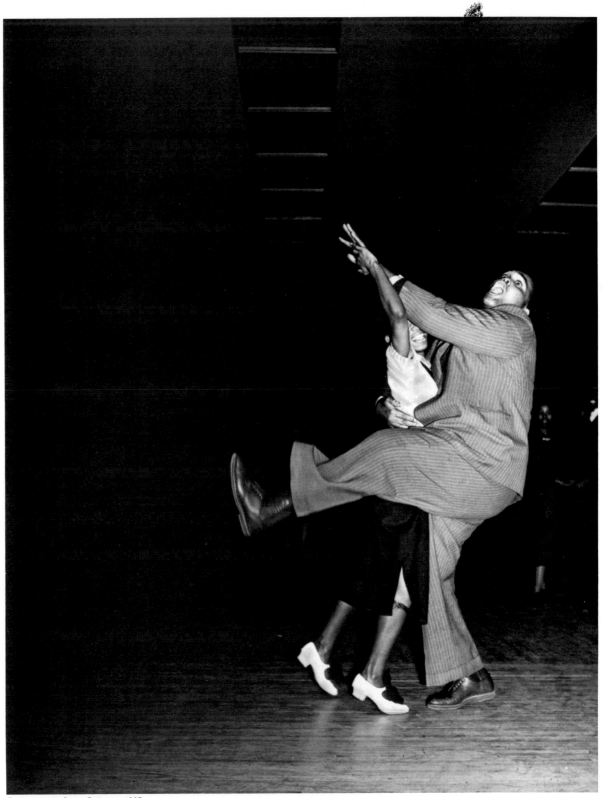

Dancers at the Savoy Ballroom, 1937

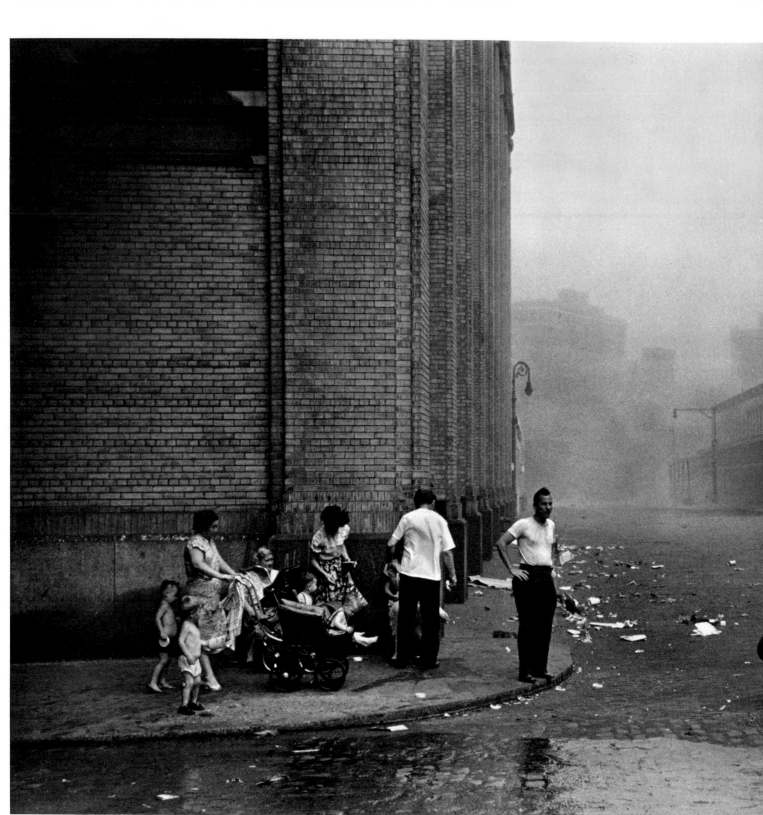

Sandstorm, July 4, 1949

Ruth Orkin

Ruth Orkin's connection with the Photo League was formalized by politics. She recalls: "I had been going to forums at the League for quite a while, but I became an actual member as an act of principle, two weeks after the Attorney General's list *(page 83)* came out. I never took any classes—that was a good thing about the League, it wasn't strictly classroom. It was also someplace for photographers to get together and learn from each other informally, like cafés in European cities where artists meet to keep up with what's going on. To me, documentary photography is what's real. And reality is what moves people in the long run.

"This picture is a study of the bleak, decaying streets in an old section of Greenwich Village. The building on the left, a warehouse, was clattering with noise all the time. The street wasn't well paved—the cobblestones went back to the 18th Century and the dirt lodged between them. In the right background is a wholesale meat market, which added to the street litter.

"I took the picture just as a gust of wind came up and blew grit swirling around the people who were sunning themselves on the corner. They were Polish and Irish, very poor, who lived there. It was a neighborhood that was always alive with people, even in the midst of the dirt and decay."

Eliot Elisofon

Eliot Elisofon, once president of the Photo League, remembered these pictures as being "made at a time when I was learning how to record the New York scene—what it looked like, where the people were. It was a way of saying, 'This is New York.' I took both of them with a 3 1/4 x 4 1/4 Speed Graphic, a slightly smaller version of the hand-held view camera press photographers then used, and in this picture *(right)* what interested me was the design that the structure of the elevated lent itself to. There was also the repetition of the words of the toothpaste ad under each step—in themselves the words were almost meaningless, but the pattern they formed reinforced the design.

"What fascinated me about the shoe-shine man *(opposite)* was the fact that he had printed the passages from the Bible letter by letter with rubber stamps. He was a man of deep religious feeling, and he had put his message in the window of his booth for everyone to read. "I came to the Photo League around 1935, after I had been photographing for a year or two. I wanted to learn formal technique combined with meaningful subject matter—social conditions interested me. I remember there were all kinds of heated discussions about technique and craftsmanship as well as esthetics. In retrospect I suppose we were pretty square, but we were just trying to say something with a camera."

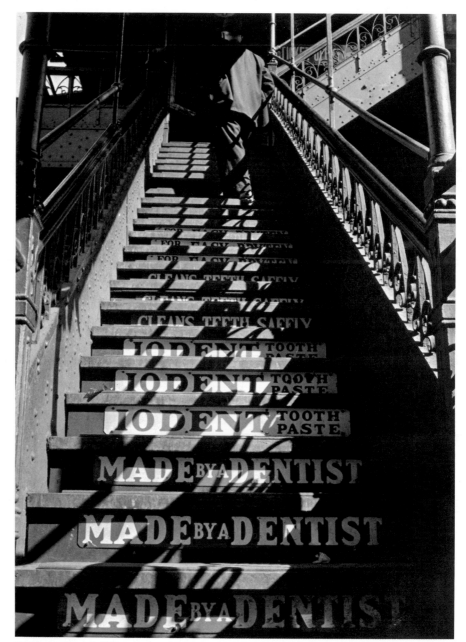

Third Avenue Elevated, 1936

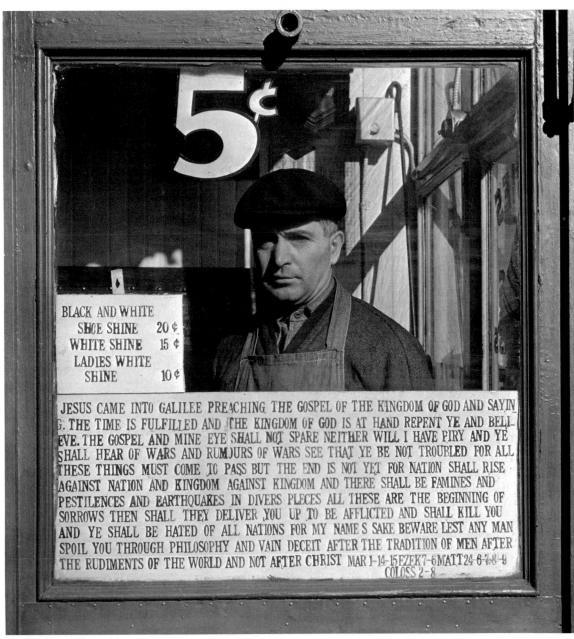

Shoeshine Man, 1936

Arthur Leipzig

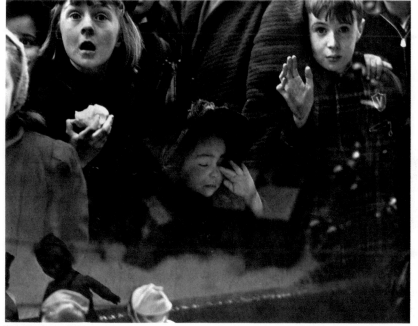

Watching Santa, 1944

"I took these pictures of kids in Brooklyn, where I was born and brought up," says Arthur Leipzig. "To make the one above, I stood inside a store window, hidden behind a Christmas display, and shot the kids looking through the window at a mechanical Santa Claus. The one at right is from a series on street games in the city. My inspiration was a picture of Pieter Bruegel, the Flemish painter, called *Children's Games*. It shows scores of half-grown kids, playing some 80 different games. Some of them, I found as I wandered around, were still being played today, even though the painting was done in 1560.

But mainly I noticed that poor kids in urban areas have their imaginations and very little else to work with. In this picture, the kids had some chalk, so they made up chalk games.

"I wouldn't label my work documentary," Leipzig says. "I just photograph the way I feel—but the League helped me to learn to do that." He joined the Photo League as a beginning photographer in 1942, attracted by its low fees. He recalls: "Two weeks in Sid Grossman's class, and I knew what I wanted to be. Six months later I got a job as a newspaper photographer, but I stayed in the League till around 1949."

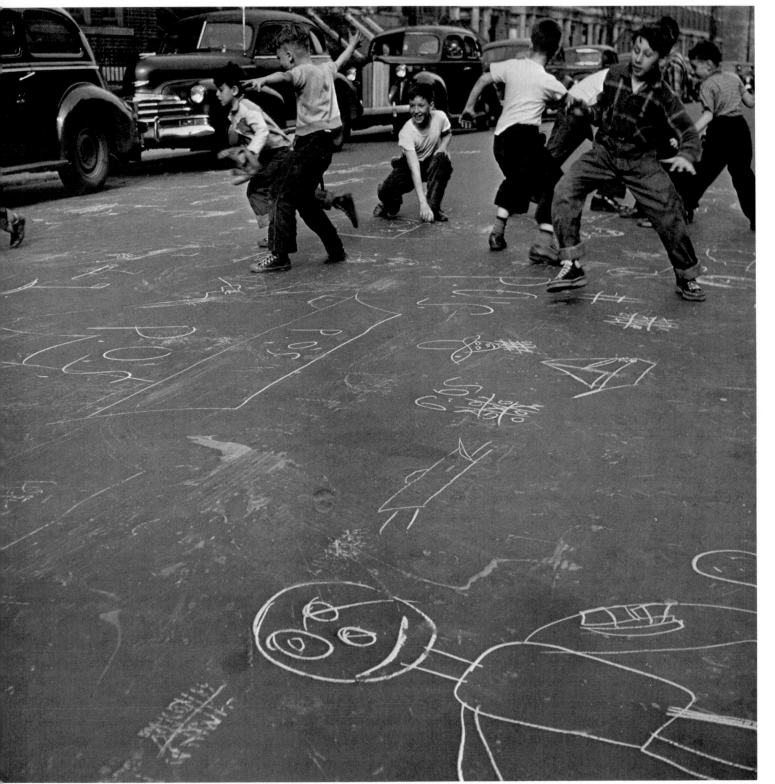

Chalk Games, 1943

Morris Engel

When Brooklyn-born Morris Engel was 18, in 1936, he noticed a Photo League advertisement in a newspaper. Learning photography sounded interesting; he decided to join and enrolled in the six-dollar course, a bargain even in that Depression year.

Once he had learned some of the basics of picture taking, Engel joined several other young photographers in the Photo League Feature Group. Headed by Aaron Siskind *(pages 92-93)*, the group first turned its attention to Harlem and produced what came to be called the Harlem Document. Engel recalls that at the time he had a job in a bank and was able to do photography only on weekends. He tramped around Harlem on Sundays, shooting roll after roll of film with his Rolleiflex. The picture at far right of a Harlem candy and newspaper vendor staring out of a cluttered street-corner stand became part of the completed document.

Engel also worked on another project known as "Park Avenue North and South." Park Avenue was sharply divided at 96th Street; to the north were slums, to the south an elegant residential area. The picture at right, taken well south of this dividing line, shows not only the nature of that well-to-do part of New York, but also captures a subtle relationship of individuals.

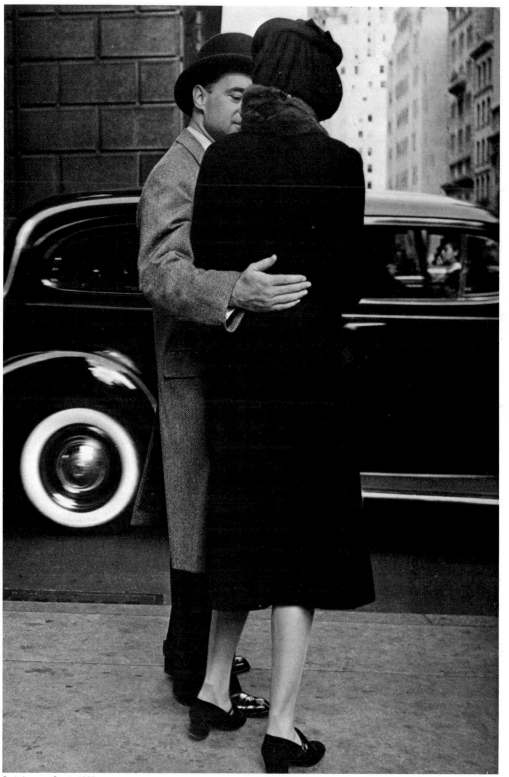

Park Avenue, South, 1938

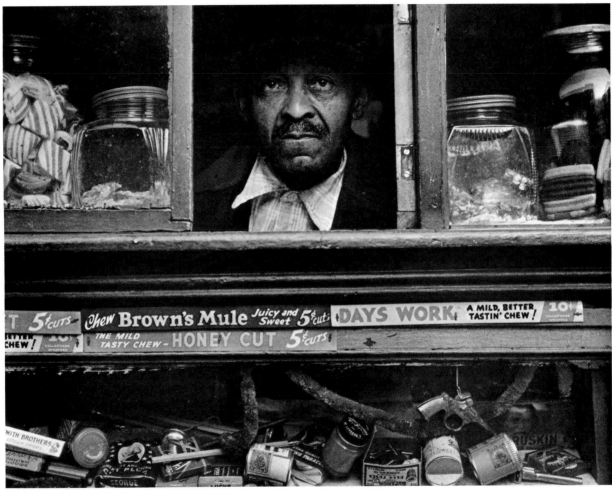

Harlem Merchant, 1937

Lou Bernstein

Shortly after Lou Bernstein took up photography as a hobby he joined a camera club, but "their outlook was too pedagogical," he says, "so I tried the Photo League instead. I thought of photography as a means of self-expression and the League's philosophy suited me because it emphasized the expression of personal viewpoints, even in the photographs we took of social conditions. I think that's an attitude that is missing in almost all of the photography schools today; there should be an institution that encourages young photographers to express themselves."

The picture at right is of a Brooklyn building superintendent and his wife, who were acquaintances of Bernstein. He says of it, "I think the man's attitude tells something about how we cherish a person who is close to us, but at the same time, I had the feeling he was flaunting himself." The picture opposite was taken at Coney Island. Bernstein had been "watching how this baby was playing with her father, showing respect for him one moment and taking advantage of him the next, the way babies sometimes do. Here she's taken him by surprise, and gotten the upper hand for a second. I think pictures often reveal motives we don't even know about ourselves in our relationships with people—but exactly what they are is not for me to say; it's for each viewer to decide for himself."

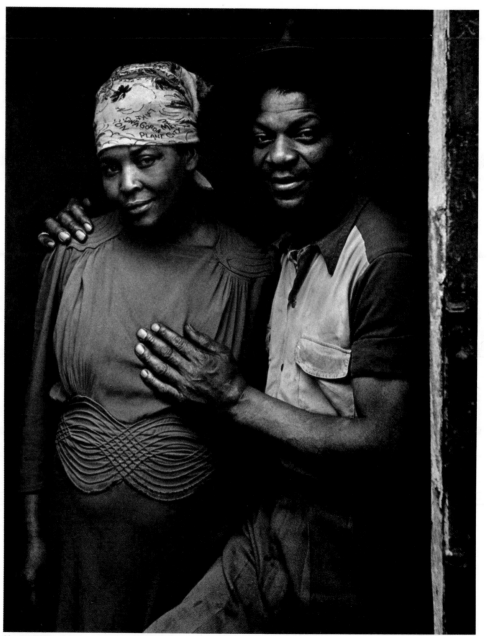

Man and Wife, 1941

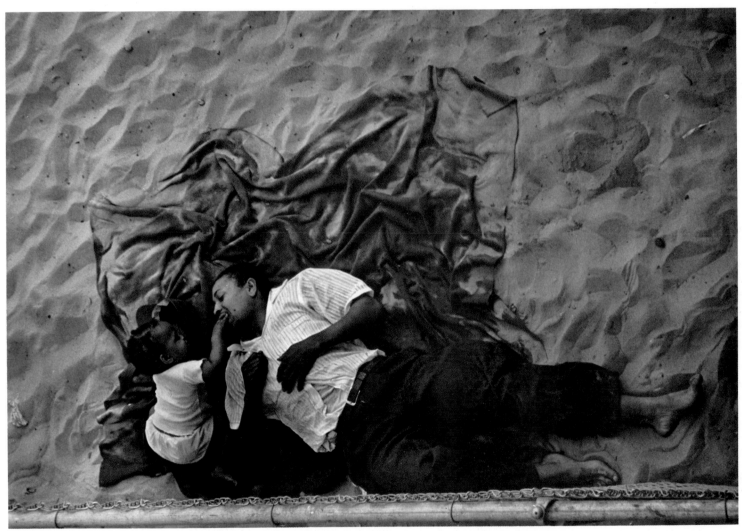

Coney Island, 1943

Rose Laible, 1947

Around 1940, when Bill Witt was working as a photographer in a New York City studio, his co-worker Dan Weiner brought him into the League. "Except for my four years in the service," says Witt, "I stayed in the League until 1949. I even taught a course in advanced technique for a semester after the War. The League meant different things to different people. For me, it was the only photographic group at the time that was producing meaningful pictures. I liked the FSA photographers (Chapter 2), and I felt that the League was trying to document the East as the FSA had documented the Dust Bowl.

"But I liked to photograph all aspects of life around me, and I was always more interested in esthetics than were many of the people in the League. I remember at the time of a big Photo League show in 1949 I had become interested in nature and abstract photography. I had some pictures of that type in the show, and they raised eyebrows.

"I used a Rollei to take this picture of my grandmother poring over the evening news when she was in her seventies. Since she lived downstairs from us in my house in Newark, I was in and out of her apartment—I was interested in recording the surroundings that old people manage to keep around them, like the old-fashioned lamps and tables she had. And she herself was a very interesting, strong person—she had been brought over from Germany as a child in a sailing ship, she married and had two children, and she lived to be 102."

Lester Talkington

"On my way home from work. I was attracted by the warm, natural joy of this child skipping rope. I sat down in a doorway, which shielded the lens from the sun, and got this shot." says Lester Talkington of the picture at right, taken on a block in Manhattan that borders East Harlem. His camera was a pocket-sized Kodak Vollenda, which he liked because he could carry it around, ready to slip out of his jacket and unfold for candid shots like this one, for which a shutter speed of 1/250 at an aperture of f/8 froze the little girl in midair.

A native of Fort Worth, Texas, Talkington began doing photography early, "playing with the family Kodak as a kid." He joined the League in 1947, after his wife, the daughter of a photographer, urged him to develop his craft. In the League he was exposed to "a real wonderful education. Their emphasis was on the documentary, but they didn't *make* you be a documentary photographer. They made you think about what you were doing. I still do documentary work occasionally, but what I get the greatest pleasure out of now is details of nature—like Edward Weston, only I use a 35mm camera and I get something quite different.

"I left the League around 1950 when I moved out of the neighborhood where the meetings were held. By then I had become good enough so that I had to decide whether to give up my job as an ad writer and go into photography full time. Babies were coming, so I stayed with my writing. But the League—they were really great people." □

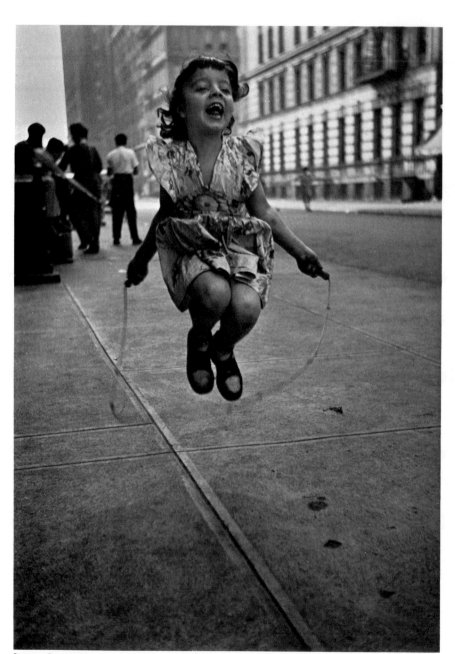

Skipping Rope, 1950

A Commitment to Inspire 110

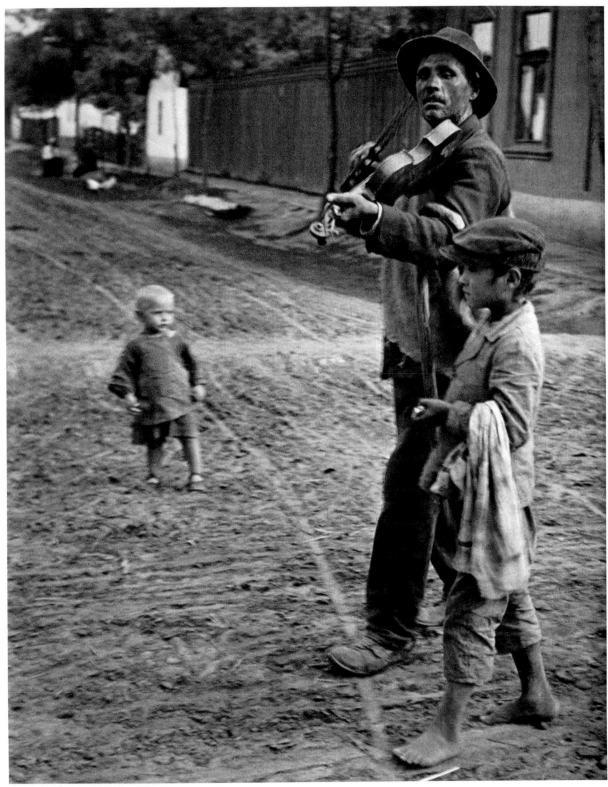

ANDRÉ KERTÉSZ: *Blind Musician,* 1921

A Commitment to Inspire

To one elite group of documentary photographers, neither the literal reporting of the 19th Century nor the social criticism of the early 20th has sufficed to comment upon the world around them. Their careers extend over some seven decades—nearly half the life span of photography itself. They have shared with the photographers in previous chapters the belief that a photograph can convey information accurately and provoke an active response. Yet their goals have been much more ambitious than those of even the most dedicated among their predecessors. Not content simply to mirror life's passing parade or to lobby through photographs for new laws to relieve poverty and oppression, these documentarians have striven to influence people's basic attitudes. They have hoped that their photographs might bring to an end the desire to oppress and exploit, that they might instill tolerance, respect, even love among men.

Six photographers—André Kertész, Paul Strand, Dorothea Lange, Henri Cartier-Bresson, W. Eugene Smith and Martine Franck—represent this group on the following pages. All six share lofty human aims, yet each follows a unique approach to documentary photography. Kertész is now recognized as the father of an informal, personal style. It evolved naturally, while he was a very young man, out of his desire to keep a journal of his life. But instead of a pencil and notebook, he used a camera. Every scene he encountered was a subject: people he knew well and people he saw only once, the views he saw daily and the ones he would never see again. The blind violin player on the preceding page is a good example. While visiting a friend outside Budapest, Kertész chanced upon the itinerant musician, who was being led from place to place by his son. Another child, the friend's little boy, approached the pair with childish curiosity, and Kertész recognized the superficially ordinary scene as an extraordinary moment of human confrontation. He never saw the fiddler again, but his instantaneous response provided an inspiring record of gentleness and respect.

In the hands of Paul Strand, the photographing of ordinary people and scenes took on a more aggressive purpose and a stricter discipline. He shared Kertész's view that the world's ordinary people must not be forgotten, but he held the conviction that they will be destroyed unless they fight those who would exploit them. He used his camera to aid their cause, whether they were Mexicans, Egyptians, Frenchmen or Hebrideans. With documents of their faces and their works, he sought to convince the viewer of their dignity and nobility. People in Strand's photographs seem to stare out in defiance of those who would crush them.

Henri Cartier-Bresson acknowledges Kertész as his teacher, and his work bears a similarity to Kertész's in its concern with every phase of human activity—whether play or work, love or war. But Cartier-Bresson imbues his pictures

with a unique sense of time. They record what he calls the decisive moment, the instant when a mood is best expressed. Those shown here are not action pictures, although they may stop some movement of body or hand. What they freeze is attitude, the glance of an eye, the tilt of a head, the twist of a torso — of one person or several in one picture. His genius is to sense when a combination of expressions and postures communicates his message and, in that instant, to record the reality, refined and concentrated, of the pleasures and pains of ordinary experience.

Dorothea Lange, on the other hand, spent little time documenting the ordinary. One day early in the Depression, when she was working as a portrait photographer, she was drawn out of her studio by the realization that "outside the world was just in smithereens." From that day onward, her place was "outside." She used her camera for nearly 30 years to try to pick up the pieces of a shattered world. She deplored the miseries wrought by both men and nature, and her early FSA photographs were an attempt to combat them. She was most comfortable when she was photographing her fellow Americans, although she seemed to document them most ably when their circumstances were painful. It was mainly in her later years, particularly when chance took her to the Middle and Far East, that she turned her camera on tranquil subjects *(pages 132-137);* but when she did, she extracted the very essence of what was right in the world.

Like Kertész and Cartier-Bresson, W. Eugene Smith was intrigued by every facet of daily life, and like Lange he made documents both to expose ills and to record examples of perfection. But the special factor that marks Smith's photography is its fervent, gripping emotionalism. His pictures always contain (and arouse) powerful — sometimes violent — feelings. In a war scene, the viewer shares Smith's hatred of death and destruction; in a photograph of a doctor, his admiration; in a picture of a young animal, his love of its tenderness and vulnerability. Had it been possible, Smith would have expelled pain from the life of every creature.

Born just before the world war in which Smith took some of his most powerful photographs, Martine Franck carries the tradition of honoring humanity — and shaping its vision — into a new generation. She works by a remarkably systematic approach, exhaustively exploring a single theme that excites her interest or compassion, whether French holidaymaking, English country living, or aging around the world *(pages 144-150)* — always hoping, by her results, to "inspire the viewer to think or to dream." That hope links her with the photographers above in the belief that documentary photography can help to bring out the best in people. It also marked her as an exception throughout much of her early career, when most documentary photographers *(Chapter 5)* were chronicling the world from a less sanguine viewpoint.

André Kertész

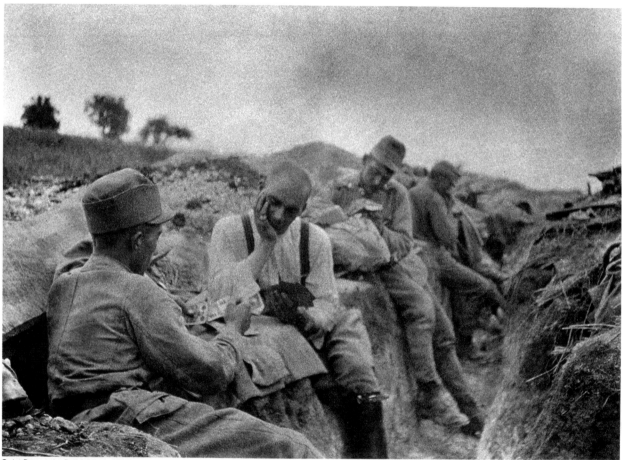

Quiet Day on the Polish Lines, 1915

As an infantryman in the Hungarian army, Kertész chronicled World War I. Lulls in the fighting, like the one depicted above, spoke most poignantly of the bleakness of soldiers' lives.

As a small boy in Budapest, André Kertész longed to own a camera. Finally, when he was 18, he was able to buy a small box ICA 4.5 x 6cm and with it he kept what he called an "optical diary," a portrait of his world intended for no one's eyes but his own.

This diary is simply a record of scenes—both ordinary and extraordinary—that gave character to life in Hungary in the years between 1912 and 1925. Kertész brought to it no training in photography. But perception, curiosity, a keen eye for composition and his deep affection for the people and places around him equipped Kertész to create a series of documents that are at once vivid and appealing.

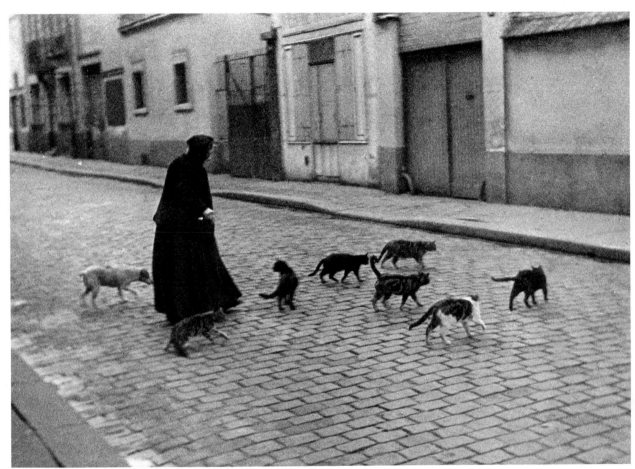

Paris Scene, 1929

Without consciously trying, he captured all the sensory elements that make a mood. In his Hungarian photographs the viewer can almost sense the dampness and earthy smell of the air, or the feel of mud rutted by wagon wheels and cobbles made slick by rain.

The basic character of Kertész's early work persisted more or less unchanged after he went to live in Paris in 1925. Places and people, whether famous artist friends or nameless passersby, were still his favorite subjects, and he portrayed them with the same affection that he had his native Hungary. One rule still guided his work—to photograph only what he loved: "If I do not have the contact, I do not touch."

For days the photographer watched this woman feeding stray cats and dogs. She was outraged when she caught him stalking her with his clumsy box camera. Changing tactics, he pursued her again for this picture only when he had a little Leica that escaped her suspicious eye.

113

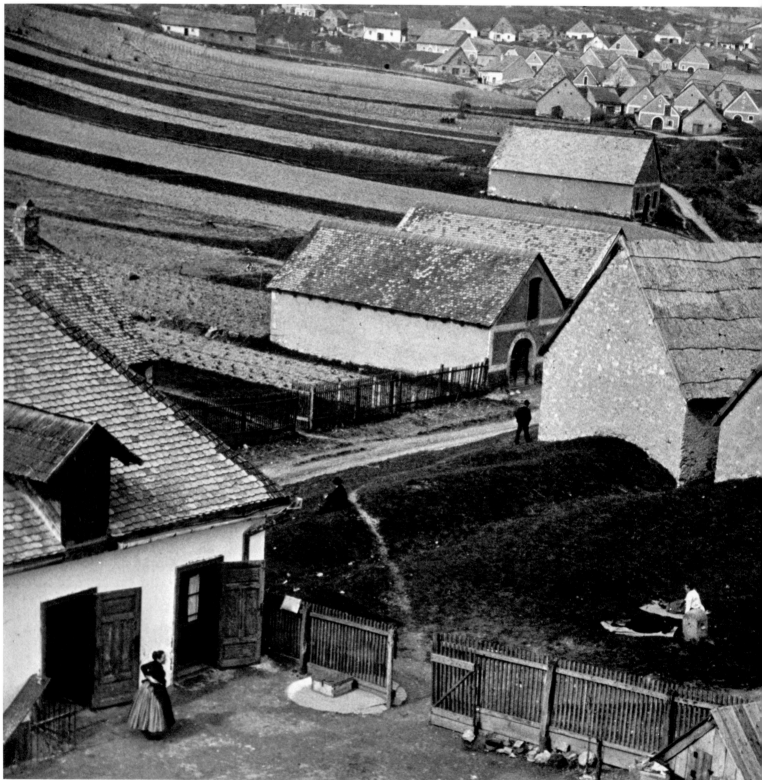

Village near Budapest, 1919

Eugene, 1914

The bold light-and-shadow patterns (above) cast
by a street lamp over an empty square at night
caught Kertész's eye. But he felt the picture
needed a dark figure for balance, so he enlisted
his brother Eugene, who held perfectly still for the
three-to-four-minute exposure. The resulting
picture of a man and his shadow as he approaches
the menacing darkness records the essence of
night and solitude in the sleeping city of Budapest.

◄ From atop a steep hill, the photographer studied
the village of Budafok and its means of livelihood.
Softly rounded expanses of turf, covering wine
cellars, seem to cushion the sharp-peaked
houses, while in the distance parallel cultivated
and fallow fields make stripes down a hillside.

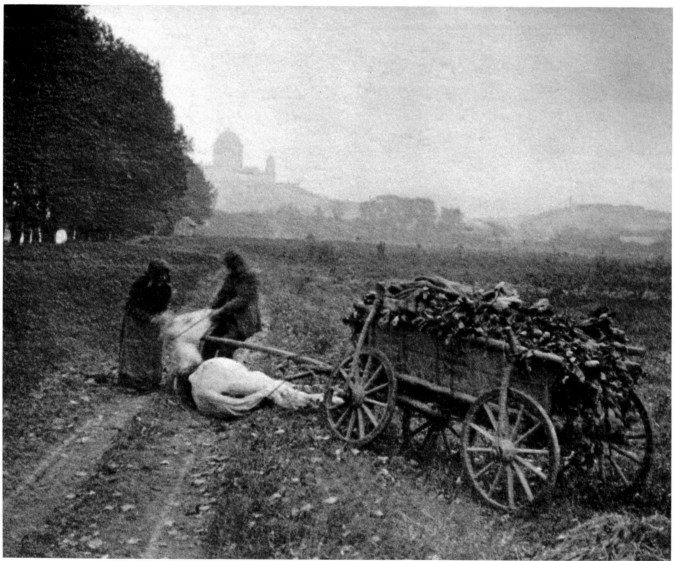

Heading for Esztergom, 1916

*Total grayness deepens the mood of pathos
recorded in this glimpse of a peasant man and his
wife urging their fallen horse to its feet. The
buildings of the medieval town of Esztergom
appear as a faint curtain in the distance.*

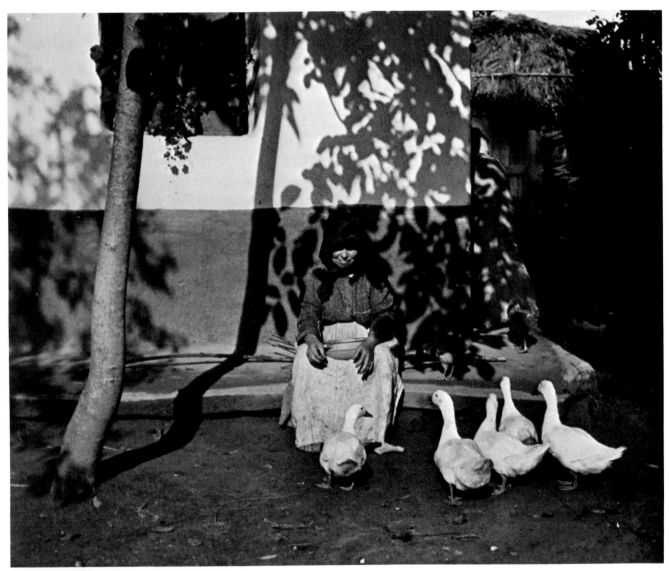

Peasant Woman, 1924

In this picture of a peasant woman amid a family of
ducks, the photographer noted a moment of
pastoral peace in the Hungarian countryside. The
sun is warm and the woman, dappled in shade,
smiles with an evident sense of well-being.

Paul Strand

A nomad woman of stern beauty faces the camera ▶
with dignity, conveying by her steady gaze and
serene composure the innate strength that Strand
found in human beings everywhere. Photographing
such a woman was in itself an achievement,
for her Muslim faith not only discourages social
exchange between women and strangers but
generally disapproves of posing for pictures.

"It is one thing to photograph people," Paul Strand once wrote, "it is another to make others care about them by revealing the core of their humanness." Strand himself was one who cared. He spent his career documenting the working people of many nations—and revealing in them the nobility that endures despite oppression.

His photographs achieve their power from a simplicity as unadorned as the subjects he chose. It was the product of slow and meticulous working methods; Strand sometimes took months getting to know a town and its inhabitants even before he unpacked his gear. The gear included large-format cameras and prisms he could attach to their lenses, allowing him to face a subject at right angles, thus going unnoticed as he worked. After his negatives were made, he often worked for days on the prints. By experimenting he achieved the balance of richness and delicacy that he deemed worthy of the people whose lives he recorded.

A tomb boldly painted with a symbolic mosque, which signifies that the deceased completed a pilgrimage to Mecca during his lifetime, documents an aspect of life in Upper Egypt, where people in the simplest village find esthetic expression in paying homage to their dead.

Tomb at Faiyum, Egypt, 1959

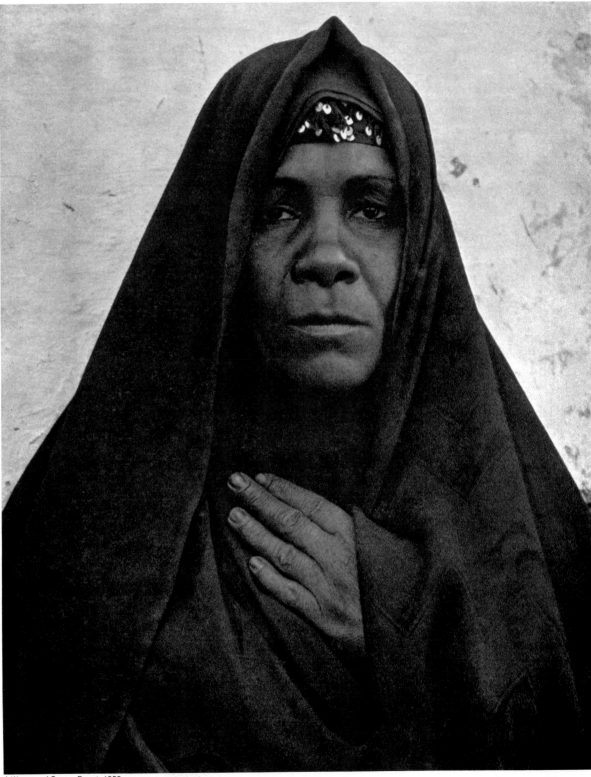

A Woman of Gurna, Egypt, 1959

Charkieh, Delta Region, 1959

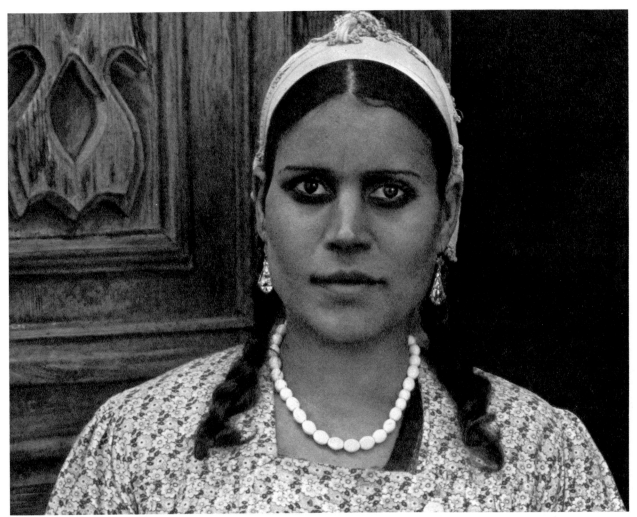

Galia Aitah, Woman of the Delta, 1959

◄ *Spindly eucalyptus trees tower above a cluster of sun-dried brick houses at Charkieh, built in the same way that Egyptians have constructed their dwellings since ancient times. It was not history that attracted the photographer, but rather remnants of the past that could be revealed in the life style of present-day Egyptian villagers.*

With glistening eyes ringed in kohl—a cosmetic older than Cleopatra—a young woman wears a traditional print dress with her glass earrings and bead necklace. Although the 1952 revolution gave Egyptian women considerable freedom to follow modern styles, most peasants, or fellahin, continue to dress as they have for centuries.

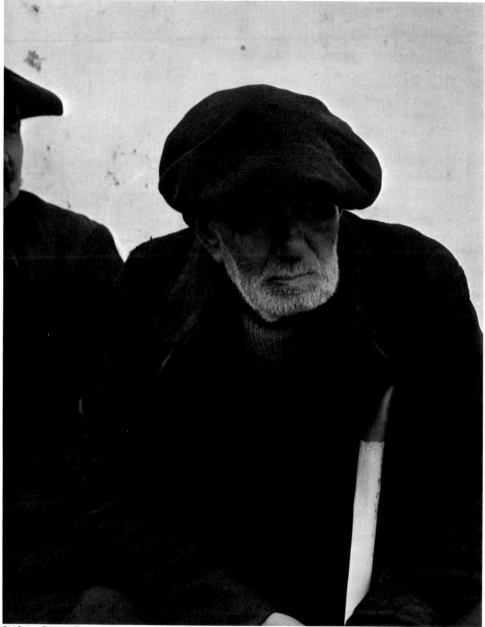

Old Sailor, Brittany, France, 1950

A retired fisherman, deprived by old age and failing vision of the dignity of his work, casts a vacant gaze beyond the camera toward the harbor from which he used to sail. The photographer returned to the site two years after recording this poignant scene—and found the grizzled sailor again seated on the same seaside bench, a living monument to the lassitude of old age.

A vineyard laborer in the Cognac district of ▶ France stands up to the camera with the serene gaze that comes from pride of workmanship —seemingly unconscious of the ironic contrast between his threadbare suit and the expensive liqueur his strong hands toil to help make.

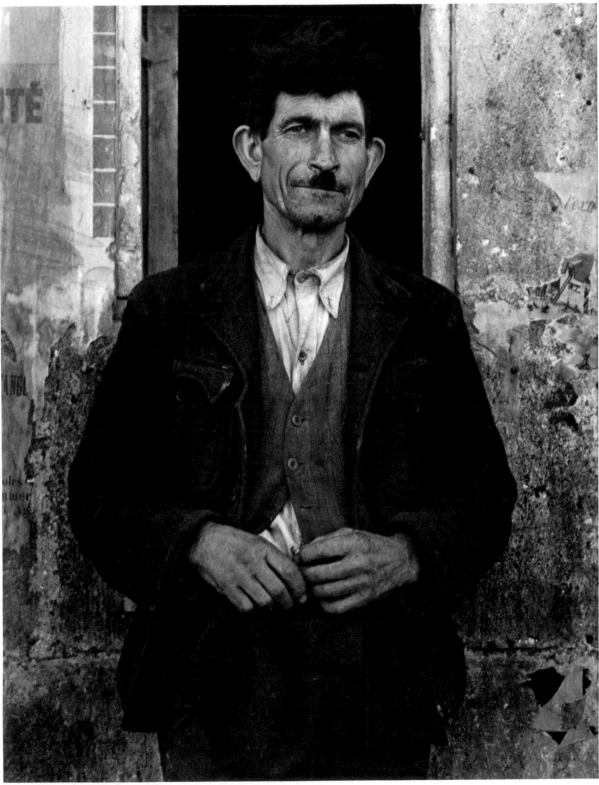

Vineyard Laborer, Gondeville, France, 1951

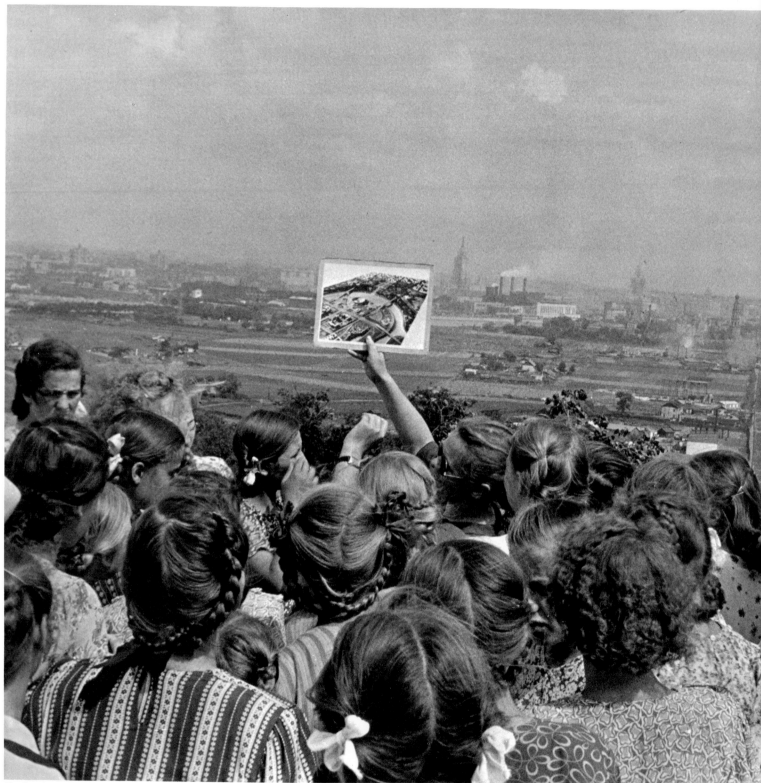

View from Lenin Hills, 1954
124

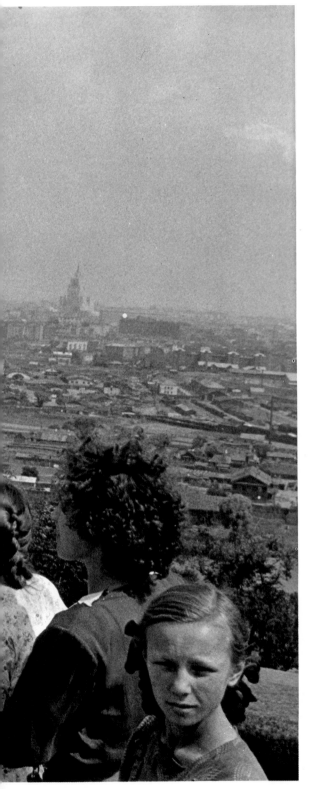

Soviet regulations prohibited the taking of "panoramic views of cities." But to Cartier-Bresson, the awesome expanse of Moscow could not be documented without one. A group of students atop Lenin Hills inadvertently obliged him: During an outdoor lecture, the instructor held up an aerial photograph of the Khamovniki quarter of the city for the students to compare with the view before them — an allowable picture that the photographer instantly snapped.

Henri Cartier-Bresson

Henri Cartier-Bresson may be the closest thing yet to a human camera. He sees with an eye that has, as he puts it, a built-in frame, "in slices of one-hundredth second . . . spinning films out of myself like a silkworm." His eye, hand, heart and camera are all linked into a single system, and he uses them to state a simple fact: This is how life appeared at that moment.

He believes that in every episode in life there is a time when all the elements align in a meaningful geometry, a pattern that tells all there is to tell about that episode. Sometimes the geometry lasts for only a fleeting instant; at other times, it occurs as part of a slowly shifting arrangement. In either case, Cartier-Bresson feels that it is his job as a documentary photographer to capture the scene. He must be the dispassionate observer, always ready to stop time at the precise moment when the picture is complete.

Cartier-Bresson is a tireless traveler, and his work has taken him from his native France to a dozen countries. In 1954 he went to Moscow for the first time, simply to photograph the Soviets in "every visible aspect of daily life." He spoke no Russian and had to rely on an interpreter, who often assisted by explaining the photographer's actions to skeptical bystanders. Official restrictions limited what he could record, and his informal methods were a distracting novelty to his subjects. Nevertheless, he returned to Paris with photographs for a book, *The People of Moscow*, bearing the appearance of effortlessness that earmarks his work. They make the viewer part of the Cartier-Bresson system, as if one had tiptoed around Moscow with him.

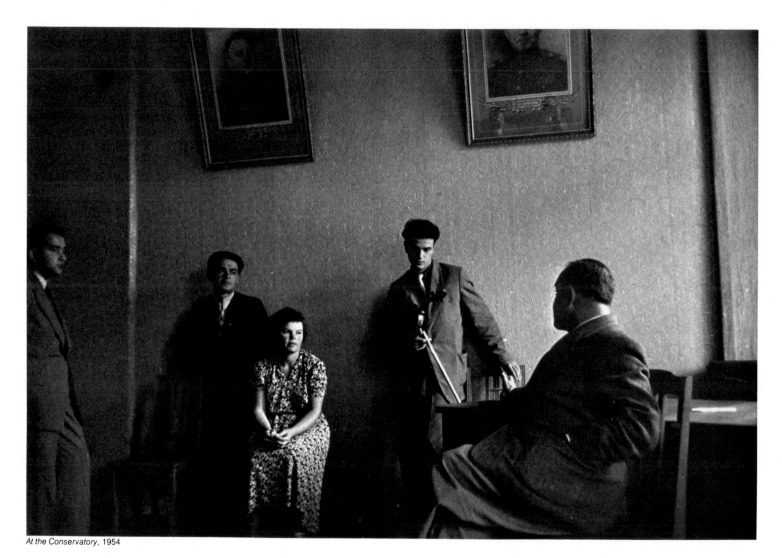

At the Conservatory, 1954

Moscow's cultural institutions —theaters,
museums, libraries and schools —fascinated
Cartier-Bresson, as did the pleasure the
Muscovites take in them. Besides photographing
people as they taught, studied and performed,
he sometimes came upon students and teachers
just relaxing together. An afternoon at the
Moscow Conservatory yielded this photograph of
music students as they chatted with virtuoso
violinist David Oistrakh after a vacation.

In the downward gaze of a truck assembly-line worker listening to a word of advice from a woman inspector, the photographer depicted a seriousness that is essential in the Soviet spirit. The scene is the ZIS factory, where trucks and luxury cars are made, and where Cartier-Bresson spent most of his time among the laborers, seeking to document the physical strength and dedication he admired in them.

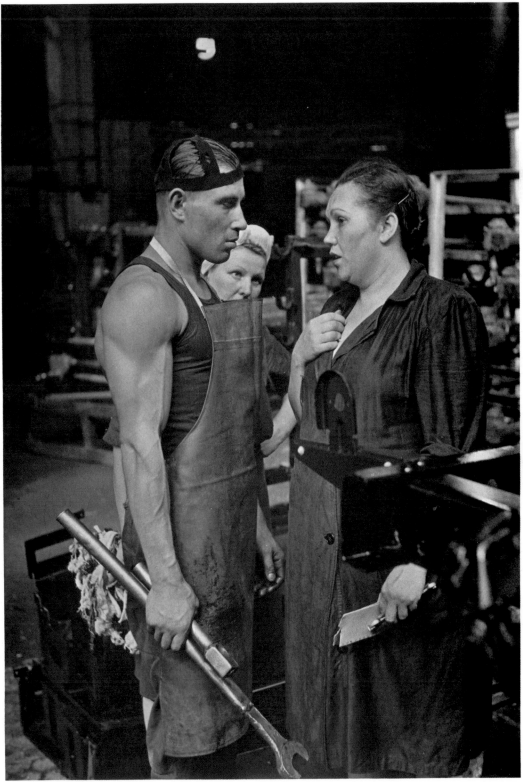

At the ZIS Factory, 1954

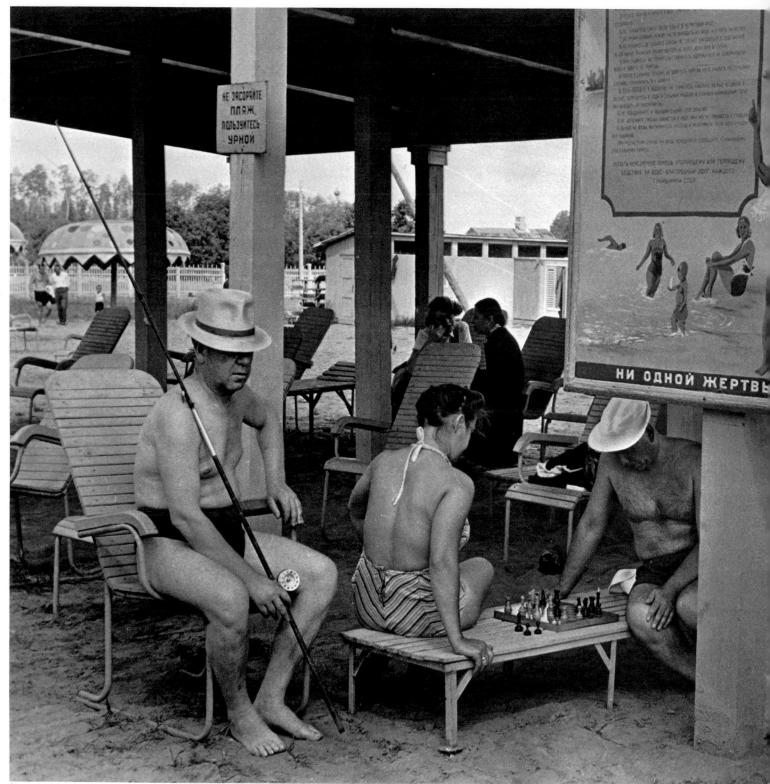

Beach outside Moscow, 1954

The beach at Silver Forest, in a Moscow suburb, is permeated in this picture by a mood of restrained relaxation — a restraint concentrated in the instant when hard furniture, hat angles, body postures and unsmiling faces combine to convey a certain stiffness. The photographer, who is known for his pictures of the more ebullient relaxation of his fellow Frenchmen, noted that the mood here "always remains quiet and decent."

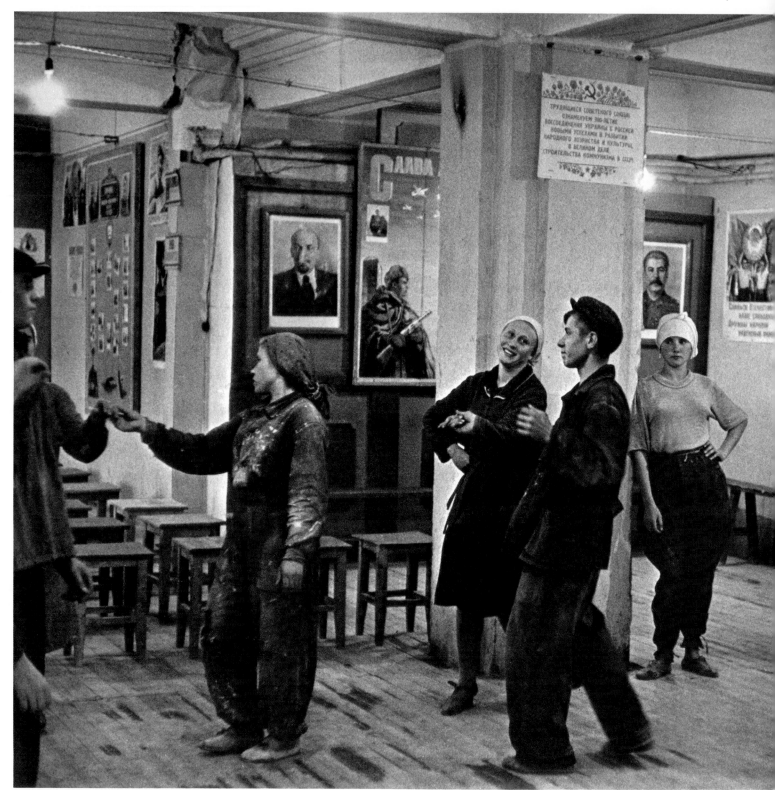

Lunch Break, 1954

In an apartment building still under construction, the lively sound of accordion music led the photographer to an unfinished flat that the construction workers —male and female—had converted into a temporary clubhouse. On its walls were the standard Soviet décor: portraits of Lenin and Stalin, an honor roll of the best workers, messages exhorting increased production. But the workers seemed to take little note of these official encouragements; their lunch hour provided time for an impromptu dance, savored by participants and onlookers alike.

Dorothea Lange

Before she accompanied her husband, economist Paul S. Taylor, on a journey throughout Asia in 1958 when he was a government consultant on community development, Dorothea Lange had devoted most of her career to documenting America. She was fearful of entering, let alone photographing, an unknown land so remote from her own. But the photographs she brought home show that the Orient did not confound her. She found in Asian faces and attitudes a reflection of some of the human qualities she had always prized the most, and these she documented. A barefoot monk's stance, in her viewfinder, became a symbol of elemental grace.

Yet when another trip abroad came up four years later, in 1962, and she prepared to go to Egypt with her husband, Lange again felt the same reluctance. She wrote to a friend, ''I go because Paul's work takes him there. For my own work I would choose to remain in my own country.'' She was ill when they departed (she died two years later of cancer), but modern, Muslim Egypt captivated her, as the world around her always had, and it raised her above her fears. The people she saw were no antiques but were active, living in the present. And Lange photographed them that way: not as relics from the past, but as proud bearers of ancient tradition.

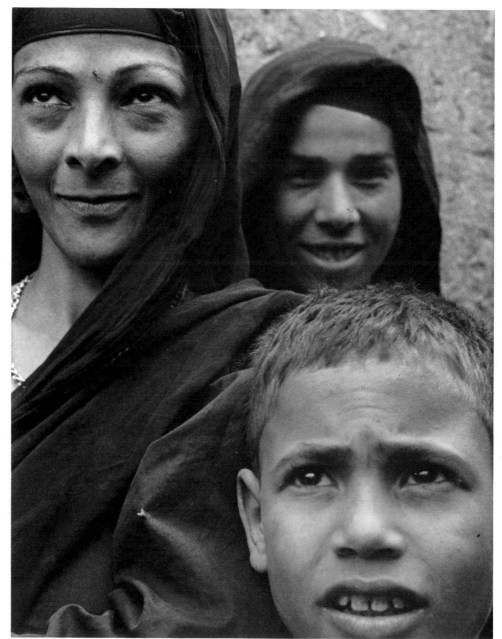

Egyptian Villagers, 1963

Dorothea Lange walked through villages seeking to photograph individual people close up, but her American features and her camera made such an unfamiliar sight that villagers jostled and crowded around her. So she often took pictures of groups like this trio, recording the warm curiosity that welcomed her wherever she went.

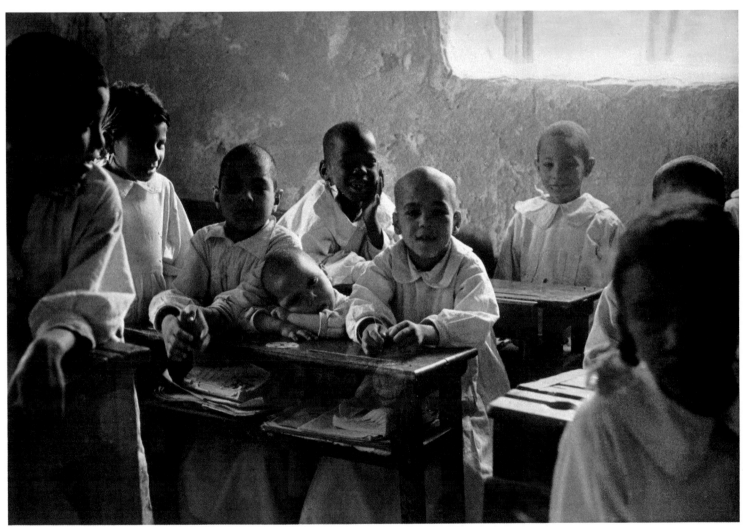

Classroom, Egypt, 1963

Fascinated by the newness of a foreigner—and a photographer, at that—these schoolchildren erupted with delight when Lange entered their classroom. Choirboy uniforms and cropped hair were unable to disguise their impish ebullience. Like kids anywhere, they wanted to be in on the action—and to get in the picture.

Feet of Monk, Burma, 1958

134

◀ *The stance of a Buddhist monk conveys the grace that, to many Westerners, is a notable trait of Orientals. This natural elegance is shown not with a full portrait of the holy man and his face but simply with a study of his feet.*

The wiry figure of this Egyptian farmer was emphasized by outlining him against the stark, cloudless sky. His well-worn workbasket and sinewy legs help to document the hard life of the fellahin in the Nile River region.

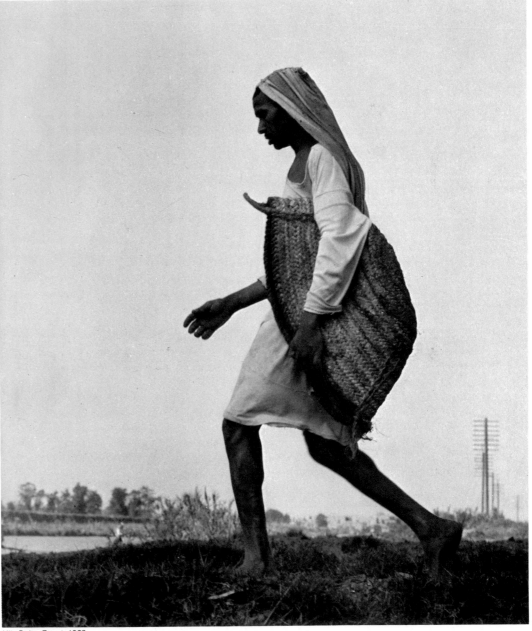

Nile Delta, Egypt, 1963

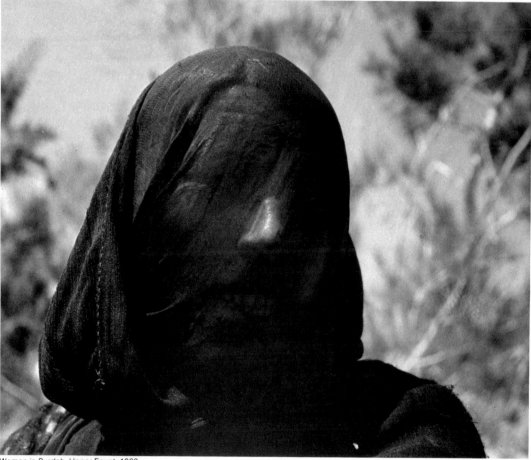

Woman in Purdah, Upper Egypt, 1963

An Egyptian woman, behind a traditional Muslim veil, presents a shadowy, mysterious visage to the camera. Her hidden expression reflects the photographer's own quandary: Egypt was a strange land where an unknown language was spoken and unfamiliar traditions observed. The veil represents the obscurity through which the face of modern Egypt had to be perceived.

Led by a gay, dancing child, a procession of ▶ village women and children carry baskets of food to graves in honor of the dead. The ritual, which has survived 5,000 years of history, dramatizes the continuity between modern, Muslim Egypt and the enduring traditions of ancient times.

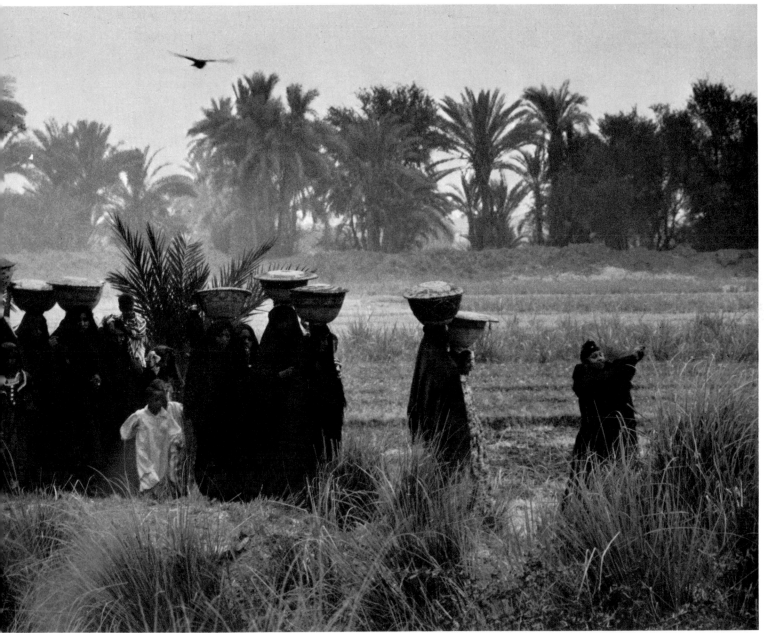

Bearing Food to the Dead, Upper Egypt, 1963

Man of Mercy, 1954

Fawn, Africa, 1954

◀ *Both gentleness and intense determination mark this revealing portrait of a Smith hero — Albert Schweitzer, the missionary doctor who won the Nobel Peace Prize in 1952. The photographer spent five days and nights in the darkroom to achieve the dramatic contrasts and subtle details of this picture.*

Smith once remarked that visitors to Albert Schweitzer's medical colony in Lambaréné were never sure "whether it is an African village, a game preserve or a medical hospital." He surmised that "it is the sum of all three," and showed that sum in his pictures. The gentle-eyed fawn was a respected member of the community as were its human citizens, including the German doctor who headed it.

Looking back decades after the close of World War II, W. Eugene Smith regarded his shattering photographs of that global conflict as a failure: They had not caused war to be abolished for all time. His bitter feeling of defeat in an impossible task indicates the high goals this emotional documentarian always set for himself. Throughout his career, Smith poured his soul into his work in the hope of persuading those who viewed his photographs that wars and cruelty must come to an end, that respect and tenderness are due all living creatures.

Few viewers share Smith's conviction that he failed. The depth of feeling his photographs evoke is expressed in a letter he got after the War from a Japanese who had recently seen one of Smith's pictures: "Please kindly accept pleasure I find of photograph. I see it first time. I hold it and see it until tears are make in my eyes. It was very beautiful photograph. I sorry, which we did."

139

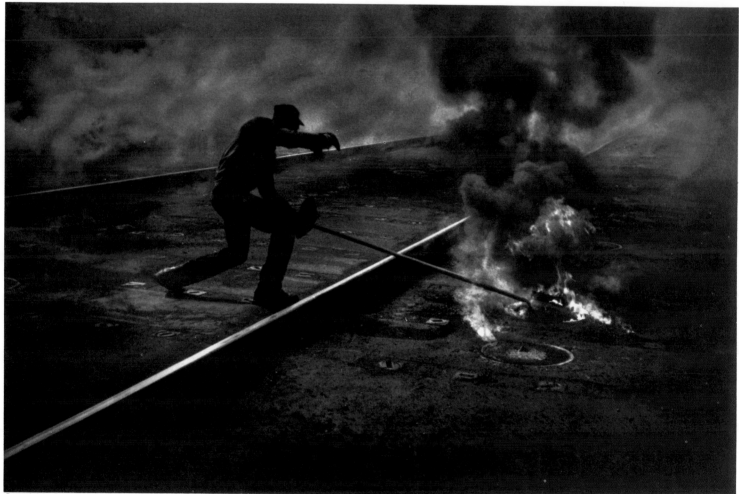

Dance of the Flaming Coke, 1956

A steelworker gracefully coaxes flaming coal into an underground furnace, where temperatures up to 2,000° will convert it into the coke used to process iron ore. This photograph was part of an exhaustive picture story that documented every aspect of life and work in Pittsburgh.

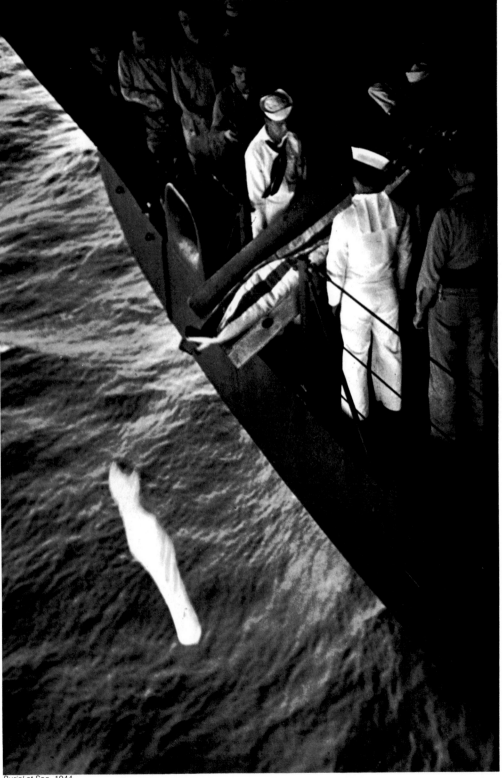

A sailor, casualty of a raid on Kwajalein atoll in World War II, is sent to his final rest in the Pacific off the deck of the aircraft carrier Bunker Hill. With such emotion-charged pictures, Smith eloquently pleaded for an end to the evils of war. He got his photographs at great personal risk. He spent most of the War covering the fighting — and two years recuperating from a severe shell wound he received on Okinawa.

Burial at Sea, 1944

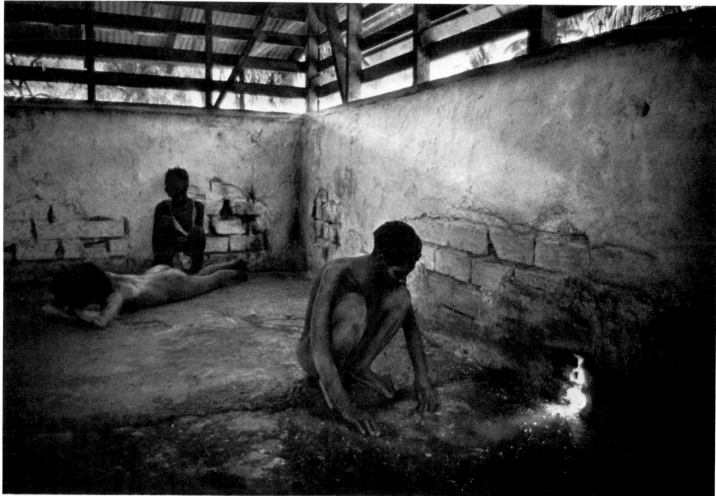

Pont Bedeau Hospital, 1958

*Patients at a Haitian mental hospital languish,
unclothed, in a bare shed with dirt floors. It seems
that society has simply penned them up where
they will be out of sight. But this revelation
of their misery, once seen, cannot be dismissed.*

For days, the photographer followed Dr. Ernest Guy Ceriani on his rounds in Kremmling, Colorado, for the famous Country Doctor essay that appeared in Life. The story reaches a climax with the poignant picture at right of Dr. Ceriani, who has just stitched the forehead of a child injured by a kick from a horse. Weary and deep in thought, he is searching for a way of telling her parents that she probably will lose the sight of one eye. An amputation, a birth and a death were part of the doctor's day; his selflessness is captured in every picture of the essay.

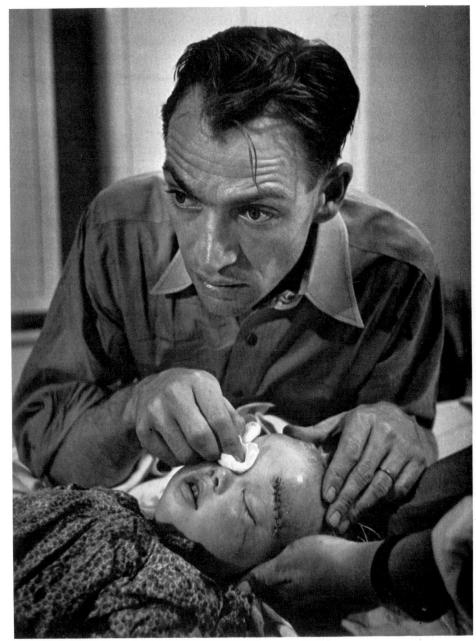

Country Doctor, 1948

Martine Franck

New York City, 1979

During her travels for a Paris news agency, French photographer Martine Franck noticed differences in the ways people grow old in different parts of the world. They both intrigued and distressed her. The confident, respected elders she saw in the East continued to live at the center of their families. But in France and other Western countries the old were often victims of what she calls "segregation by generation"—an "artificial cutting up by ages" that leaves them virtual outcasts, consigned to state institutions.

Only rural residents seemed to escape the sentence, commonly living at home and tending to their chores as always. For the industrial or office worker, Franck notes, retirement arrives "with a tap on the shoulder, a thank you for services rendered, and a passport to the land of old age." For Western women, who typically outlive their husbands, a worse retirement begins when they are widowed.

Franck has been photographing the world's elderly for six years—recording not only their status but also their feelings about growing old, which ranged from disgust to hope to blank indifference. "I looked for a theme in which everybody would feel implicated," she writes. "In fact, I noticed that most people prefer to pass old age by with an embarrassed silence, or to dodge it with witticisms."

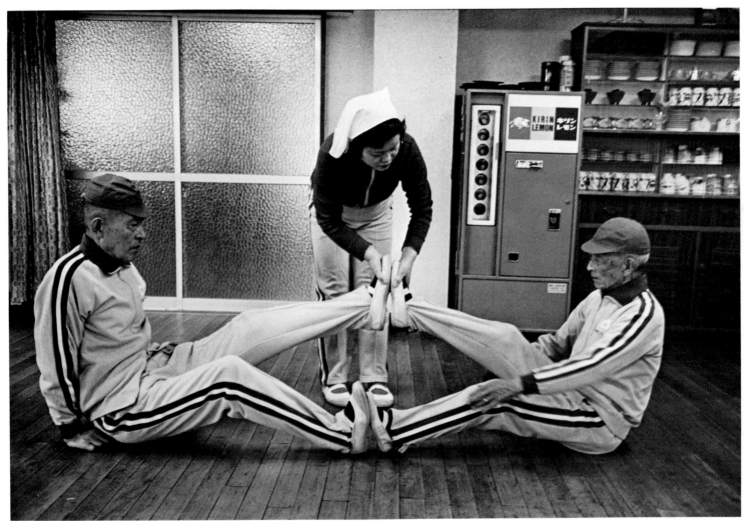

Near Tokyo, Japan, 1978

◄ *Their expressions somber, almost grim, two women walk past bowls of soup in the cafeteria line of a Salvation Army residence in New York City. This modern shelter, noted Martine Franck, encouraged self-sufficiency and was run more like an apartment building or a hotel than a nursing home.*

At a home near Tokyo, an aide coaches two men through a gymnastic exercise, one of a series of daily activities designed to keep the well-to-do residents physically and mentally fit. Nursing homes like this are still rare in Japan, where custom usually dictates that the elderly reside with their families.

Nanterre, France, 1978

*"It was shocking to see the lack of communication
between people whose paths cross without their
ever meeting,"* Martine Franck *wrote of the French
state-run institution where she took this photograph.
The three women seem to exist within tiny pockets of
isolation, a condition Franck found typical of the
home's 4,800 residents, who were segregated by
sex even in the gardens and recreation areas.*

Lauenen, Switzerland, 1979

A Swiss farmer basks in the sun on the porch of the weathered-timber lodge where he lives with his family. Although crippled and dependent for mobility upon the crutches leaning next to him, this patriarch still contributes his share to the upkeep of the farm by tending the poultry yard, one of whose denizens struts by at lower right.

Paris, 1979

*Before the start of a race through the Bois de
Boulogne in Paris, a hardy and cheerful group of
senior runners gather to be photographed with
No. 374, a perennial entrant who, at the age of 80,
was the oldest participant in the event.
Sponsored by the French newspaper Le Figaro,
the annual contest is open to all, with special
categories for young and old alike.*

Near Xian, China, 1980

Although blindness now prevents her from seeing it, a 98-year-old woman keeps a picture of her deceased husband on the wall of the living quarters she shares with her son's family on a commune in central China. The woman was too weak to get out of bed without great difficulty — a cane rests nearby to help her — but Franck reports that she was completely lucid.

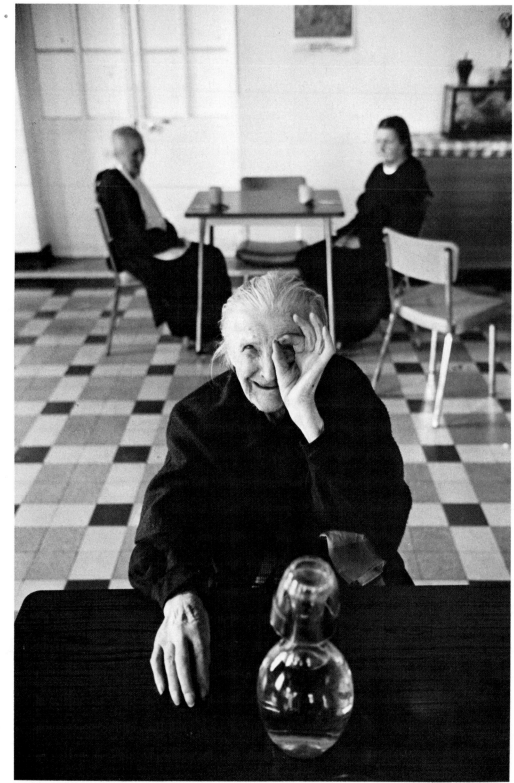

In the dining room of a state-run nursing home in a Paris suburb, a woman resident takes intense, almost childlike delight in imitating Martine Franck looking through the viewfinder of her camera. "She questioned me for a long time about what I was doing and why I was photographing her," says Franck. "Then, all of a sudden, she lost interest and wanted to talk about herself."

Ivry, France, 1975

Critics of Complacency **5**

ROBERT FRANK: *Convention Hall, Chicago*, 1956

Uncovering the Wasteland of Affluence

In a landmark book on economics in 1958, Harvard professor John Kenneth Galbraith reported on a radical change in income among Americans. In the wartime and postwar decade ending in 1950, the poorest fifth of United States families had increased their real income by 42 per cent. The income of the next-to-bottom fifth had grown by 37 per cent. Families in the middle fifth of the population were making 24 per cent more money. Some of the gains, but not many, had been won at the expense of those at the top of the heap of American society. Except for pockets of "insular poverty" in areas like Appalachia and among minorities, said Galbraith in *The Affluent Society,* Americans in general had become—without anybody's realizing it—well off.

This revolution on the economic landscape doubtless helped to account for a revolutionary change in the viewpoint of photographers documenting the country's social landscape. From the time of Jacob Riis, concerned photographers had used their cameras as trumpets to sound a call for action against society's ills. Their pictures, realistically grimy, had first rallied the public to war on poverty and all its ugly consequences—slums, child labor, sharecropping, sweatshops. Later photographers had an even more ambitious goal: to combat through their pictures deficiencies in the ethical as well as the physical condition of mankind, not only in the United States but all over the world. In the view of John Szarkowski, director of photography at The Museum of Modern Art, all these documentarians aimed "to show what was wrong with the world and to persuade their fellows to take action to make it right." But by the 1950s a different attitude had begun to appear among documentary photographers. They looked at the fabric of the affluent society, and although they found it full of holes, they concluded that it was not up to them to mend it.

In the vanguard of this new generation of photographers was the Swiss-born Robert Frank. Like him, Lee Friedlander, George Gardner, Garry Winogrand and Diane Arbus have each recorded a distinctive vision of the world. In common, however, they felt bound by no mission whatever except to see life clearly; they set out not to reform the world but merely to know and reflect it. Winogrand could have been speaking for the entire group when he said, "I don't have messages in my pictures. . . . The true business of photography is to capture a bit of reality (whatever that is) on film."

Explaining these people's refusal to act as reformers, critic Alan Trachtenberg wrote in *The Nation:* "These young photographers propose, with very rapid cameras, to present a view from within. There is no effort to judge but instead to express. The snapshot or the passing glimpse seems the appropriate vehicle for a society which has lost a sense of whole relationships. Many of the glimpses . . . show man-made but uninhabited landscapes; emptiness conveys the leading feeling of social desolation. The anatomy is

exposed cold-heartedly. Apathy, loneliness, anomie are not simply reflected but ingrained in the chrome and Formica and plate-glass surfaces which carry their distortions to the eye . . . mordant celebrations of a plastic environment. Glutted with artifacts, with artificialities, this social landscape suffocates. The word 'social' itself becomes a bitter joke. Many of these pictures leave the feelings paralyzed, gripped in fear and mystification.''

Along with intent, technique also changed. Though Diane Arbus worked slowly and deliberately, Frank, Winogrand, Gardner and Friedlander are all fast shooters, snapping away without premeditation. It is not that they do not think as they work; rather they have speeded up their thought processes to make the act reflexive, shooting what they see before the conscious mind has time to analyze or rearrange it.

The pictures in this chapter—from Robert Frank's cynical look at some politicians on the previous page to Diane Arbus' peek into a living room all ready for Christmas *(page 197)*—simply argue that in the affluent society something is awry. If they have a hint of a prescription for curing social ills, it is no more than the straightforward notion that the solution to any problem begins with seeing it clearly. Such a coldly clear look is often disturbing, telling us things about ourselves we would rather not know, and these pictures are more likely to be provocative than pleasurable.

In defense of this kind of work Frank has said: "I have been frequently accused of deliberately twisting subject matter to my point of view. Above all, I know that life for a photographer cannot be a matter of indifference. Opinion often consists of a kind of criticism. But criticism can come out of love. It is important to see what is invisible to others—perhaps the look of hope or the look of sadness. Also, it is always the instantaneous reaction to *oneself* that produces a photograph.''

Robert Frank

Robert Frank flared across the horizon of photography like a comet. He became something of a celebrity in 1959, and by 1962 had stopped making still pictures. But behind him he left what is generally regarded as the best single volume of contemporary United States documentary photography; his pictures still astonish his peers.

Frank turned to serious photography in Switzerland at the age of 18, and when he immigrated to America five years later he had already won some recognition for his work, which was basically European and sentimental. In the United States he did a stint of fashion work at *Harper's Bazaar,* and then in 1955 became the first European to win a Guggenheim Fellowship in photography. He promptly bought a secondhand Ford and set out to document his adopted nation.

After 10,000 miles of travel, Frank assembled 83 of his pictures in a book he called *The Americans* — and could find no publisher. "It was scrofulous stuff," says John Szarkowski of The Museum of Modern Art, "those lunch counters, those bus depots and those plastic booths and those nickelodeons! The book challenged the way Americans were supposed to look. . . . It was about whole segments of life that nobody had thought the proper concern of art."

Frank's pictures documented Americans as a remote, separated and alienated mass of human beings staring past each other. Frank was called a Communist — "a deliberate distortion," he says, "but you know how it was in the Fifties." He explains his dour documents by saying: "I had never traveled through the country. I saw something that was hidden and threatening. It is important to see what is invisible to others. You felt no tenderness."

Walker Evans was one of the few Americans to recognize the value of Frank's book. "It is a far cry from all the woolly, successful 'photo-sentiments' about human familyhood," he wrote. *The Americans* was finally published in 1958, not in the United States, however, but in Paris. "Only because the Paris publisher was a friend of mine," says Frank. A quantity of French-language copies was sold in the United States, but that edition was soon remaindered.

Yet the word slowly spread, and the book, out of print, became much sought after. In 1959, Grove Press issued the first United States edition; in 1969, Grossman Press reissued it. Noting this 10th anniversary, *Creative Camera* of London said it "must be the most famous photoessay ever produced."

But by then Frank had finished with still photography. In 1961 or 1962, he thinks, he lost his Leica — and did not mind at all. "Unless one becomes a commercial artist or a fashion photographer, making a living is almost impossible," he says. Today he makes his livelihood by teaching cinematography, some of which he does himself on a noncommercial basis. But as for the documentary photograph, he explains, "I had done it. I had made a book without interference. At best, to go on would have been a repetition."

Trolley, New Orleans, 1955

"A streetcar goes by on a main street, maybe Bourbon Street, in New Orleans," Frank remembers, "and there are people looking out at something. I wasn't thinking about segregation when I shot it. But I did feel that the black people [in the back of the bus] were more dignified."

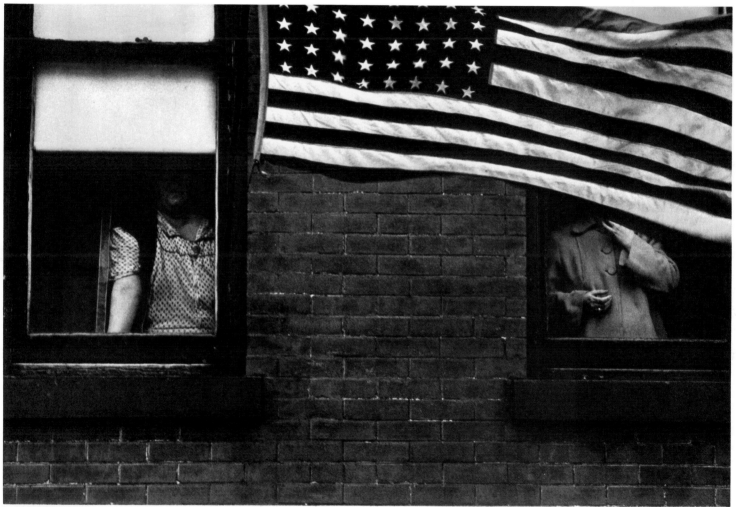

Parade, Hoboken, 1955

*In 1955, when Hoboken, New Jersey, celebrated
its 100th anniversary, Frank happened to be there
visiting a friend. "This is a picture of two people
who were standing behind one of the flags, behind
glass and in shadows. They're sort of hiding." To
the photographer, it is "a threatening picture."*

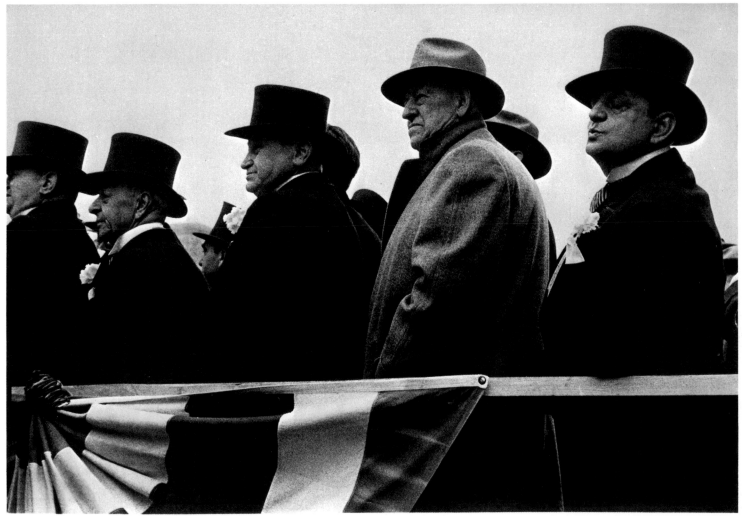

City Fathers, Hoboken, 1955

The day of the Hoboken centennial was cold, but
most local political leaders, watching the end of
the parade from a wooden reviewing stand, turned
out in formal finery despite the weather. It was no
accident, wrote photographer Walker Evans,
"that Frank snapped just as those politicians in
high silk hats were exuding the utmost fatuity. . . .
Such strikes are not purely fortuitous. They
happen consistently for expert practitioners."

159

Saint Francis, Gas Station and Hall of Justice, Los Angeles, 1956

*With cross held aloft, a statue of Saint Francis
seems almost defiantly to confront the Los
Angeles County Hall of Justice. "What moved
me," Frank says, "was that, against the
background of that hideous city building, there
was the little vase with a flower. The combination
of that big gray block of cement and those
recurring images of gas stations and the flower. . . ."*

Charleston, South Carolina, 1955

"It was the first time I was in the South," the
photographer remembers, *"and the first time I
really saw segregation. I found it extraordinary
that whites would give their children to black
women when they wouldn't allow the women to
sit by them in the drugstore. I did very few
pictures that made a political point like this."*

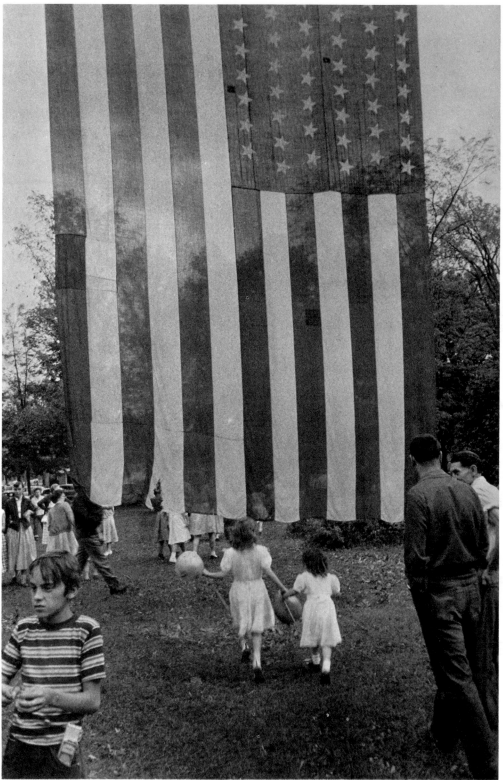

Here is the Fourth of July pretty much as it is supposed to be: the Stars and Stripes bigger than life, floating over a busy scene of people walking about, children on the move, a whole community buzzing. But the flag is patched in several places, rent in another, its flimsy material almost ghostly; and of the few faces visible, none is smiling.

Fourth of July, Jay, New York, 1955

162

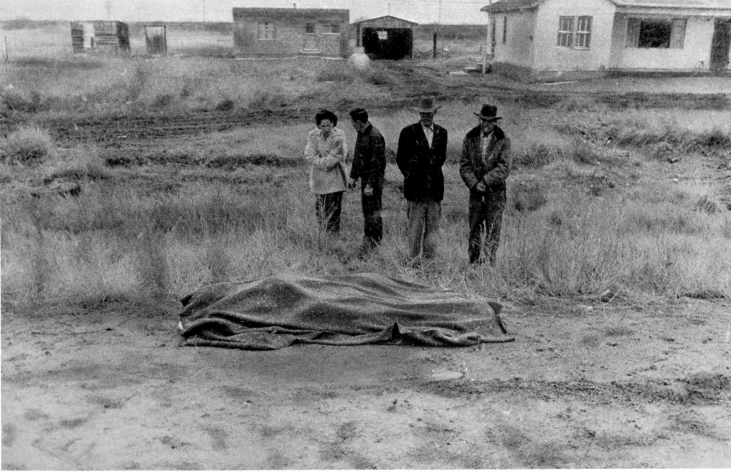

Accident on U.S. 66, Arizona, 1956

In the isolation of the Arizona desert, bypassed by the mainstream of American life, these Indians from a Navajo reservation see and hear the transcontinental traffic that roars past them on Route 66 — but rarely get more than a glimpse of the people in the speeding cars. Now sudden death on the highway has changed all that, depositing two of these remote people at their feet. Stolidly contemplating the two blanketed corpses from another world, the Indians are still as distant from that world as ever.

163

Ranch Market, Hollywood, 1956

The countergirl under the Christmas decoration has walled herself off from Christmas and from the world. A young woman in a lively setting, face to face with hungry people, she has hardened her eyes and frozen her pleasant features into a mask that sets her apart — and makes the picture a chilling record of one soul lost among many.

The girl in the foreground is a starlet come to a
movie première, to be seen by the crowd. She is at
a high point in her career, surrounded by fans,
yet a million miles away. Somehow she manages
to look at once impregnable and defenseless.

Movie Première, Hollywood, 1956

Lee Friedlander

Lee Friedlander's pictures show a distraught and frantic America. A busy street alongside a gas station seems fractionated, its bits and pieces separated and stirred up—hurrying cars, rearview mirror, overhead lights, parts of people. A photograph of a quiet wedding party is disturbed and distorted by a passing automobile; a Manhattan singles bar is cold and grim, a place to size up the lonely.

There is a brooding message of disorientation, of something having gone askew in these pictures. Yet Friedlander, whose camera sees this, is puzzled when anyone suggests that he has documented a sense of 20th Century unease. A rather boyish man born in 1934, friendly and unpretentious, he shrugs his shoulders and says he just likes to take pictures; whatever the viewer sees in them is his own business. "It fascinates me that there is a variety of feeling about what I do. I'm not a premeditative photographer," he says. "I see a picture and I make it. If I had a chance, I'd be out shooting all the time. You don't have to go looking for pictures. The material is generous. You go out and the pictures are staring at you." Often they stare at him through car windows, for many of his photographs are scenes he spots as he drives on a trip or simply while doing errands near home.

Friedlander literally walked into photography one day in his native Aberdeen, Washington. His father had sent him to a portrait studio to pick up some proofs; when no one answered his ring, he recalls, "I walked through the curtain and there was this old man putting paper into dark water. He didn't see me. As he put the paper in, people's faces

came out. It was the greatest trick." At 12, Friedlander got his first camera, an old folding model; and at 16, with high school finished, he went off to a Los Angeles photography school. By 1956 he was in New York doing record-album covers and other commercial work. A friend showed him books of photographs by the great documentarians Eugène Atget *(pages 36-42)* and Walker Evans *(pages 65-69)*. "Wow, it knocked me out," he says. "It was a revelation. Seeing Evans' and Atget's work and meeting Evans was a breakthrough for me. From that time on that's the tradition I worked in."

Friedlander makes his living with commercial work, but in his characteristically easy-going way he melds it into his more personal photography. "Commercial work takes me, like teaching, to where I can do my own work. Wherever I work commercially it is not going to take me where I don't want to be; it won't take me into a vacuum."

Friedlander talks casually and openly about his craft, but in his pictures the smiling easiness vanishes. Here is a world that is cold, angular, bleak and dry of spirit. "Little poems of hate . . . bitterly funny observations," wrote his mentor Walker Evans of one collection of his pictures. "An atmosphere of disquieting fatality," says another critic. Even Friedlander's representations of people in physical contact with each other *(pages 173-174)* are hard, tough and stubbornly unromantic. Despite his disclaimers of intent, his work reveals a photographer who is intellectually perceptive, a man with a strong view of the world that emerges intuitively, like a reflex, in the 1/100 second that it takes to snap the scene.

Hillcrest, New York, 1970

One winter day the photographer stopped his
pickup truck for gasoline about five miles from
New City in Rockland County, New York, where he
lives. *"It's a nothing, a couple of gas stations,
a shopping plaza, not many people, lots of cars.
I looked out and this is what I saw."* What
he saw he caught in his camera: a crazy-quilt
pattern of cars, signs and suburban clutter.

Friedlander, his wife and two children stopped in this California town early one morning on a vacation trip. "I always walk around and look around when we hit some town or city," he says. He spied a window with some pictures in it; the bottom one was of Marilyn Monroe. He took a photograph that shows his lone shadow looming ominously over the ambiguous window.

Monterey, California, 1970

Seattle, Washington, 1970

After a summer trip to Washington State, the Friedlander family headed south to Los Angeles where Lee was going to teach photography at the University of California. Before leaving they put up at a Seattle hotel. Early in the morning father and son went into the street for a walk. In the post-dawn light the boy stood on the street (left) looking at himself in a window. His father's picture, using the mirror image of himself, his son and the nearly empty street, catches visually the hush of a city before the morning rush.

169

Madison, Wisconsin, 1966

Friedlander believes that studio photographers'
windows tell a lot about a neighborhood. When he
looked at this window and saw his shadow on
a portrait he chuckled and snapped it. The result
memorializes a typical neighborhood portrait
studio—with the added intrusion of the visitor's
shadow. The picture is in a volume by Friedlander
called Self Portrait, containing 42 pictures,
each marked by his presence on the scene.

Atlantic City, New Jersey, 1966

The photographer was taking a picture of his wife
when something startled her. "The kids were
young then," he says, explaining her expression
to any parent; "maybe she was looking at them."
Mrs. Friedlander's taut face contrasts with the
joviality of the men in the blown-up picture in the
window behind her: in back, the self-conscious
smiles of men posing; in front, the unposed
look of a mother concerned about her children.

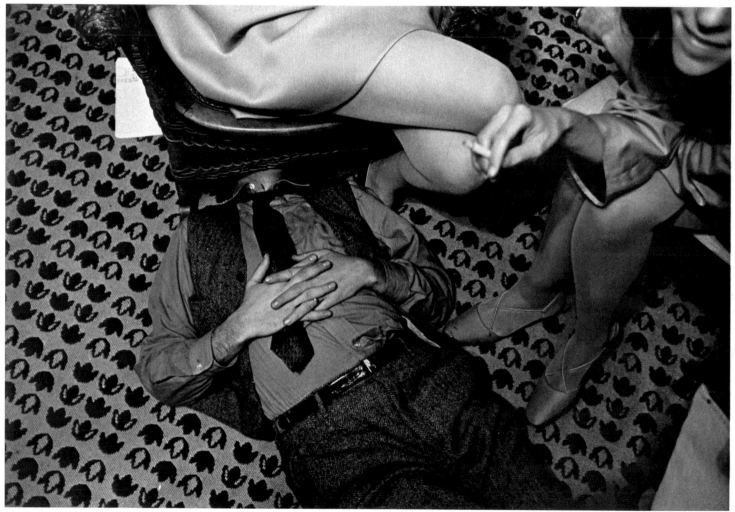

New York City, 1967

"This was made at a party following an old friend's wedding," the photographer explains (the friend was fellow photographer Garry Winogrand —pages 186-195). "It was a small party at his apartment and it lasted a couple of hours. I don't know who the man is who was lying down." But however unintentionally, Friedlander and his temporarily faceless subject document the tired frivolity into which parties often lapse.

"I went to a party with Ron Kitaj, the painter," says Friedlander. "He was teaching classes at the University of California at Los Angeles at the same time I was. He was a much more social guy, and I asked if he could take me to any parties I could photograph. I think the party was for the young man in the picture; I don't really know. I didn't know anybody there except Ron." Yet the photographer again recorded, through his nameless companions of the moment, the special quality of one kind of social gathering.

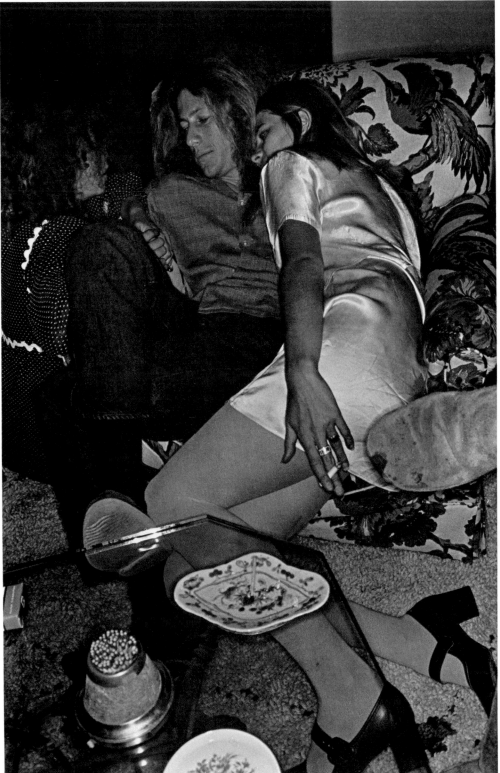

Los Angeles, 1970

173

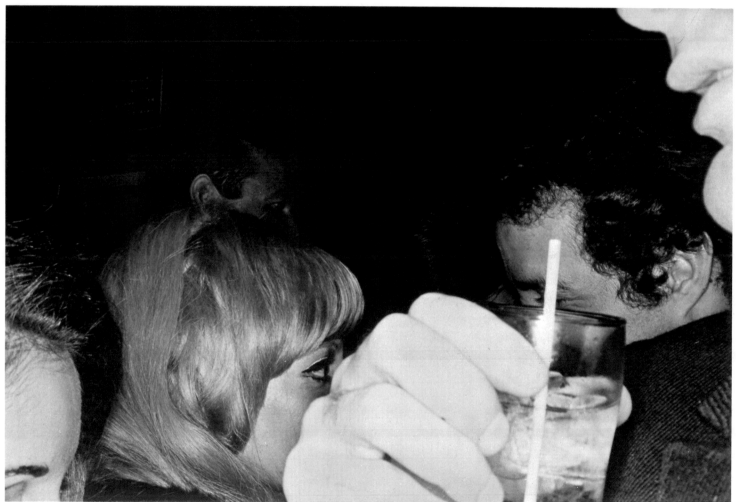

New York City, 1968

*Commissioned by a magazine to do a series of
photographs on Manhattan's singles bars, where
unattached people may become attached,
Friedlander went to four or five a night to get this
picture. He moved in on one packed crowd,
revealing in his close-up view the appraising eyes
behind the convivial, seemingly open-handed
gestures typical of these meeting places.*

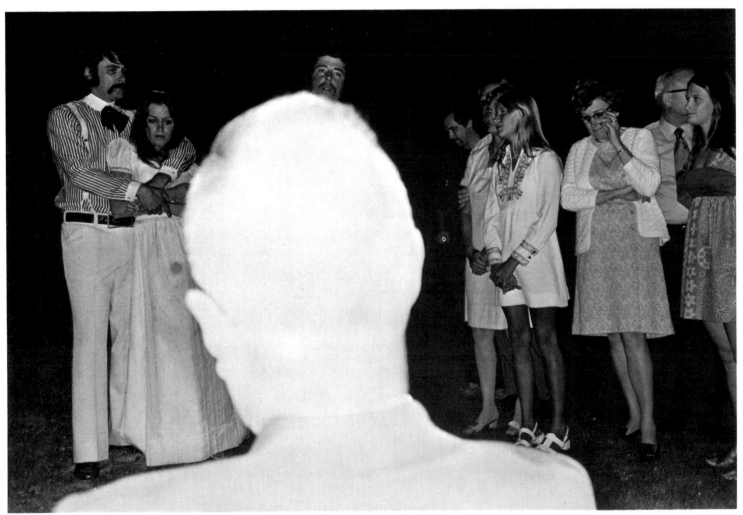

Glendale, California, 1970

While Friedlander was teaching at UCLA, he was
invited to a wedding by a friend of the groom. "I
took this picture while the wedding was going
on," he says. "The people looked serious
and thoughtful." In the split second recorded
here, shooting over the shoulder of a spectator,
he caught the solemnity that attends even an
informal, highly casual California wedding.

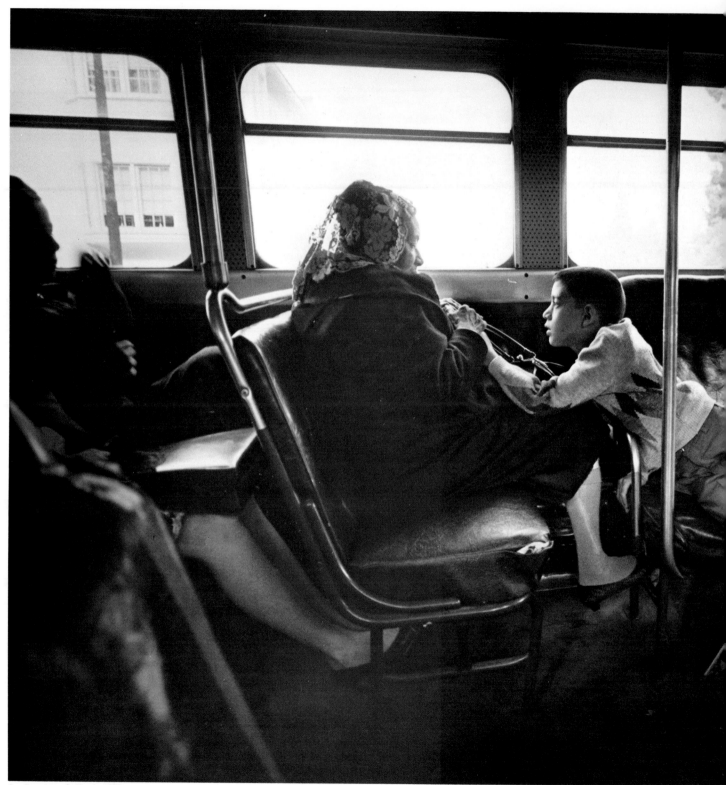

San Francisco, California, 1970

George Gardner

On a city bus in San Francisco, a woman
clutches the hand of a boy, probably her grandson,
as he leans toward her, rapt with attention.
Photographer George Gardner did not talk to the pair
or overhear their conversation—and in fact rarely
bothers his subjects. "I like to work simply," he says,
"with as few variables as possible."

Even among the wandering tribe of documentarians, George Gardner is remarkable for his restlessness. A friend once described him as "a gypsy photographer, roaring in and out of towns on his motorcycle, camera at the ready." Since 1970, he has been winging around the country in his single-engine airplane, logging upward of 40,000 miles a year in pursuit of his images.

The object of that incessant motion is, paradoxically, something stubbornly and quietly unmoved. Whether shooting the nearly deserted street of a farm town in Nebraska or a jammed parade route in lower Manhattan, Gardner searches for what he calls "real" people in the "quiet" section of society—"people that got left behind when everyone moved to suburbia and got jobs with IBM." And he renders them not as society's discards but with a portraitist's sympathy, their dignity fully intact.

Like his subjects, Gardner keeps well off the beaten corporate track. He lives on and runs a farm, using manual labor as a sort of restorative tonic for the travel and intense concentration required by his photography. He took to the camera in a roundabout way: While he was working as a trapper after high school, he decided it was easier to photograph animals than to catch them.

Animals soon led to people, the American people. "America is my place," explains Gardner. "Any place else, I'm just a tourist, I don't connect. In America, I feel as if I have some deep notion of what's going on. . . . I can *feel* this country." Then he adds a characteristic qualification: "But the connection between me and it is tenuous enough so that I really do have to pay attention. Otherwise, I will lose it. So I don't relax."

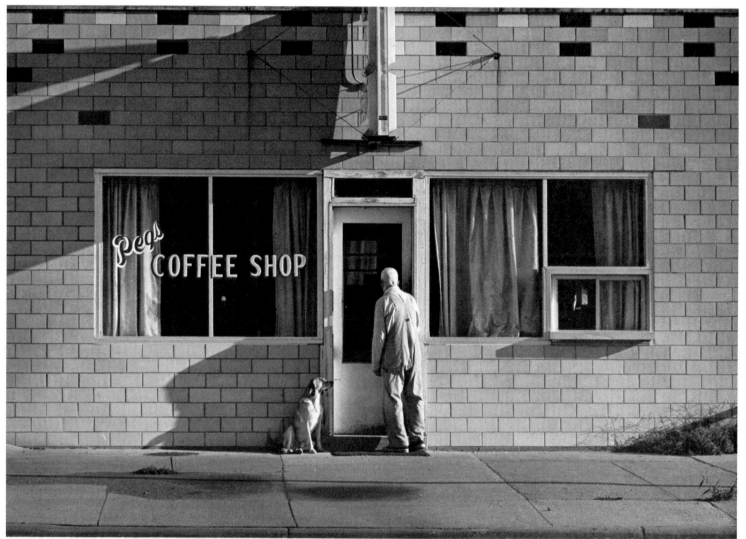

Blair, Nebraska, 1972

A man enters a café in a small town in the Missouri River valley. The dog sitting obediently beside the door suggests that the visit is a daily ritual. Gardner took the stark photograph while on a one-day assignment for the town's chamber of commerce.

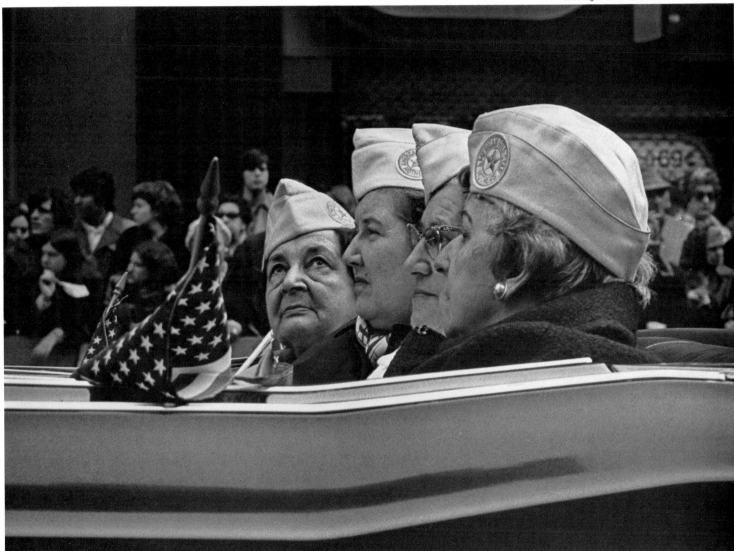

Parade, POWs' Return, New York City, 1973

Bothered more by the bulk than by the weight of his load, a man awkwardly carries a cage of rabbits across a parking lot in Upstate New York. George Gardner took this photograph at a weekly livestock auction near his farm, on which he —like the hefty man shown in the picture —raises rabbits.

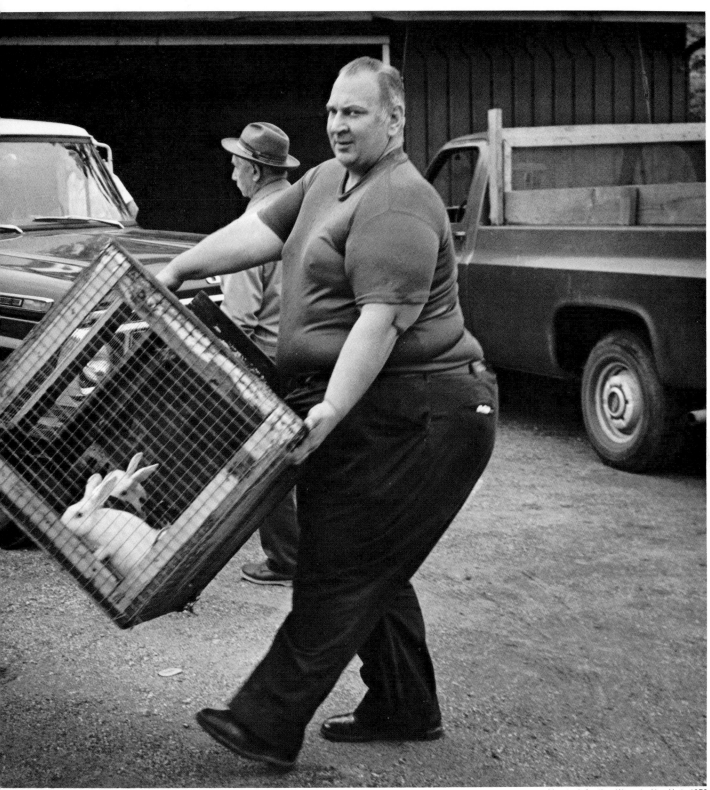

Livestock Auction, Wassaic, New York, 1976

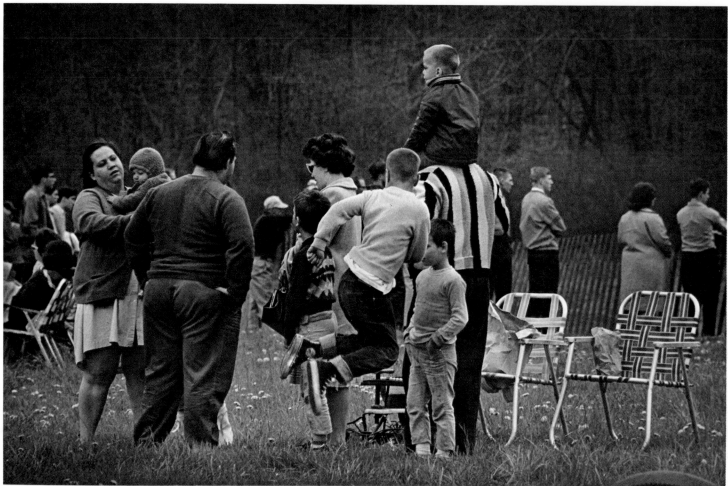

Motorcycle Race, Easton, Pennsylvania, 1966

At a motorcycle race in Pennsylvania, a leaping boy—stopped in midair—seems to ride an invisible bike of his own behind the backs of his earthbound family. George Gardner was himself touring by motorcycle when he stopped to observe this crowd. He offers only a deadpan explanation for how he captured the scene: "You aim the camera at something long enough," he says, "and one time out of a thousand something odd is going to happen."

Hands clasped as though in prayer, a private ▶ pilot perches on the edge of his seat as he ponders an oversized globe. Gardner caught this picture in an airfield lounge while he was waiting for the weather to clear for his first solo flight.

Joliet, Illinois, 1970

Staring blankly ahead, a young woman sits
bracketed by her elders in the lobby of an old
Hudson River railroad station. The high, Gothic
window, the drab interior and the single swordlike
ray of sunlight cleaving the bench add to the
faintly inquisitional tension surrounding the women.

A woman carries a fashion magazine (which in ▶
turn carries a glamorous model on its cover) on
the street of a small city in West Virginia. The
photograph sets up a series of ironic contrasts
between its two subjects—not only the obvious
contrasts of race and dress but also a humorous
one contained in the very different expressions
with which the women regard the camera.

Hudson, New York, 1978

Welch, West Virginia, 1968

Garry Winogrand

Garry Winogrand declares that he deals in the banal and the commonplace, using his camera simply to catch ordinary people doing ordinary things. Yet somehow an unsettling element of strangeness appears. Many of his pictures document paradoxical groupings, momentary encounters between people *(right),* animals in unusual contexts—scenes that force the viewer to think twice about what kind of reality they show him.

Winogrand came to his unconventional style by a fairly conventional route. A native of New York City, he bought his first camera when he was a weather forecaster in the Army Air Forces of World War II, and afterward studied painting at New York's City College and Columbia University on the GI Bill. He turned permanently to photographing because "there wasn't a lot of torturous work with the brush." He quickly became a craftsman well able to achieve the results asked by his clients, and made for himself a successful career as a commercial photographer. However, Winogrand's private work turned to ordinary happenings and ordinary people.

These he documents incessantly, his Leica clicking constantly—"the fastest gun in the East," as a contemporary remarks. "No one moment is most important," says Winogrand. "Any moment can be something." But he is very selective in the prints he makes from his rolls so that what the viewer gets to see is not a random moment of life but a view of humanity the way Winogrand sees it. The photographs emerge taut, full of little twists and confrontations, telling brief stories, often mysterious: three cowboys crouching near three bulls, each threesome uniform, contained and seemingly unaware of the other; a wide-eyed boy nose to nose with an elephant at the zoo; one dog leading another by a leash.

For such thought-provoking views of a world made up of dramas, confrontations and jokes, big and little, Winogrand adamantly refuses to supply any interpretations of his own. "The photo is a thing in itself," he says. "And that's what still photography is all about."

New York World's Fair, 1964

On a sunny afternoon at the New York World's Fair, eight people rest on a bench: a couple talking at left; next to them a closely linked trio of girls; then a pair of girls looking with interest at something outside the picture; finally an older man, oblivious of them all, reading his paper. The photographer is an observer unobserved, recording the cryptic unfinished stories that make up the reality of life.

Hollywood Boulevard, Los Angeles, 1969

Here is a typical Winogrand encounter—existing
not in the minds of its participants, but in the
eye of the photographer and his camera. Its
poignancy, as in the picture above, comes from
the deep gulf that lies between the close-together
people: in this case a helpless cripple shadowed
in his wheelchair and the three pretty, very
lively girls passing by in the bright sunlight.

Dallas, Texas, 1964

On a busy street corner during an American
Legion convention, a legless man crawls across
the pavement, begging alms. All around him are
healthy, prosperous Legionnaires. They are aware
of his presence, and they give him room, yet
everyone carefully ignores him. The picture raises
disturbing questions (did he and they share the
same war?), and in leaving them unanswered it
exposes some of the connections and separations
that tangle the threads of American society.

Bronx Zoo, New York, 1959

All this picture documents is the members of two species cautiously investigating each other — a boy with a handful of peanuts and a look of wonder, and an elephant with an appetite. But when it turned up on a contact sheet, the photograph fascinated the photographer. He took to frequenting zoos, and in the encounters he witnessed there he found striking revelations, like this one, of the funny and puzzling relationships among the creatures of the world.

A heroic, Texas-sized figure of a John Wayne-type cowboy dwarfs human visitors to the annual state fair in Dallas —and seems to cow them too.

Texas State Fair, 1964

Zoo, New York, 1962

*Many of Winogrand's pictures involve unusual
confrontations — often, but not always, between
people. This one depicts a three-way face-off
between humans and animals at the Bronx Zoo,
with all three couples apparently equally
intrigued by what goes on before their eyes.*

The Pet, 1962

The matter of relationships, which lies at the
core of so many Winogrand photographs, takes
on a different and humorous twist here as
applied to two dogs, one of which is inexplicably
but calmly leading the other by a leash.

Texas State Fair, 1964

*Roaming behind the scenes at a livestock show,
the photographer caught two trios juxtaposed as
though in a ballet. Three cowboys hunker in a row
while beyond them three Brahma bulls stand
upright, also in a row. Both groups manage to
ignore each other — and the picture comes
off as a satirical study in noncommunication.*

Albuquerque, New Mexico, 1958

A child stands in blazing sunlight, limned against the black void of a garage just off Route 66 in New Mexico. This black-and-white contrast is repeated by the ominous dark cloud looming out of the Sandia Mountains; the tiny human figure seems to set life against the blackness of death.

Diane Arbus

In 1962 the late Diane Arbus, a 39-year-old New Yorker, applied to the Guggenheim Foundation for a fellowship in photography. She was no run-of-the-mill applicant: Born to wealth in a department-store family, she grew up on Central Park West, had a governess, was privately educated, married at 18 and afterward collaborated with her husband, a fashion photographer. Neither was she a neophyte: Her words and pictures, including portraits of people in the news, had appeared in *Harper's Bazaar* and other magazines. Now she wanted to strike out for herself in work of a more serious nature.

"I want," she wrote the Guggenheim committee, "to photograph the considerable ceremonies of our present." In that category of subject matter she included anything that went on in "ceremonial places" (the beauty parlor, the funeral parlor, even people's parlors), as well as "ceremonies of competition" (contests and sports events) and "ceremonies of celebration" (conventions and pageants).

The Guggenheim committee agreed. Diane Arbus, armed with camera and black-and-white film, set out to document the commonplace, the taken-for-granted and the bypassed deviates or freaks of nature. To this human material, involved with ceremonies few thought ceremonial, she brought a wise child's eyes, a gentle manner and a steely persistence. Some of the remarkable pictures she took in the ensuing years appear on these pages. Time after time, the familiar looks unexpected and freakish when seen through her scathing eye, and the freakish looks unexpectedly familiar.

A short four years after getting the Guggenheim Fellowship (she received a second one in 1966), Diane Arbus was an acknowledged artistic success, sharing a major show at New York's Museum of Modern Art with Lee Friedlander and Garry Winogrand.

She usually worked in the manner of an old-fashioned portrait photographer, talking with her subjects earnestly and sympathetically, making pictures that were collaborations between the subjects and herself. For her camera no person was too ordinary—or too repugnant—to record. She painstakingly tracked down any subject that interested her—transvestites, suburbanites, dwarfs, prizewinners, twins, even nudists—working hard to document those aspects of mankind that most people overlook or look away from.

An immobile image of the lifeless quality of mechanically celebrated holidays, this acid photograph was taken at a suburban housing development on Long Island. The expensive furnishings and plentiful presents indicate the prosperity of the inhabitants, but the antiseptic arrangement suggests a spiritual coldness at odds with the open-hearted love and honor Christmas gifts should represent. For all the neatness of the room, the clocks do not agree.

Levittown, 1962

A low-angled close-up, harshly lit with a flash, this street shot shows the influence of news photography, which Diane Arbus greatly admired because she felt it was so factual. In her hands the journalistic technique achieved an honesty many levels higher than most news photographs attain, for the "reality" it discloses appears — as in this picture — to be put on, a mask for some deeper truth. "A photograph is a secret about a secret," she once wrote about such pictures. "The more it tells you the less you know."

Woman with a Veil on Fifth Avenue, 1968

An elegant coiffure and costume and a setting elaborately furnished with exotic objets d'art only accentuate the feeling that here something is awry. The appearance of a confident and well-ordered world is contradicted by the clutter at lower left — a contradiction reinforced by the subject's uneasy pose and strained expression.

Widow in Her Bedroom, New York City, 1963

The 79-year-old king and 72-year-old queen of a senior citizens' dance had never met before; their names had been picked out of a hat at a gathering of elderly people in New York City. They face the camera with a grimness that belies the festive nature of the affair they reign over.

The King and Queen of a Senior Citizens' Dance, 1970

Bedecked with symbols of superpatriotism, a young man waits to take his place in a win-the-war-in-Vietnam parade in Manhattan. His expression and his trappings are so very ordinary the viewer senses that he — and the celebration he is about to join — are not ordinary at all but manifestations of most unusual times.

Boy with a Straw Hat Waiting to March in a Pro-War Parade, 1967

Man Dancing with a Large Woman, 1967

This picture of a mismatched couple at a formal dance is another of Diane Arbus' documents of "ceremonies of our present." All uncover joylessness in what should be happy activities; here a man, peering over the shoulder of a partner half a head taller than he is, seems to be dancing not because he wants to but because it is a social duty. The question the photograph asks is, Why in the world should it be required?

Two youngsters have the ballroom floor to themselves after disposing of all competition to win a dance contest and the trophies at their feet. It is an occasion that seems to call for congratulations. But the children's expressions, smug beyond their years, make this picture a savage comment on a world that encourages childish mimicry of adult sophistication.

Junior Interstate Ballroom Dance Champions, Yonkers, New York, 1962

Identical Twins, Roselle, New Jersey, 1967

Cathleen (left) and Colleen were posed against a neutral background and placed within the frame so simply that the photograph resembles a snapshot. This casual treatment of what most people consider quite unusual — identical twins — was characteristic of the photographer's work: portraying the extraordinary as something perfectly ordinary and acceptable.

Penetrating Other People's Worlds 208

BRUNO BARBEY: *Silesian Miner*, 1981

Penetrating Other People's Worlds

Compared with the cool and sometimes cynical critics of the 1950s and 1960s, the seven documentarians in this chapter seem paragons of generosity, compassion, even affection. All documentary photographers strive to record the telling image and to convey it to the viewer clearly; so do these seven. But their eyes seem distinctly unjaundiced, their approach always sympathetic, their hearts worn—if not exactly on the sleeve—at least somewhere near the viewfinder. Not for them the ironic study of human foibles and pretensions: Their pictures show a passionate concern for the humanity of their subjects that reminds the viewer of the committed, inspirational photographers in Chapter 4—photographers like W. Eugene Smith *(pages 138-143),* Dorothea Lange *(pages 132-137)* and Henri Cartier-Bresson *(pages 124-131).*

Yet these new photographers are by no means copyists, aping the techniques and styles of distinguished mentors or each other. Their careers represent an almost incredible range of interests and projects. They have devoted themselves to everything from a portrait of Poland to a study of the milieu of Bombay prostitutes. Subjects in between include the Maasai of East Africa, severely disabled hospital patients, and Western cowboys. One photographer concentrated on her daughter, another on his Georgia neighbors. Each topic on this diverse list is demarcated by distinct bounds—limits of scope that the photographers imposed on themselves. The broadest picture essay is Bruno Barbey's look at Poland, photographed during six visits that took place from 1967 to 1981.

Yet even then, a close intimacy informs nearly all of Barbey's images, imposing a kind of emotional limit on the essay. It is almost as though he had photographed a family instead of a nation. In this, he was accurately reflecting the mood of the Poles themselves. His portrait on the preceding page of a Silesian miner—emblems of his union and church proudly pinned to his traditional garb—is especially revealing of the sense of national unity that the temporary success of the Solidarity labor movement and the elevation of a popular Polish prelate to the papacy gave all Poles.

For his portrait of cowboys, Bank Langmore drove thousands of miles back and forth across the American West. Yet he too imposed a definite limit: He refrained from shooting ranch activities not directly related to the horse-riding herdsmen who were his subjects. Other photographers held themselves to subjects who lived on a single, brothel-lined street, were confined to a particular hospital or belonged to a certain tribe. Overall, these seven documentarians convey the impression that the day of the sweeping statement is over, that limits allow a subject to be probed more fully and understood more intimately. "I am convinced that photography is capable of deeper penetration and more trenchant observation than the uses to which it has been put heretofore," notes Paul Kwilecki, who confines his work to his home county in Georgia.

Not surprisingly, a topic plumbed so thoroughly is usually one for which the photographer feels a special kinship. "They are the people we might have been or might one day become," says Patt Blue about her chronically disabled subjects. "I feel I am a mouthpiece, a voice for them." In a highly frank and direct manner, Blue continues the tradition of seeking reforms by calling attention to the patients' plight. But most of the other photographers simply feel a strong attraction, a special pull, to their subjects: They find them interesting and intriguing human beings, people they would like to show to the world. This is obviously true of Melissa Shook, who kept a record of her daughter's development from punctilious toddler to protesting teen. It is equally true of Mary Ellen Mark and the prostitutes she photographed on Bombay's infamous Falkland Road. Mark came to know, even to admire, the streetwalkers, brothel girls and madams as "very special women": survivors in a crowded and harsh environment who could be trusted implicitly (as their customers could not) with her camera equipment. Many of her subjects eventually became her friends—or became her subjects only after becoming her friends. She would, of course, like to see their lot improved, but she does not expect—and did not take—her pictures to accomplish that task.

Mary Ellen Mark normally works in black and white. Her reason for using color in the Falkland Road series was in the finest documentary tradition: "Color was such an important aspect of the women's lives," she says. "It was one of the few luxuries they had—their use of color in how they put on make-up and dressed." Black and white, she felt, would unduly emphasize the grimmer aspects of their lives. Color is coming to prominence in documentary work partly because of the superb sensitivity of modern color film, which can catch fleeting actions or peer into shadowy corners. But another reason—Mark's reason—is that more and more photographers realize that color is an integral part of their subjects, especially subjects that are being studied warmly and in depth. Color adds enormously to the vividness and intimacy of the viewer's experience. (Compare Bruno Barbey's shot of a folk painting on pages 212-213 with Paul Strand's on page 118.) Carol Beckwith, who trained as a painter, found it only natural to work in color when she did her study of the exotic and resplendent Maasai. "I couldn't possibly take the photographs in black and white and deprive the viewer of all that color," Beckwith says. She may be speaking here for an entire new generation of documentary photographers.

A Special Bond
Bruno Barbey

French photographer Bruno Barbey first saw Poland while covering a state visit by General Charles de Gaulle in 1967. Barbey was fascinated, and returned five times in the next 15 years, usually to cover major news events—the historic return of Pope John Paul II in 1979, the grassroots labor movement organized by Solidarity in 1981. But always Barbey had another, private purpose: to renew and expand his own acquaintance with the Poles themselves.

During his eight-month stay in 1981, Barbey captured the essence of Solidarity's challenge to the Communist regime, as witness the stunning shot at right of striking textile workers defiantly celebrating Mass behind the locked gates of their plant. "A page of history was being written," comments Barbey. Yet such powerful photojournalism is only one aspect of an intimate, warmly sympathetic portfolio that has as much to do with the everyday lives of an enduring people as with the cymbal-clash of great events.

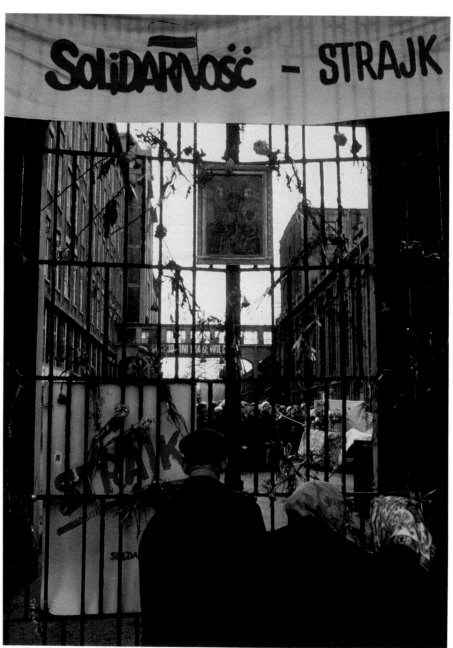

Passersby watch as striking workers celebrate Mass in the courtyard of their textile mill outside Warsaw. The factory gates are decorated with flowers, ribbons and Solidarity strike notices (all in red and white, the Polish national colors) as well as a portrait of the Black Madonna, Poland's beloved patroness. The 12,000 workers—most of them women—occupied the plant for three weeks in one of the country's longest and largest strikes.

Zyrardów, 1981

210

Gdansk, 1976

Café waitresses in the Baltic port of Gdansk, home of the shipyards where Solidarity began, look over a customer's check. Four out of five Polish women work outside the home, making up nearly half the nation's labor force; yet they must still clean, cook, and stand in ration lines to buy for their families.

White ducks waddle toward their owner as she touches up a festive folk painting on a thatched building in southern Poland. Fully one third of the Polish people live outside the cities, on farms and in the still-plentiful forests. For hundreds of years these rural Poles have decorated their barns and houses, inside as well as out, with floral and animal paintings. The custom faded away during the 19th Century, but began to revive when Poland regained its independence after World War I.

Zalipie, 1976

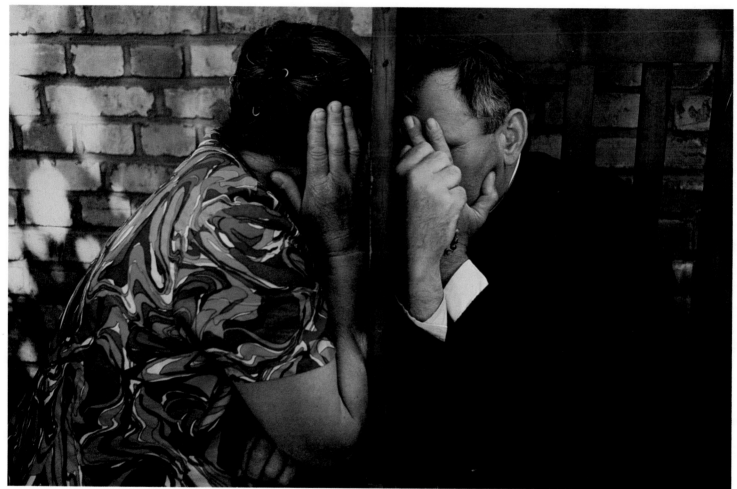

Czestochowa, 1979

*Concentrating on his sacred business, a priest at
a Pauline monastery in the shrine city of
Czestochowa hears a penitent's confession. On
religious holidays the pilgrims overwhelm the
available booths, forcing the clergy to conjure
the closed atmosphere of the confessional outdoors.
This picture was taken on a special holiday:
the first return home of the Polish Pope John Paul II.*

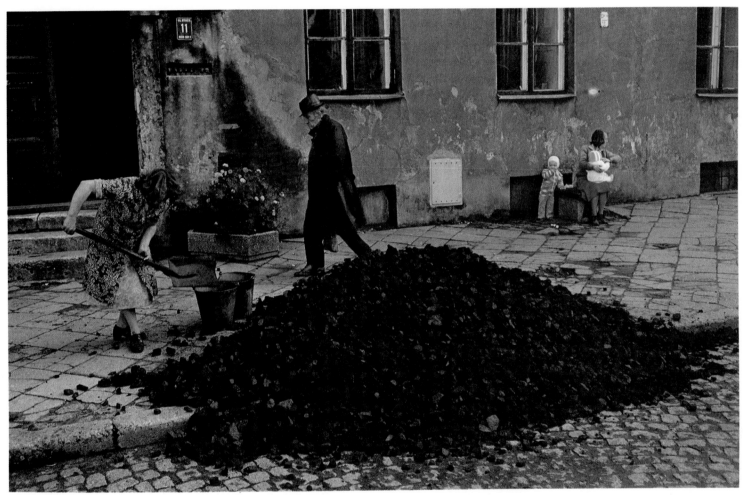

Chelmno, 1981

In the northern town of Chelmno a woman shovels coal into buckets to carry it to her bin. Poland is the world's fourth largest producer of coal, but most of the ore is reserved for export to the Soviet Union. Coal for household use is strictly rationed, and the winter's supply, delivered by horse-drawn carts, is simply dumped on the sidewalk in front of the house.

A Special Bond
Melissa Shook

Many parents keep photographic records of their growing children, proudly if somewhat haphazardly tracking their progress from diapers to degrees. However, photographer Melissa Shook found herself consumed with documenting her daughter Krissy. When Krissy was about three, Shook realized why: "My mother died when I was twelve and I lost my memory, or most of it, of my childhood," Shook writes. "I was photographing my obsession with a childhood that might not be remembered."

Of course, Shook had no reason to believe that her own fate would befall Krissy. But she points out that "obsession is illogical, deep-rooted." The Krissy pictures were "talismans against loss, a bargain with death": They guaranteed that something of Krissy's childhood would endure no matter what happened to either mother or daughter.

The photographs are also a uniquely intimate body of work, distinguished by Shook's superb eye for expression and gesture. Shook has continued to photograph Krissy throughout her teens but—not surprisingly—discovered that the obsession began to fade when Krissy was about 12. "I was no longer haunted by my inability to remember," she notes. "By then something internal had healed."

Silhouetted by the sunlight pouring in through the bay windows, Krissy's father walks out of a room in the family's San Francisco apartment. His two-and-a-half-year-old daughter, wearing a large floppy hat and little else, stays behind to survey the beer containers and other clutter that adults have strewn across the floor. It was a period the photographer describes as "the tail end of the Haight-Ashbury days," referring to the San Francisco district that became synonymous with the hippie movement.

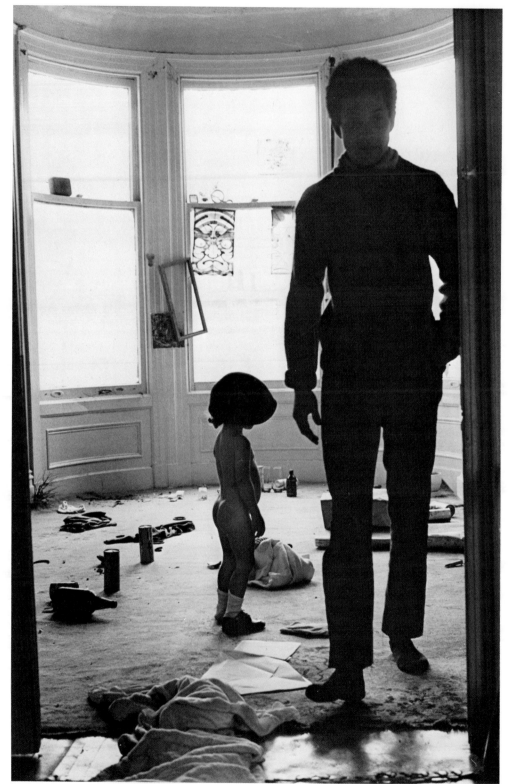

Krissy and Darryl, Page Street, San Francisco, 1967

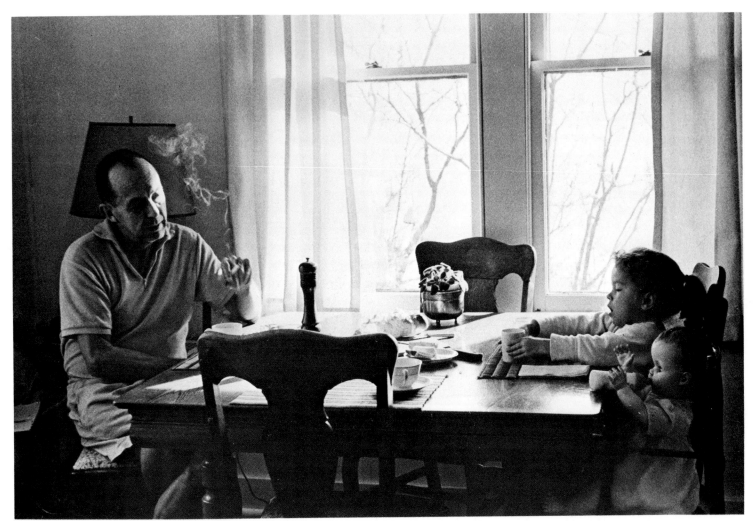

Krissy and Her Grandfather, Milford, Connecticut, c. 1968

As her grandfather relaxes over a cigarette and coffee, Krissy stretches for her own cup. The youngster had arranged her doll on the chair beside her, carefully propping up the bottle in its mouth. "Everything is very precise in the picture," says Shook. "That's very much what she was like."

217

Krissy and Naima, c. 1972

During an outing in the country, Krissy (right)
and a friend were "fooling around, dancing around,
playing" when Melissa Shook photographed
them with their bodies entwined and their heads
impishly thrown back. "I've grown through
Krissy," Shook comments. "She is a charmed being,
a beautiful animal, an interesting person."

This formal portrait of Krissy as a reserved young ▶
woman wearing an antinuclear T-shirt (which carries
the message "no nukes is good nukes") is part
of a series that documents her high-school years. "I
can't lurk around and photograph the same way I
used to," notes Shook. "That stopped when she was
about 12 or 13, and she took control. But she's
perfectly happy to let me do the series."

Krissy, December 20, 1980

A Young Street Prostitute in the Olympia Café, 1978

Falkland Road, notes Mary Ellen Mark, is "like any other busy lower-class street in Bombay"—with one big difference: The nondescript four- and five-story buildings that line it are a warren of cubbyhole brothels. Each cramped room is both home and work place for a half dozen or so prostitutes—some just 11 years old—and their madam. Customers stroll along the street, looking over the small goods hawked by vendors and ogling the explicit come-hither antics of the women.

For 10 years Mark struggled unsuccessfully to penetrate and to photograph the Falkland Road life. "The women threw garbage and water and pinched me," she recalls. "Crowds of men would gather around me." A drunk punched her in the face. Still, on every visit to India, she returned—determined to "earn the trust of the women," to outlast the hostility. Finally her persistence made the prostitutes curious; "and slowly, very slowly," she writes, "I began to make friends."

Mark first got to know the homeless streetwalkers, then the brassy women in the streetside cages, and finally the more elite prostitutes upstairs. She became so accepted a fixture in one brothel that she was often allowed to stay the night. And she photographed the prostitutes as an insider—and friend—would, concentrating on the details of their daily lives: their meals, friendships, baths and children as well as their work. Appropriately, she frequently shot with a quiet 35mm camera equipped with a rangefinder, using color film to balance the exotic, sensuous atmosphere against the tawdry setting.

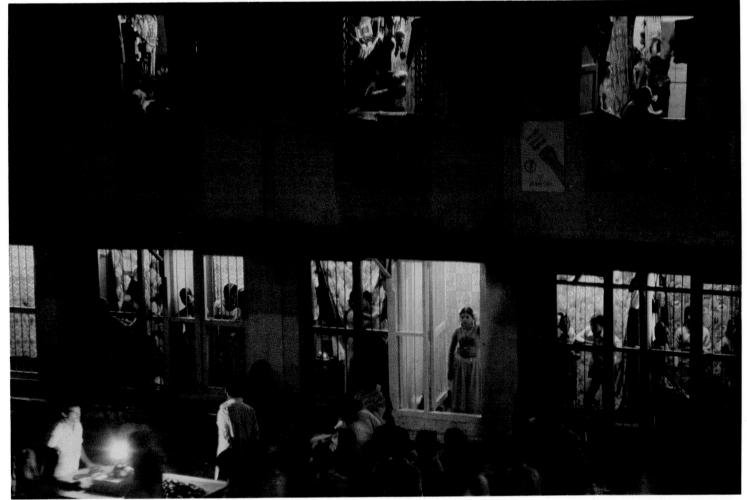

Cages on Falkland Road at Night, 1978

◄ *A teenage prostitute stares vacantly as she takes a drag on a cigarette in the Olympia Café, the largest and most pleasant tea shop on Falkland Road. The café was the favorite refuge of the streetwalkers, who lived and slept outdoors, renting beds in the brothels when they had customers. "It also became my favorite place," says Mark, "and it was here that I made friends with many street girls."*

As the evening crowd mills outside, the women in the cages and windows along Falkland Road wait for customers to approach. Each tiny chamber is a separate brothel, with its own madam, from three to 10 prostitutes, and a few beds curtained off for privacy. Many of the women were runaways from their home villages, or had been sold into prostitution by impoverished parents. "Given the choice," one madam told Mark, "I would have rather stayed in my village. But if I had stayed there, I would never have known what I had missed."

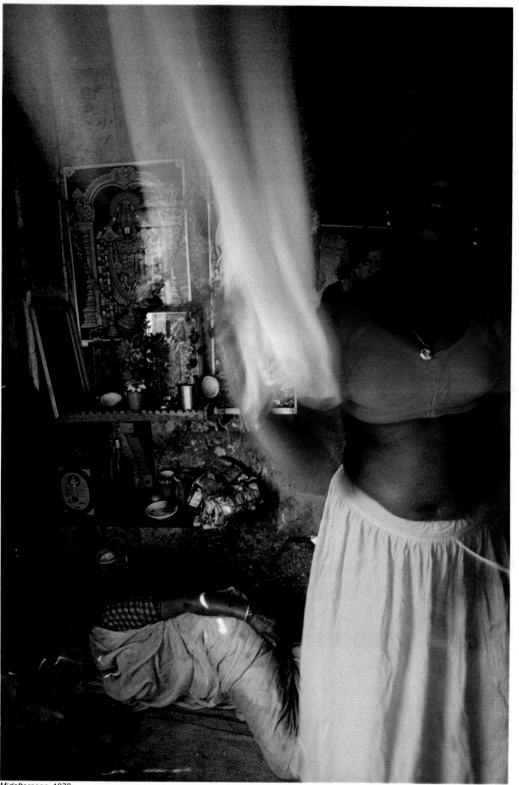

A madam naps on the floor of her single-room brothel while one of her girls removes a garment from a clothesline—an act blurred during the slow exposure dictated by the dim light. A picture of a popular movie star seems to peer over the girl's shoulder. The shelves above the madam hold cooking supplies and traditional religious images. During the day, Mark reports, the prostitutes cook, sleep and tend to chores. "It is all very much like normal Indian family life."

Midafternoon, 1978

222

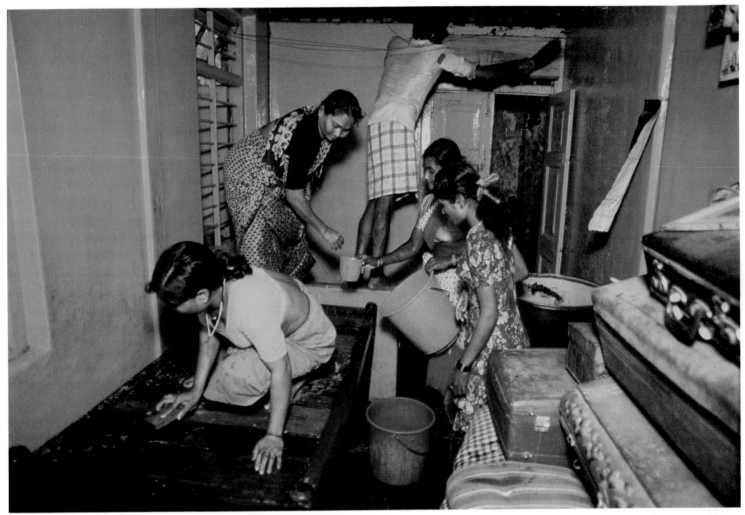

Untitled, 1979

Bending by the window, a madam named Saroja oversees her girls in the annual scrub-down on January 1st, a day when all Falkland Road cleans house. Saroja was a former prostitute who saved and borrowed to rent the space for her brothel. "Like all madams," notes Mark, "she has complete control over her girls. The relationship is one of master and slave — but also of mother and daughter."

Patt Blue

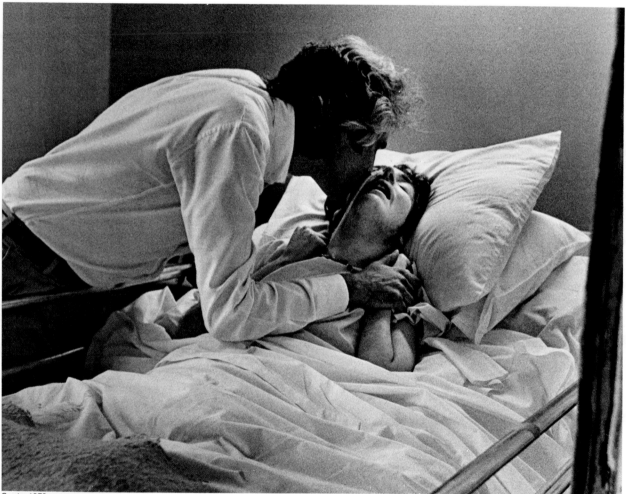

Carrie, 1979

When Patt Blue first visited a hospital for the permanently disabled, her impulse was to flee. Curiosity and, later, affection made her stay—and return weekly for more than three years. The patients were the victims of stroke and accident, birth defects and debilitating progressive diseases. Some could not speak or move; others got about in motor wheelchairs controlled by a nose, a chin or an elbow.

Blue spent six months as a volunteer, getting to know the patients as men and women before she started to photograph them as subjects. Many had been in the hospital for decades, gradually forgotten by family and friends. "They were suspended between life and death," Blue says, "virtual prisoners of their bodies."

Almost completely paralyzed and blind, a patient named Carrie receives a kiss from her former husband at the end of his visit. Ten years earlier Carrie had been stricken with multiple sclerosis, a mysterious, debilitating disease of the nervous system; she was then a lively 24-year-old in the second year of marriage. "He touched her like a healer—his hands on her every moment," Patt Blue noted of this visit. "Carrie became a person—not a sick person, not a case—a patient, but a woman."

Jeanette, 1978

A victim of cerebral palsy looks over her wheelchair with a terrible directness. Now 40 and never able to walk, talk or use her hands, she has been in the hospital for more than two decades. "You must be very attentive to their eyes," says Blue. "It is the only way many patients can communicate their needs."

Walter, 1978
226

Bill and Elizabeth, 1979

◄ *In this bleak shot, a patient with cerebral palsy sits among the things that make up his daily hospital world: his bed, wheelchair and portable radio, which is tagged with his name and chained to his chair so it will not be stolen or knocked off and broken. Photographer Patt Blue reported that this man felt frustrated by his dependency and the waiting—to be washed, dressed, fed—that inevitably went with it. Finally, after 20 years in the hospital, he was assigned his own aide and apartment in special city housing for the disabled.*

A patient named Bill affectionately holds the arm of his girl friend, Elizabeth, who is paralyzed and unable to speak. Suffering from a chronic liver ailment, Bill had more mobility than most patients and was Elizabeth's constant companion for 12 years—comforting her, feeding her, even brushing her hair and cleaning her teeth. He died four months after this picture was taken; Elizabeth had a new companion within a week. "Death is so much a part of their lives," says Blue, "that they accept it quickly, both for themselves and for those close to them."

Bank Langmore

06 Ranch, Alpine, Texas, 1975

No other figure is as typically American as the cowboy. Yet he is becoming a rare breed, now more common to television than to the West. Texas photographer Bank Langmore—fondly recalling youthful summers on a ranch—traveled some 20,000 miles to document the remaining authentic cowboys: "those unique men, descendants of the range riders of a century ago, who still make their living entirely on horseback."

Langmore rode with them at spring brandings and fall roundups, becoming so saddle sore, he says, "that I had to sleep with my hind end sticking out of my bedroll." He learned to steady his camera on horseback, and also discovered that cameras swinging freely on straps were a menace when a horse started to gallop. Covered with bruises, the photographer had holsters made for two cameras, and then—to the delight of the cowboys—he wore them on his hips, gunslinger-fashion.

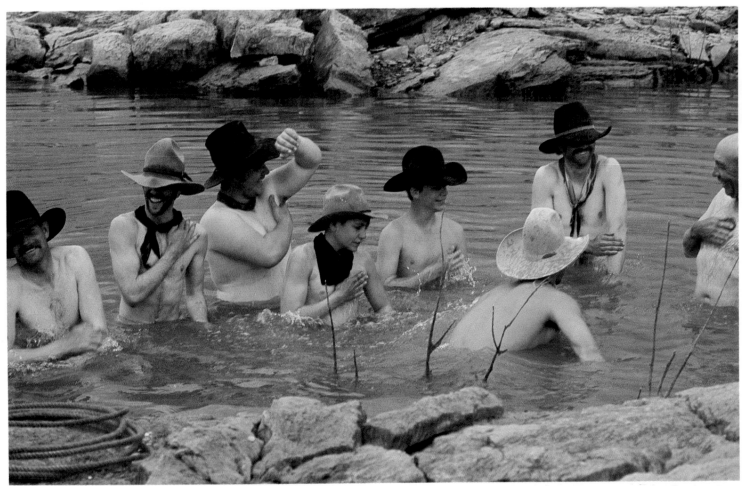

Bell Ranch, Tucumcari, New Mexico, 1974

◄ *His rope at the ready, a young Texas cowboy helps work the cattle during fall roundup. Every autumn the cattle to be sold are gathered into pens, then loaded by the buyers onto trucks for shipment to grass lots and stockyards. Large ranches like those Langmore visited often have more than 100,000 head of cattle, worked by as few as 25 cowboys — a disproportion making it impossible to drive the stock to market.*

After a spring morning spent rounding up cattle and branding calves, some not-quite-naked cowboys bathe in a lake adjoining a New Mexico ranch that started as a Spanish land grant. "The last thing they take off are their hats," notes Langmore, "even when they are taking a bath or crawling into their bedrolls."

MC Ranch, Adel, Oregon, 1974

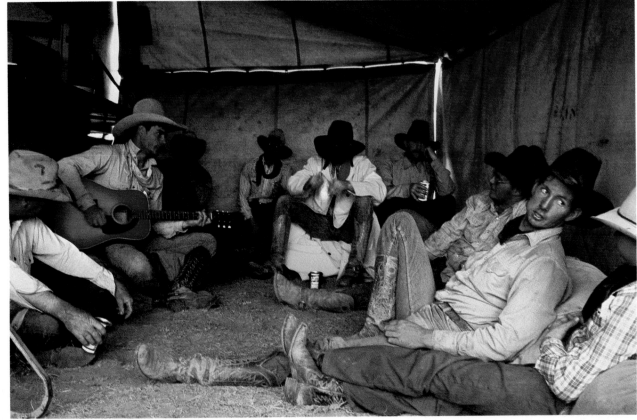

Bell Ranch, Tucumcari, New Mexico, 1974

◀ *In a washtub atop the kitchen table, a young girl waits patiently for her mother to return and finish bathing her. The child's father was in charge of a fall drive at a remote line camp on a million-acre ranch in southeast Oregon. The camp comprised a cookshack, bunkhouses and a set of corrals. This picture was taken in the kitchen where the girl's mother cooked for the buckaroos, as cowboys are commonly called in parts of the Northwest.*

Cowboys on a ranch in eastern New Mexico while away a rainy evening by drinking beer, singing songs and telling stories under a tent attached to their chuck wagon. Most of the open range has been fenced in, and team-drawn chuck wagons are becoming a rarity —largely because of the difficulty of finding and keeping competent field cooks. Otherwise, "the cowboy life hasn't changed a hell of a lot from a hundred years ago," says Langmore. "It's hard work and it's seven days a week."

Paul Kwilecki

Dr. M. A. Ehrlich in His Office, 1980

Decatur County is a thousand square miles of modest farms and quiet hamlets tucked away in southwest Georgia. It is an ordinary place, as Paul Kwilecki admits—yet it is one Kwilecki has spent more than two decades photographing. "People have the mistaken idea that what they might find dull in reality is likewise dull in art," he explains. "I am giving you a *real* place, a place filtered through a human being who was born and raised here, who's got all the prejudices and wounds that living in this place means." Kwilecki documents his county slowly, and in pieces—concentrating on a river, a park or a row of houses for months at a time. The subject, to him, is inexhaustible and universal. "I will not have life enough to photograph all that is here," he declares. "To me, Decatur County is a metaphor for the whole world."

232

Tobacco Tenant House, 1964

◀ Stethoscope dangling from his neck, a Decatur County physician peers quizzically through the screen door of his store-front office. Paul Kwilecki had been photographing the doctor on and off for about six years when he got this fortuitous shot: While adjusting his camera tripod, Kwilecki glanced up, saw this scene, and "quickly did what had to be done and took the picture"—then continued with the planned session. "My pictures are quiet pictures," he says, "but they are made with passion."

On the porch of her weathered quarters, a tenant farmer's wife braids her daughter's hair while her son shyly hides behind the chair. Another family, seen down the porch, occupies the far end of the quarters. Shade-tobacco farms with tenant labor were "one of the last vestiges of plantation life," says Kwilecki, but they disappeared when their hand-grown crop — the leaf for wrapping cigars — was widely replaced by a manufactured wrapper in the early 1970s.

233

Baptism, Mount Zuma, 1977

At a Sunday morning baptism on the banks of the Flint River, a parishioner who helps with the immersions stands knee-deep in the water as the minister leads his congregation in hymn. Afterward, Kwilecki learned that the minister's 20-year-old son had died only two hours before the service; the minister had gone forward vigorously with his duties, firm in his faith that God had called his son.

Under the shade of spreading oaks, townspeople and shoppers from the surrounding countryside rest on the benches that line the central square in Bainbridge, Decatur County's seat and largest town, with about 12,000 residents — roughly half the population of the entire county. The small park is rarely empty. "People just sit there and talk and watch people go by on the sidewalk," says Kwilecki.

Willis Park, 1978

A Special Bond

Carol Beckwith

Magadi, Kenya, 1978

For centuries, the Maasai of East Africa guarded their grazing lands and ancient pastoral ways with a warlike ferocity. But in recent years their independence has been threatened by the formidable encroachments of the modern world — an inexorable invasion prompting photographer Carol Beckwith to term the Maasai "an endangered people."

Beckwith spent more than two years assembling a dazzling visual record of what remains of traditional Maasai life. Her photographs show that much of their

original fierceness survives in their proud bearing and their exhilarating ceremonies. And those Maasai who have resisted the lure of cities or of agriculture remain as dependent upon the herds they graze on the wide, grassy savannas of the Great Rift Valley as their ancestors were. Cattle give them milk for a daily staple, meat for festive occasions, leather for clothing, and one of their chief building materials — dung to seal their huts.

Beckwith gave special attention to the age-defined stages through which the

Maasai pass. An elaborate ritual circumcision in the midteens signals the passage from carefree boyhood to warriorhood. Another ceremony transforms the warrior, when he is about 30 years old, into an elder, ready to marry one of the girls ritually marking their advance into womanhood at puberty. In time he adds more wives, amasses a herd of cattle — the measure of Maasai success — and attains the revered status of senior elder: the traditional protector of the Maasai's vanishing folkways.

◄ Outside her family hut, an exuberant young girl jumps high into the air —perhaps emulating the warriors, who pride themselves on the height and control of their leaps in the jumping dance. Childhood is a leisurely and informal education in the ways of the tribe. "Girls gradually learn the womanly arts," wrote a Maasai warrior who studied in the United States. "Boys develop their running and throwing skills, begin to learn about cattle, and play at being herdsmen."

Recently circumcised Maasai teenagers celebrate at the circumcision ceremony of another youth. During the two or three months of healing, the young men wear charcoal- and oil-stained garments and distinctive, coiled brass ornaments on their temples. They roam the countryside in groups, visiting others about to undergo the painful ritual, urging them on to manhood with songs and relentless teasing.

Kajiado, Kenya, 1978

237

Kedong Valley, Kenya, 1975

238

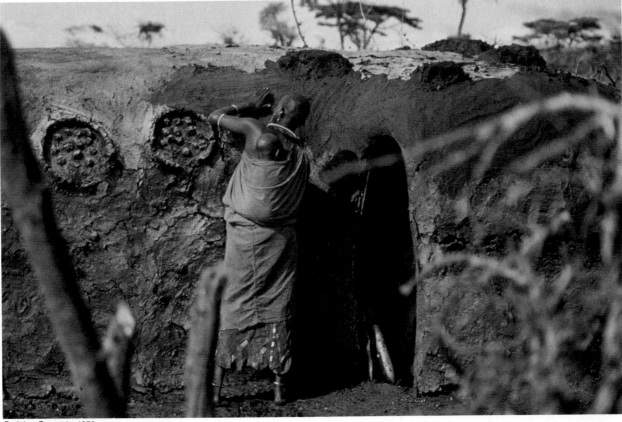

Endulen, Tanzania, 1978

◄ *Their long, plaited hair dressed with ocher, Maasai warriors sing as they prepare for a vigorous jumping dance. The brightly beaded children swaying their backs to the rhythm are the warriors' girl friends. Forbidden to marry before elderhood, the warriors are permitted to associate only with girls who have not yet reached puberty. The leafy branches tucked under the arms of some of the warriors act as a deodorant when held for 15 to 20 minutes.*

Carrying her baby on her back, a Maasai woman patches her storm-damaged hut with a thick coat of cow dung. The material dries like clay, keeping the branch-and-leaf structure weathertight and quickly losing its pungent odor. Building a hut is one of the first duties of a married woman, and each wife of the polygamous males maintains her own abode.

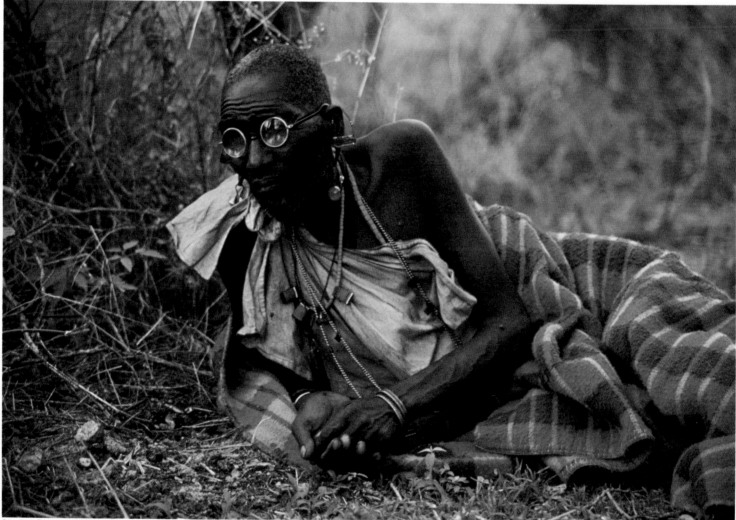

Olbalbal, Tanzania, 1979

Wrapped in the blanket cloak signifying his rank,
a senior elder reclines in contemplation, oblivious of
the flies that dot his body. At this stage in their
lives, the men assume a dignified demeanor and
become the honored preservers of Maasai
legends and customs. They also gather in councils
to settle community disputes and mete out
justice, making wrongdoers pay heads of cattle as
recompense for theft, adultery and even murder.

Bibliography

General

Abbott. Berenice. *The World of Atget*. Horizon Press. 1964.

Adams. William Howard. *Atget's Gardens*. Doubleday. 1979.

*Agee. James and Walker Evans. *Let Us Now Praise Famous Men*. Houghton Mifflin. 1941.

Anderson. Sherwood. *Home Town*. Alliance Book Corporation. 1940.

Arbus. Diane. *A Box of Ten Photographs*, portfolio of original prints. 1971.

Atget. Eugène and Marcel Proust. *A Vision of Paris*. Macmillan. 1963.

Baldwin. Sidney, *Poverty and Politics: The Rise and Decline of the Farm Security Administration*. University of North Carolina Press. 1968.

Barbey. Bruno, *Portrait of Poland*. Thames and Hudson. 1982.

Barret. André. *Autochromes 1906-1928*. Tresors de la Photographie. Paris. 1978.

*Capa, Cornell. ed., *The Concerned Photographer, The Photographs of Werner Bischof, Robert Capa, David Seymour, André Kertész, Leonard Freed, Dan Weiner*. Grossman, 1968.

Cartier-Bresson, Henri:
Cartier-Bresson's France. Viking Press, 1971.
The Decisive Moment. Simon and Schuster. 1952.
The Europeans. Simon and Schuster. 1955.
**The World of Henri Cartier-Bresson*. Viking Press. 1968.

*Cordasco. Francesco, ed., *Jacob Riis Revisited: Poverty and the Slum in Another Era*. Anchor, 1968.

Deschin, Jacob, *Say It with Your Camera: An Approach to Creative Photography*. Whittlesey House, 1950.

Evans, Walker, *American Photographs*. Doubleday. 1938.

†Fárová, Anna, ed., *André Kertész*. Grossman, 1966.

†*Five Photographers*. The Sheldon Memorial Art Gallery, University of Nebraska, 1968.

Franck, Martine, *Le Temps de Vieillir*. Editions Denoël Filipacchi, Paris, 1980.

*Frank, Robert, *The Americans*. Aperture Inc., Grossman, 1969.

Freed, Arthur, *Eight Photographs*. Doubleday, 1971.

*Friedlander, Lee, *Self Portrait*. Haywire Press, 1970.

*Friedlander, Lee and Jim Dine, *Work from the Same House*. Trigram Press, 1969.

Gardner, George W., *America Illustrated: Photographs 1960-1980*. Tackfield, Ltd., 1982.

*Goldston, Robert, *The Great Depression: The United States in the Thirties*. Bobbs-Merrill, 1968.

†Grossman, Sid and Millard Lampell, *Journey to the Cape*. Grove Press, 1959.

Gutman, Judith Mara, *Lewis W. Hine and the American Social Conscience*. Walker and Co., 1967.

Hurley, Forrest Jack, *To Document a Decade: Roy Stryker and the Development of Documentary Photography by the Farm Security Administration*. University Microfilms, Ann Arbor, 1971.

Jacques-Henri Lartigue, Gordon Fraser. London. 1976.

*Kirstein, Lincoln and Beaumont Newhall, *Photographs by Cartier-Bresson*. Grossman, 1963.

Kwilecki, Paul, *Understandings: Photographs of Decatur County, Georgia*. The University of North Carolina Press, 1981.

*Lange, Dorothea:
Dorothea Lange. Doubleday, 1966.
"The Making of a Documentary Photographer." University of California Bancroft Library, Berkeley, 1968.

Lartigue, Jacques-Henri:
Boyhood Photos of J.-H. Lartigue. Ami Guichard, 1966.
Diary of a Century. Viking Press, 1970.

Lubove, Roy, *The Progressives and the Slums: Tenement House Reform in New York City 1890-1917*. University of Pittsburgh Press, 1962.

*Lyons, Nathan, ed.:
Photographers on Photography. Prentice-Hall, 1966.
Toward a Social Landscape: Bruce Davidson, Lee Friedlander, Garry Winogrand, Danny Lyon, Duane Michals. Horizon Press, 1966.

MacLeish, Archibald, *Land of the Free*. Harcourt Brace, 1938.

*Mark, Mary Ellen, *Falkland Road: Prostitutes of Bombay*. Alfred A. Knopf, 1981.

Morris, Kelly, ed., *Paul Kwilecki: 100 Decatur County Photographs*. The High Museum of Art, 1980.

Newhall, Beaumont, *The History of Photography from 1839 to the Present Day*. Doubleday, 1964.

Newhall, Nancy, *Paul Strand, Photographs 1915-1945*. Simon and Schuster, 1945.

Orkin, Ruth:
A Photo Journal. Viking Press, 1981.
A World through My Window. Harper & Row, 1978.

†"The Photo Journalist: W. Eugene Smith, Dan Weiner." The Fund for the Republic, 1958.

Raper, Arthur F. and Ira De A. Reid, *Sharecroppers All*. University of North Carolina Press, 1941.

Riis, Jacob A.:
The Battle with the Slum. Macmillan, 1902.
**How the Other Half Lives*. Dover, 1971.
The Making of an American. Macmillan, 1970.

*Rothstein, Arthur, John Vachon and Roy Stryker, *Just before the War: Urban America from 1935 to 1941 as Seen by Photographers of the Farm Security Administration*. October House, 1968.

Saitoli, Tepilit Ole, *MAASAI*. Harry N. Abrams, Inc., 1980.

*Smith, W. Eugene, *W. Eugene Smith: His Photographs and Notes*. Aperture Inc., 1969.

†Steichen, Edward, ed., *The Bitter Years: 1935-1941*. Doubleday, 1962.

Stone, Benjamin, *Sir Benjamin Stone's Pictures: Records of National Life and History*. Cassell and Company Ltd., London, 1906.

Strand, Paul and James Aldridge, *Living Egypt*. Horizon Press, 1969.

Strand, Paul and Basil Davidson, *Tir A'Mhurain*. Grossman, 1968.

Strand, Paul and Claude Roy, *La France de Profil*. Editions Clairefontaine, 1952.

Strand, Paul and Cesare Zavattini, *Un Paese*. Giulio Einaudi editore S.P.A., 1955.

Stryker, Roy and Nancy Wood, *In This Proud Land: America 1935-1943 as Seen in the F.S.A. Photographs*. New York Graphic Society, 1974.

†Taylor, Florence I., *Child Labor Fact Book*. National Child Labor Committee, Publication No. 403, 1950.

Thomson, John, *Illustrations of China and Its People*, 4 vols. Sampson Low, Marston, Low and Searle, London, 1873-1874.

Tyler, Tom, *The Cowboy*. William Morrow and Company, 1975.

Walker Evans. The Museum of Modern Art, 1979.

Ware, Louise, *Jacob A. Riis: Police Reporter, Reformer, Useful Citizen*. D. Appleton-Century Company, 1938.

†Winogrand, Garry, *The Animals*. New York Graphic Society, 1969.

Periodicals

Album. Aidan Ellis and Tristram Powell, London.
Art Forum. Charles Cowles, New York City.
Art in America. Art in America Co., New York City.
Camera. C. J. Bucher Ltd., Lucerne, Switzerland.
Camera Arts. Ziff-Davis Publishing Co., New York City.
Creative Camera. International Federation of Amateur Photographers, London.
GEO. Gruner + Jahr USA, New York City.
Infinity. American Society of Magazine Photographers, New York City.
Life. Time Inc., New York City.
The Nation. Nation Magazine Company, New York City.
Photo Notes. The Photo League, New York City.
Popular Photography. Ziff-Davis Publishing Co., New York City.
U.S. Camera World Annual. U.S. Camera Publishing Corp., New York City.

* Also available in paperback
† Available only in paperback

Acknowledgments

The index for this book was prepared by Karla J. Knight. For the assistance given in the preparation of this volume, the editors would like to express their gratitude to the following: Mauro Apolloni, Director, Galleria Rondanini, Rome; Doon Arbus, New York City; Edward Bady, Hicksville, New York; Thomas F. Barrow, Associate Curator, Research Center, George Eastman House, Rochester, New York; Willa Baum, Director, Regional Oral History Office, The Bancroft Library, University of California, Berkeley, California; Roger Bruce, Washington, D.C.; Peter C. Bunnell, Curator, Department of Photography, The Museum of Modern Art, New York City; Jerry Burchard, Chairman, Department of Photography, San Francisco Art Institute, San Francisco, California; Paul Carlson, National Endowment for the Arts, Washington, D.C.; John Collier, Associate Professor of Anthropology and Education, San Francisco State College, San Francisco, California; Lanfranco Colombo, Editor, *Il Diaframma*, Milan; Arnold H. Crane, Chicago, Illinois; Jack Delano, Rio Piedras, Puerto Rico; Jacob Deschin, Contributing Editor, *Popular Photography*, New York City; Robert Doherty, Director, Allen R. Hite Art Institute, University of Louisville, Louisville, Kentucky; Robert M. Doty, Associate Curator, Whitney Museum of American Art, New York City; Walker Evans, Old Lyme, Connecticut; Alan Fern, Assistant Chief, Prints and Photographs Division, Library of Congress, Washington, D.C.; Robert Frank, New York City; Lee Friedlander, New York City; Professor L. Fritz Gruber, Cologne; Alex Harris, Center for Documentary Photography, Durham, North Carolina; Terese Heyman, Curator of Photography, Oakland Museum, Oakland, California; Michael Hoffman, Publisher, *Aperture*, Millerton, New York; Forrest Jack Hurley, Assistant Professor of History, Memphis State University, Memphis, Tennessee; Marvin Israel, New York City; Jerry Kearns, Acting Head, Reference Section, Prints and Photographs Division, Library of Congress, Washington, D.C.; Carole Kismaric, Associate Editor, *Aperture*, New York City; Russell Lee, Lecturer, Art Department, The University of Texas, Austin, Texas; Carl Mydans, Larchmont, New York; Anna Obolenski, A.N.A., Paris; Starr Ockenga, Boston, Massachusetts; Charles Pratt, New York City; Beppe Preti, Art Director, *Il Fotografo*, Milan; Johanna Robison, Curatorial Assistant, Oakland Museum, Oakland, California; Walter Rosenblum, Professor, Department of Art, Brooklyn College, Brooklyn, New York; Edwin Rosskam, Roosevelt, New Jersey; Arthur Rothstein, New Rochelle, New York; Bernarda B. Shahn, Roosevelt, New Jersey; Aaron Siskind, Providence, Rhode Island; Patricia Strathern, Magnum, Paris; Roy Stryker, Grand Junction, Colorado; John Szarkowski, Director, Department of Photography, The Museum of Modern Art, New York City; Paul S. Taylor, Professor of Economics Emeritus, University of California, Berkeley, California; David Vestal, Associate Editor, *Camera 35*, New York City; Garry Winogrand, New York City.

Picture Credits *Credits from left to right are separated by semicolons, from top to bottom by dashes.*

COVER: © 1980 Harry N. Abrams, Inc. From *MAASAI* by Tepilit Ole Saitoti, photographs by Carol Beckwith, published, Harry N. Abrams, Inc.

Chapter 1: 11: Collections Albert Kahn, Département des Hauts-de-Seine, Boulogne-Billancourt. 16 through 19: John Thomson, copied by Paulus Leeser, courtesy Arnold H. Crane Collection. 20 through 25: Reproduced by permission from the Sir Benjamin Stone Collection of Photographs in the Birmingham Reference Library. All photographs except page 25 copied by Derek Bayes. 26 through 31: Jacques-Henri Lartigue from Rapho Guillumette. 32 through 35: Collections Albert Kahn, Département des Hauts-de-Seine, Boulogne-Billancourt. 36 through 42: Eugène Atget, courtesy The Museum of Modern Art, New York.

Chapter 2: 45: Lewis W. Hine, courtesy George Eastman House. 46: John Thomson, from *Street Life in London*, Sampson Lowand Co., London, 1877, copied by Derek Bayes, courtesy Bill Jay. 48: Jacob A. Riis, from *How the Other Half Lives*, Charles Scribner's Sons, copied by Paulus Leeser. 49 through 55: Jacob A. Riis, courtesy The Museum of the City of New York. 57 through 63: Lewis W. Hine, courtesy George Eastman House. 65, 66: Walker Evans, courtesy The Museum of Modern Art, New York. 67: Walker Evans, copied by Paulus Leeser, courtesy The Museum of Modern Art, New York. All photographs on pages 68 through 78 except page 71 were taken for the Farm Security Administration, courtesy Library of Congress. 68: Walker Evans. 69: Walker Evans, courtesy The Museum of Modern Art, New York. 70 through 75: Ben Shahn. 76 through 78: Russell Lee.

Chapter 3: 81: Sid Grossman. 84, 85: Sol Libsohn. 86, 87: Sid Grossman. 88, 89: Jerome Liebling. 90, 91: Jack Manning, courtesy George Eastman House. 92, 93: Aaron Siskind, courtesy George Eastman House. 94, 95: Ruth Orkin. 96, 97: Eliot Elisofon. 98, 99: Arthur Leipzig. 100, 101: Morris Engel. 102, 103: Lou Bernstein. 104, 105: William Witt. 106: Lester Talkington.

Chapter 4: 109 through 117: © André Kertész. 118 through 123: Paul Strand. 124 through 131: Henri Cartier-Bresson from Magnum. 132 through 137: Dorothea Lange, courtesy The Oakland Museum. 138: W. Eugene Smith for *Life*. 139 through 143: W. Eugene Smith. 144 through 150: Martine Franck/Magnum, Paris.

Chapter 5: 153 through 165: Robert Frank. 167 through 175: Lee Friedlander. 176 through 185: © George W. Gardner. 187 through 189: Garry Winogrand. 190: Garry Winogrand, courtesy The Museum of Modern Art, New York. 191: Garry Winogrand. 192: Garry Winogrand, courtesy The Museum of Modern Art, New York. 193 through 195: Garry Winogrand, courtesy The Museum of Modern Art, New York. 197 through 204: Diane Arbus, courtesy Doon Arbus.

Chapter 6: 207 through 215: Bruno Barbey/Magnum, Paris, from *Portrait of Poland*, published by Hoffmann und Campe, Hamburg. 216 through 219: Melissa Shook. 220 through 223: Mary Ellen Mark from Archive. 224 through 227: Patt Blue © 1981. 228 through 231: Bank Langmore. 232 through 235: Paul Kwilecki. 236 through 240: © 1980 Harry N. Abrams, Inc. From *MAASAI* by Tepilit Ole Saitoti, photographs by Carol Beckwith, published, Harry N. Abrams, Inc.

244

Index
Numerals in italics indicate a photograph, painting or drawing of the subject mentioned.

Documentary Photography
Revised Edition

BY THE EDITORS OF TIME-LIFE BOOKS

TIME-LIFE BOOKS, ALEXANDRIA, VIRGINIA

For information about any Time-Life book,
please write:
Reader Information
Time-Life Books
541 North Fairbanks Court
Chicago, Illinois 60611

TIME-LIFE is a trademark of
Time Incorporated U.S.A.

Library of Congress Cataloguing in Publication Data
Main entry under title:
Documentary photography.
 (Life library of photography)
 Bibliography: p.
 Includes index.
 1. Photography, Documentary. I. Time-Life Books.
II. Series.
TR820.5.D64 1983 778.9'907 82-19411
ISBN 0-8094-4432-1
ISBN 0-8094-4433-X (lib. bdg.)
ISBN 0-8094-4434-8 (reg. bdg.)

ON THE COVER: Festooned with
beaded necklaces and headbands, two
young East African girls adorn
themselves for a ceremonial dance with
their tribe's warriors. The picture is
typical of the brilliant and intimate
documentary photographs that Carol
Beckwith made during a stay of more
than two years among the Maasai
tribes of Kenya and Tanzania.

This volume is one of a series devoted to the art and technology of photography. The books present pictures by outstanding photographers of today and the past, relate the history of photography and provide practical instruction in the use of equipment and materials.